MAPPING THE NEW WORLD

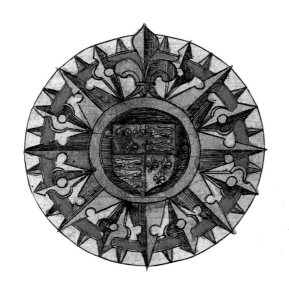

Renaissance Maps from

THE AMERICAN MUSEUM IN BRITAIN

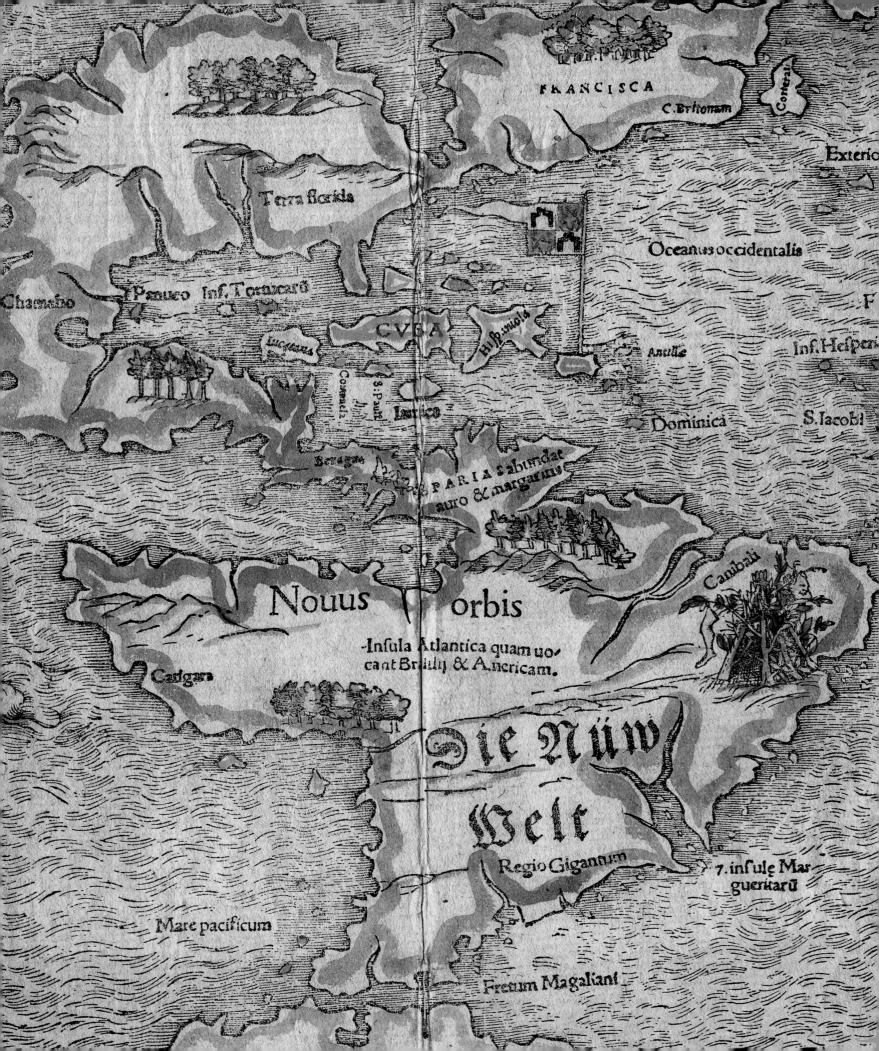

MAPPING THE NEW WORLD

Renaissance Maps from

THE AMERICAN MUSEUM IN BRITAIN

ANNE ARMITAGE & LAURA BERESFORD

SCALA

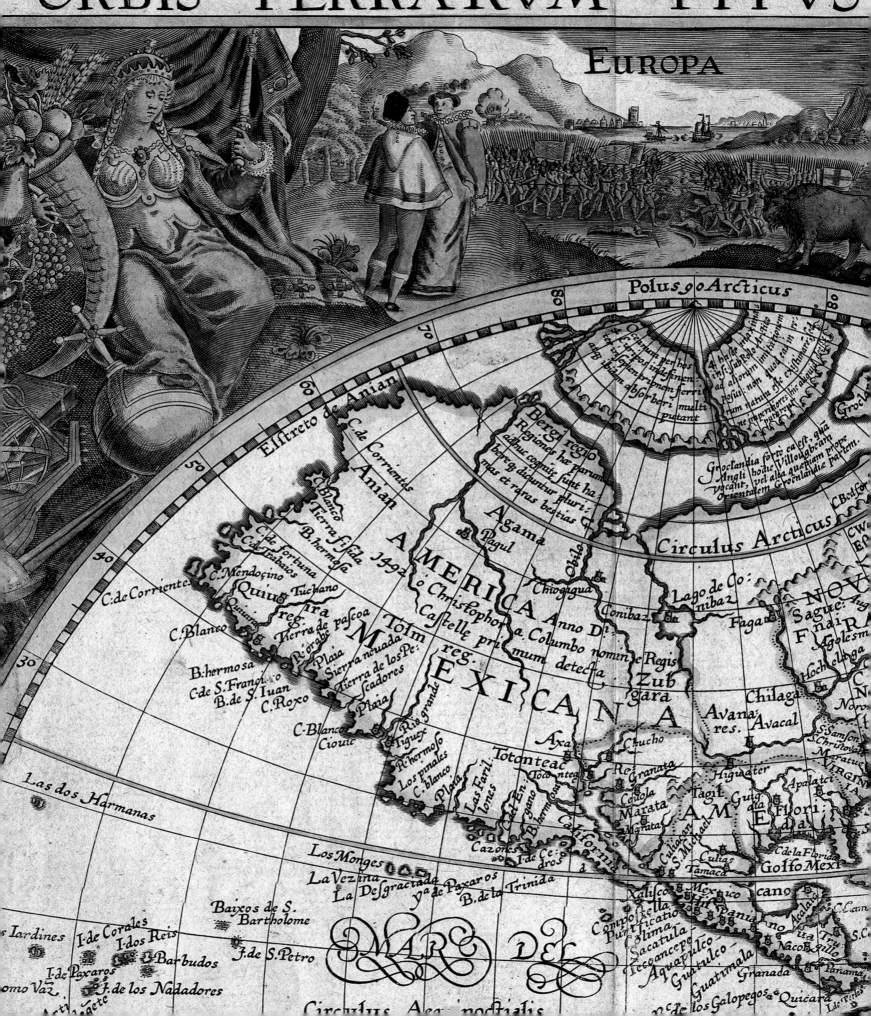

ORBIS TERRARVM TYPVS

FOREWORD

It gives me great pleasure to introduce the third catalogue produced by Scala Arts & Heritage Publishers devoted to our core collections at the American Museum. Following publications focusing on quilts and folk art, this volume illustrates the changing shape of the Americas as Renaissance cartographers, working from ancient and medieval sources, learned more about the New World on the far side of the Atlantic Ocean. One of our institution's two founders, Dr Dallas Pratt – an American psychiatrist and collector – bequeathed over two hundred exquisitely detailed maps to the American Museum. Before his death in 1994, Dr Pratt's collection was acclaimed by scholars as one of the finest private holdings of pre-1600 printed world maps east of the Atlantic.

My thanks, and those of my colleagues, go to Anne Armitage, formerly the Museum's Librarian and Editor, for preparing this catalogue, co-authored by Laura Beresford, our Curator. Katherine Hebert, our Collections Manager, assembled the necessary illustrations from the magnificent photography undertaken by Stuart Ross, when he was Head of Visual Resources at the American Museum. We would also like to take this opportunity to thank William McNaught and the antiquarian map dealer Jonathan Potter for their kind assistance.

Several close friends of the American Museum have supported the publication of this catalogue, notably:

The Claverton Theatre Club

Linda Hackett
The CAL Foundation

The Haranzo Family

Mr and Mrs Robert Ian MacDonald
The Cranshaw Corporation

I take pleasure in thanking all of these friends, whose generosity and enthusiasm have helped bring our world-class collection of maps to the attention of a new generation of collectors and scholars.

Richard Wendorf, *Director*
The American Museum in Britain

PAGE 1: Compass rose from *The Famouse West Indian voyadge made by the Englishe fleet* (see pp. 92–3).

PAGES 2–3: Details from *Tavola dell' isole nuove…* and *Mostri marini & terrestri…* (see pp. 40–3).

ABOVE: Detail from *A Weroan or great Lorde of Virginia* (see pp. 106–7).

OPPOSITE: Detail of Europa and an American buffalo from *Orbis Terrarum Typus…* (see pp. 114–17).

PREFACE
Historical Overview

Spurred on by thoughts of treasure – particularly gold, silver, pearls and spices – European travellers changed the shape of the 'New World' as they mapped the Americas from the fifteenth to the seventeenth centuries. This era of oceanic exploration came to be known as the Age of Discovery. Once Constantinople fell to the Ottoman Empire in 1453, overland trade routes to the Middle East and Asia were barred to Christian Europe. Finding sea passage to distant spice and silk markets became imperative for the European rich, as well as for the fortune-seeking opportunists who served them.

Portugal launched the first open-sea explorations in the early fifteenth century, breaking with the coastal-sailing tradition of keeping land in sight as an aid to navigation. By venturing into the realms of sea monsters – grotesquely presented on contemporary maps as matters of fact rather than fancy – Portugal laid claim to the Madeira islands and the Azores by 1427, and then went on to explore the west coast of Africa. Portugal's great rival, Castile, had been slower to take up the challenge of oceanic exploration. After its marriage alliance with Aragon in 1469 and the subsequent reconquest of the Moorish kingdom of Granada (completed in 1492), Castile looked seawards. By claiming Granada for Christ, the Spanish monarchs severed trade ties with African markets dealing in luxury goods. (Such bounty had previously been paid as tribute by the Moors.) To avoid the humiliation of bartering with Portugal over trade through Africa, it thus became necessary to finance adventurers willing to seek out new trade routes with the East by travelling west.

Christopher Columbus famously set sail in August 1492 – the same year that Granada finally fell to his patrons, Isabella of Castile and Ferdinand of Aragon. (Ironically, the Genoese navigator had first sought funding for his quest from Portuguese coffers.) Contrary to popular belief, Columbus never set foot on mainland America. In little more than two months, he instead found his way to the Caribbean – a world 'new' to Europe, which Columbus claimed on behalf of Castile. Here he enslaved the Taíno people and forced them to mine for gold on behalf of the Spanish crown. Through overwork and disease, the Taíno population fell from an estimated 6 million in 1492 to about 60,000 by 1509. Similar stories of brutality and suffering would echo throughout European conquests of the Americas, notably that of the Spanish overthrow of the Mexica/Aztec Empire by Hernán Cortés (1519–21) and the subjugation of the Inca by Francisco Pizarro (1532). In Mesoamerica native populations declined as much as 90% – the same catastrophic fate suffered by the Taíno under the rule of Columbus.

Although outnumbered, the European invaders were successful because they gathered together armies of disenfranchised native renegades, anxious to avenge past wrongs. European dominance was also furthered by the increasing availability of detailed maps. Whereas medieval maps illustrated theology rather than geography, the Renaissance revived the classical discipline of scientifically mapping landmass. Such precision was entirely practical: only by exact measurement could the rich New World territories be claimed, plundered and ruled by their Old World conquerors.

Papal intervention resolved simmering hostilities between Portugal and Spain with the Treaty of Tordesillas in 1494, which divided the known and unknown world between these seafaring superpowers. Portugal gained control over Africa, Asia and eastern South America (Brazil). Spain was initially disappointed by the division of the spoils. Its rulers little suspected that they had already begun to build an even greater empire abroad – one built on terror and treasure that would extend throughout North, Central and South America for hundreds of years.

The impetus behind many perilous transatlantic ventures was the story of 'El Dorado', the legend of the Golden Man, which had its genesis in the Colombian highlands. This legend was sparked by stories of a treasure-laden ritual performed by the Muisca people on lakes in present-day Colombia. Describing the rite, a Spanish agent wrote in 1638:

> [T]hey stripped the heir to his skin and anointed him with a sticky earth on which they placed gold dust so that he was completely covered with this metal. They placed him on the raft… and at his feet they placed a great heap of gold to offer to his god… [When] the gilded Indian reached the centre of the lagoon… [he threw] out all the pile of gold into the middle of the lake… With this ceremony, the new ruler was received and was recognized as lord and king.

Stories of the Muisca ceremony had begun to circulate among the conquistadors in the previous century. (Marks left by Spanish attempts in 1580 to drain the great lake of Guatavita in present-day Colombia are still visible.) In time, the story of El Dorado was reshaped in retellings: the Golden Man was refashioned into a golden city. The supposed location of this later El Dorado changed as new regions of Central and South America were explored. The story of the golden city proved potent because it was so desirable to fortune-seekers of any European nation.

The legacy of the Age of Discovery still lingers. Confidence in sailing the open sea (due to improvements in ship building, map-making and navigation) ushered in centuries of colonialism whereby Europe controlled almost all the globe. Indigenous populations fell to the sword or to introduced diseases. This was particularly true of Spain's intrusions into the New World, following the arrival of Columbus among the Taíno people in 1492.

How much was lost in the successive European campaigns in the Americas can be glimpsed in the beauty and craft of pre-Columbian pieces displayed in museum collections throughout the world. Nor was guilt for these actions felt only centuries later. In the preamble to his will written in 1589, Don Mancio Serra de Leguisamo – the last survivor of the band of conquistadors who sacked Peru – repented the horror he and his fellow soldiers had inflicted on the native populations:

> *We found these kingdoms in such good order… that throughout them there was not a thief, nor a vicious man, nor an adulteress… The men had honest and useful occupations… [T]he motive which obliges me to make this statement is the discharge of my conscience, as I find myself guilty. For we have destroyed by our evil example, the people who had such a government as was enjoyed by these natives. They were so free from the committal of crimes or excesses… that the Indian who had 100,000 pesos worth of gold and silver in his house left it open, merely placing a small stick against the door as a sign that its master was out. With that, according to their custom, no one could enter or take anything that was there… [W]hen they found that we had thieves among us, and men who sought to make their daughters commit sin, they despised us.*

Leguisamo's private confession could stand as a public epitaph for this time of terror and treasure in the Americas, when the Old and New Worlds collided over God and gold.

Sir Walter Raleigh, flamboyant favourite of Queen Elizabeth I, made several fruitless voyages in search of El Dorado. Raleigh believed the golden city to be located far up the Orinoco River. In his *Discoverie of Guiana* – his exaggerated account of 1596, describing his first attempt to find this treasure – Raleigh rallied supporters to his cause, not only with the prospect of profit but also with the promise of harming England's enemy, Spain:

> *The common soldier shall here fight for gold, and pay himself, instead of pence, with plates of half-a-foot broad. Those commanders… that shoot at honour… shall find there… more temples adorned with golden images, more sepulchres filled with treasure, than either Cortés found in Mexico or Pizarro in Peru… [T]he shining glory of this conquest will eclipse all those so far-extended beams of the Spanish nation.*

Raleigh's location for El Dorado on the shores of the imaginary Lake Parime continued to be marked on English maps until its existence was finally disproved in the early nineteenth century – an indication of how potent the myth of El Dorado proved to be and why so many throughout the previous centuries dared to venture their lives and fortunes crossing the Atlantic.

THE DALLAS PRATT COLLECTION OF HISTORICAL MAPS

I n 1932 a young American – eighteen years old and enjoying a summer in Paris before entering Yale – was strolling past the bookstalls that line the banks of the Seine, when his eye was caught by what he described as:

> three quaint and colorful maps. One was of the world, with fat-cheeked windpuffers, one of the western hemisphere with a cannibal's 'lunch' hanging from a Brazilian woodpile, and the third depicted an upside-down Europe with south at the top. Who could resist?[1]

The young man was Dallas Bache Pratt (1914–1994), who went on to take medical training, serve in World War II as a psychiatrist and continue in that profession for many years. He expressed his interest in animal welfare by founding an animal rights organisation, the Argus Archives, and writing two books on alternatives to pain in animal experiments. He received the prestigious Albert Schweitzer Award for this campaigning work in 1981. From an early age, Pratt's instincts as a collector gave rise to a gradual assembly of literary memorabilia, artworks, archival documents and maps. This culminated in his greatest achievement: the founding, together with his partner John Judkyn, of the American Museum in Britain on the outskirts of the Georgian city of Bath. That story is told elsewhere,[2] but it is interesting to trace the young Dallas's early enthusiasm for collecting in an anecdote he includes in his journals. It took place while he was staying at the New York apartment of his somewhat domineering maternal grandfather, William Evarts Benjamin:

> On a wall of the dressing-room was one of the original plaster casts taken from Benjamin Haydon's famous life mask of Keats – Grandpa B. had bought it from the estate sale of Robert Louis Stevenson. When I started my own Keats collection in the 1930s, grandfather kept saying that one day he would give me the mask. For several years he tantalised me with this remark, but the gift never materialised. Finally when I was telling him about a Keats manuscript I had recently acquired from A.S.W. Rosenbach – 31 lines from the first draft of 'I stood tip-toe upon a little hill' – he said, 'I really must give you that mask.' He went off on another tack but before he had finished the sentence I marched into the dressing room, lifted the mask from the wall, and with much feeling thanked him for the wonderful gift.

Always modest in demeanour, Dallas Pratt has been described as 'the archetypal quiet American',[3] but he did have the wherewithal necessary for the assembly of substantial collections. This came from

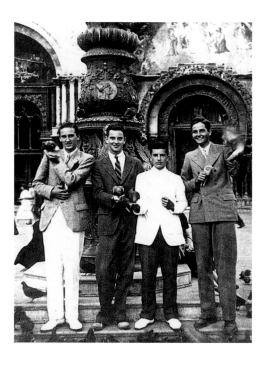

OPPOSITE: Detail from *Nova Francia* (see pp. 112–13). The tilted bar above the compass rose and to the left of the grotesque sea monster (with two blowholes) is the first attempt to depict magnetic north on a map.

LEFT: Dallas Pratt (far right) and friends in Venice in 1932 – the year he began collecting historical maps. With his companion John Judkyn, Pratt would later found the American Museum in Britain, housed in Claverton Manor on the outskirts of the Georgian city of Bath.

the wealth created by his maternal great-grandfather, Henry Huttlestone Rogers (1840–1909), who had founded Standard Oil with J.D. Rockefeller. Known on Wall Street by the sobriquet 'Hell Hound Rogers', he was one of the last of the so-called capitalist and industrialist 'Robber Barons' of what was to become known as the 'Gilded Age'. In his hometown of Fairhaven, Massachusetts, however, Rogers was known as a philanthropist, as was testified by his friend and neighbour, Mark Twain. Indeed, there was a family tradition of public benefaction. Alas, this seems not to have been the case with Dallas Pratt's mother, Beatrice Mai Benjamin (1889–1956), Rogers's eldest grandchild. Beatrice inherited a large slice of the family fortune, spending much of it on extravagant clothes, houses (in New York, Cap d'Antibes and London), parties and disastrous marriages. In his journals Dallas Pratt recalls some of the celebrities (Noël Coward), royals (the Windsors) and artists (Elsie de Wolfe) who were entertained or patronised by his often-absent mother. With this background, it would not have been surprising if Dallas Pratt had continued in the same vein, enjoying the life of a social dilettante, but there was another influence on his young life – that of his English governess, Maud Duke. 'Dear', as she was named by him and his sister Cynthia, had the main responsibility for his upbringing, instilling in him an almost puritanical sense of purpose and a desire to lead a socially useful life. In 1936, on receiving an offer from his Benjamin grandfather of a position in his Wall Street office, 'pouring over columns of figures and financial reports', Dallas Pratt analysed in his journal his feelings about the choice of his future career:

> *For the past year I have been living in a story-book atmosphere. The situation consists in the choosing of my career, the villain is Grandpa, the injured hero is myself. I am a bird in a gilded cage, bound with golden chains, surfeited with comfort, well nurtured and strongly protected, but denied the most excellent gift of freedom… You can see how easily I can dramatise my problem!*

At a time when the policies of President Franklin D. Roosevelt's 'New Deal' were causing the wealthy classes to feel threatened, Dallas Pratt pragmatically pointed out that it may well be a good idea to put himself in a position to earn a living, preferably in something like medicine:

> *I am conscious of the injustice of the system under which we live, and while I am weak enough to continue to enjoy without protest the fruits of the inequalities of that system, I cannot pretend that I could spend my life working to increase these inequalities… I think that I should divert as much as I conveniently can to useful channels, seeing that other members of my family seem determined to spend their share only for their own selfish comfort.*

Dallas Pratt's medical studies, professional duties and service in the Army Medical Corps during World War II meant that map collecting for him was sporadic and lacking focus. After his first purchases as a teenager, over the next two decades he bought highly decorative seventeenth-century maps from Dutch atlases. He had a rule never to pay more than $100 for a map. In spite of this he was able acquire good examples by John Speed (1552–1629), Willem Janszoon Blaeu (1571–1638) and other well-known cartographers. He put them in gilt frames with a black edging and, as he wrote, they 'looked nice on the wall'.[4]

Rediscovering America
It was not until 1958 that the idea came to Pratt of specialising in fifteenth- and sixteenth-century maps with a cut-off date of 1600. The notion had been sparked when, through the 'good offices'[5] of his old friend Alexander O. Vietor, curator of maps at Yale, he was able to obtain a 1508 world map by Johann Ruysch (*c.*1460–1533) – one of the earliest to show America, and possibly the first printed map by a cartographer who had travelled to the New World (see pp. 32–3). (The $100 rule had by then been forsaken, although Pratt still managed to acquire some fine items at prices that would make present-day collectors and institutions very envious!) His map collecting then went into high gear as he embarked on a quest to discover all the obtainable early maps of America and of the world that had been printed before 1600. Cartographically speaking, he wrote, he aimed to rediscover America.[6]

The great expeditions undertaken by Portuguese navigators in the fifteenth century initiated what is known in Europe as the Age of Discovery. These sea voyages began in 1418 under the direction of

BELOW: Detail of cannibals feasting and an oversized opossum from *Oceanus Occidentalis Terra Nova* (see p. 35). The inscription above the words *Terra Nova* reads: 'This land with the adjacent islands was discovered by Columbus of Genoa under the mandate of the monarchs of Castile.'

OPPOSITE: Detail of the title-page of an account by Bartolomé de las Casas outlining Spanish atrocities in the New World (see pp. 80–1). A native chief is seized by invading troops, while his followers, armed with spears, are defeated by European weaponry.

Prince Henry the Navigator, and at first edged fearfully along the African coast of the Atlantic – called by Arabs 'the Green Sea of Darkness' because of its perceived dangers – to explore and colonise islands such as the Azores, Madeira and part of the Canaries. Thereafter, Portuguese seafarers summoned enough courage to round Cape Bojador. Once circumnavigated, this now seemingly insignificant bulge on the African coast revealed neither boiling seas nor the monsters of myth. Hence the way was clear for further explorations south and east, which led to the rounding of the Cape of Good Hope by Bartolomeu Díaz in 1487 and Vasco da Gama's arrival in India in 1498. Bolder and bolder, the Portuguese reached the Spice Islands of the East Indies in 1512. Their success culminated in the triumphant return of Ferdinand Magellan's ship *Victoria* in 1522 after the first circumnavigation of the globe.

These and other European discoveries were speedily incorporated into world maps throughout the sixteenth century, but the 1492 arrival of Christopher Columbus (1451–1506) in what he believed to be Japan, or some islands in 'the Indian sea', gave scholars and map-makers pause for thought. On his return from these islands, Columbus sent ahead a letter to the Spanish monarchs, Ferdinand and Isabella, which was quickly translated into Latin with the title *De insulis nuper in Mari Indico repertis* (Concerning the Islands recently discovered in the Indian Sea) and published using the new medium of the printed page. Dallas Pratt purchased a copy of the letter (printed in 1494 by Johann Bergmann in Basel, Switzerland) and had a fine tale to tell about its acquisition. He was particularly keen to have this copy because it is from the first dated edition to contain a map – actually a pictorial chart – of the part of the New World first known to Europeans. He later reminisced about how this astonishing survival made its way to him in New York:

Amazed to find this item, rarest of the rare, in a catalogue, I quickly put through a phone call to England and was relieved to hear that it was still available. 'Please send it to me at once,' I said, in my excitement forgetting to ask when it was likely to arrive. I waited happily, but soon became anxious as days lengthened into weeks, and the precious parcel failed to appear. I phoned the dealer, who promised to 'look into the matter'. When he called back, I heard with dismay that a mistake had been made: the clerk who had mailed the Columbus Letter had thought it was a catalogue, and had sent it by surface mail tied with a string, but 'open at one end to save postage'! Since it was not registered or insured there was no way of tracing it.

I won't describe the fruitless search in the weeks which followed, or the visits to the post offices – except the last one, to the Grand Central Office. To an enquiry at the parcels room the answer was again negative. Then, at the far side of the room, I noticed an array of pigeonholes with Christmas mail piling up in them. Something drew my eye to a single slim packet in it. I pointed it out to the clerk. 'Check that one for me, please.' The clerk obliged, and read out… my name.

So, in a packet with stamps worth less than a dollar, tied with string but still open at one end, one of America's most historic documents, undamaged, was miraculously recovered. In 1972, its transatlantic journey had taken two and a half months. In 1492, Columbus did it in thirty-three days.[7]

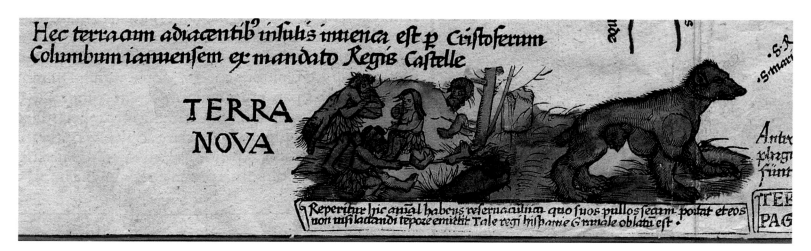

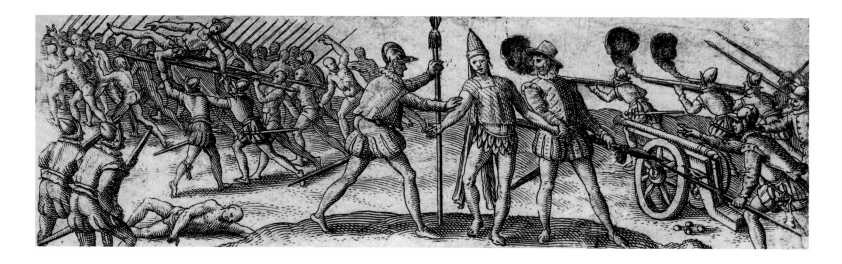

Columbus died still believing he had found a sea route to the Orient. His four voyages to the 'Indies' inspired a rush of westward explorations, firstly by other Spanish and Portuguese mariners, later by those on behalf of the English (John Cabot's voyage from Bristol in 1497) and French (under Jacques Cartier in 1535). The gradual realisation of the scale of Columbus's discovery is reflected in how the New World changed shape on European maps throughout the sixteenth century. These strange and unfamiliar regions were initially drawn as scattered islands, then as larger landmasses appearing as if through mist, to be subsequently ornamented on maps with natural features such as mountains and rivers. Both the eastern and western coasts of the Americas were almost completely charted by the end of the century.

Further Explorations to the New World

It was not long before more and more ships were making the Atlantic crossing, leading to excursions inland and, almost inevitably, the colonisation and exploitation of native peoples. Columbus had mentioned in his letter that the island he named Hispaniola was 'rich in various kinds of spice and in gold and in mines'. Rapacity was overlaid with a thin veneer of missionary zeal; Isabella, in particular, was keen to bring the Catholic faith to the 'heathen'.

Between 1499 and 1500 there were several important voyages: João Fernandes sailed north to discover Labrador for Portugal; Amerigo Vespucci wrote self-aggrandising accounts of explorations along the north coast of South America; parts of the Brazilian coastline were explored by Vicente Yañez Pinzón for Spain, and accidentally (for he was on his way to Africa and blown off course) by Pedro Alvarez Cabral for Portugal. Only a few years later in 1513, Vasco Núñez de Balboa led an expedition across the Isthmus of Panama to stand 'Silent, upon a peak in Darien' and became the first European to gaze upon the Pacific – not, as in Keats's poem, 'stout Cortes' with his 'eagle eyes'.[8]

To reflect such momentous events in the history of the colonisation of the New World by the Old World, Dallas Pratt added to his map collection various prints that had originally been made as book illustrations or separately published. One of these illustrated volumes was particularly significant, as Pratt later reflected:

An outstanding volume, by the missionary and historian Bartolomé de las Casas (1474–1566) is titled – translating from the Latin – 'A Very True Account of the Destruction of the Indies by the Spaniards'. This volume may be called the worst and best book of its time. Worst, because it contains seventeen engravings by the De Bry brothers, printmakers of Frankfort, illustrating in grisly detail the cruelties on Native Americans by the Spanish conquerors. Best, because de las Casas's book, written in 1542, influenced the Emperor Charles V to issue in that year a decree forbidding Indian enslavement. Although the law was largely ineffective, the many editions of the book, culminating in this one of 1598 with its shocking illustrations, spread the 'black legend' of Spanish cruelty and kept de las Casas's humanitarian appeal alive.[9]

First Contacts

Columbus takes a rosy view of his crew's encounters with the people he called 'Indians' in his aforementioned letter to the Spanish monarchs who financed his 1492 voyage. At first, Columbus says, the native inhabitants were fearful, but responded to a gentle approach from the Europeans:

[N]one of them denies to the asker anything that he possesses; on the contrary they themselves invite us to ask for it. They exhibit great affection to all and always give much for little or nothing in return. However I forbade such insignificant and valueless things to be given to them, as pieces of platters, dishes, and glass, or again nails and lace points; though if they could acquire such it seemed to them that they possessed the most beautiful trinkets in the world.

Columbus also mentions that the islanders 'always go as naked as when they were born' – a fact that gave an illicit thrill to European readers – and that 'the women seem to do more work than the men'. The women were also objects of interest to the Florentine yarn-spinner Amerigo Vespucci (1454–1512), who, like Columbus, was an Italian in the service of foreign powers. According to a letter appended to Martin Waldseemüller's *Cosmographiae Introductio*, Vespucci's four voyages between 1497 and 1503 were made on behalf of the monarchs of Spain and Portugal, in order to establish the lands apportioned

to them under the Treaty of Tordesillas. Some scholars believe that only two of the four voyages were genuine, the others having been composed in Florence by those wishing to outshine the achievements of Columbus, a native of Genoa. Whether he was completely truthful cannot now be determined; however, Vespucci did have a gift for story-telling, and his graphic accounts of adventures in the 'new lands and islands' were widely and voraciously read throughout Europe.

Vividly, sometimes even salaciously, Vespucci describes the natives of the north coast of South America. He admires the long black hair of the women and the absence of body hair, 'because they deem it coarse and animal-like'; they are remarkable swimmers, he observes, the women more so than the men – 'a statement I can make with authority, for we frequently saw them swim in the sea for two leagues'; and 'in person they are very neat and clean, for the reason that they bathe very frequently'. He mentions that the men are not jealous, but are, however, 'very sensual'; and as for the women, he thinks it best '(in the name of decency) to pass over in silence their many arts to gratify their insatiable lust'. The fastidious Florentine also considers them lacking in table manners 'as they recline on the ground, and do not use either tablecloths or napkins'. Vespucci also comments that the villages of Paria, where inhabitants dwelt on islands in the low waters of the gulf, reminded him of Venice. From this observation came the name 'Venezuela'.

The apparently joyful fraternisation continued. In 1535 an exploration under Jacques Cartier, on behalf of the French king, François I, arrived at a settlement on the St Lawrence River. The plan of the 'town' (the first to be made of one in North America) was acquired by Dallas Pratt for his collection. It depicts a merry scene, with Frenchmen first greeting local chiefs before the gates of the settlement's stockade, then indulging in some cheerful, friendly fun, if one can judge from the two pairs of piggy-back riders (with the French on the backs of the first Canadians, naturally). In his account

of the voyage, Cartier mentions that they were received hospitably, although they had to decline eating the food offered as it was not properly salted.

Explorers were not always made so welcome. In his widely published letter to King Ferdinand and Queen Isabella of Spain, Columbus noted that the island of Charis was inhabited by a tribe 'that is held by its neighbours to be extremely savage. These feed on human flesh.' The natives of Charis were, in fact, the Caribs, whose fearsome reputation was further enhanced by their killing and devouring of Giovanni da Verrazzano (1485–1528). This Florentine adventurer was slaughtered in full sight of his horrified crew, who were anchored out of gunshot range and thus unable to prevent the atrocity. Europeans were both frightened and fascinated by such outlandish accounts. Small wonder, then, that vignettes of 'cannibal lunches' and naked natives abounded on the edges and corners of maps, along with cornucopias of exotic fruits, spices, plants and animals.

The avid readers of such written accounts of newly discovered lands, with their accompanying maps and illustrations, were the scholars, princes, prelates and merchants of the Renaissance. Monarchs of the Age of Discovery were akin to Marlowe's hero Tamburlaine, who uttered on his deathbed:

Give me a map, so I can see what lands
Are left to conquer.[10]

In spite of Queen Isabella's yearning to bring heathen souls to Christ, the principal driving force that impelled Spanish explorations to the New World was greed. Though vast wealth accrued to Spain (and other nations) in the sixteenth century, thanks to treasures brought back from the Indies, much of this colossal fortune was ironically frittered away on waging wars in Europe. These military campaigns included those of the Emperor Charles V against the Dutch and his son Philip II's attempted invasion of England.

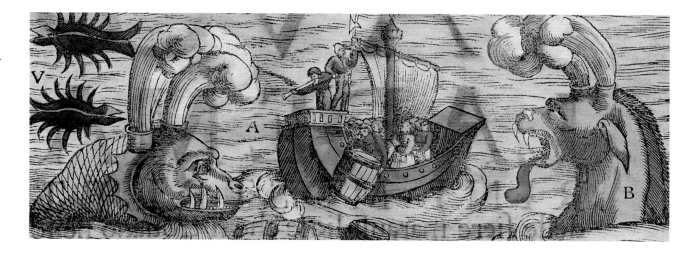

RIGHT: Detail of double-spouted sea monsters terrorising seafarers from *Mostri marini & terrestri…* (see pp. 42–3).

Secret Maps

Along with written accounts, sea charts greatly facilitated exploration of the New World. At first sea charts were regarded as secret documents, copied by hand, the unauthorised dissemination of which carried the death penalty. In 1511 the first Spanish printed version of a map of the Indies appeared. It was composed by Peter Martyr d'Anghiera (1457–1526), tutor at the Spanish Court and later chronicler of the Council of the Indies, which gave him direct contact with Christopher Columbus and his son Diego. A rare copy was acquired by Dallas Pratt; there are few copies in existence because most were suppressed by King Ferdinand on account of their accuracy and depiction of landfalls not previously made known to the public.

A later 'secret' map, created in 1559 or 1560 and later acquired by Dallas Pratt, has become popularly known as the Hajji Ahmed World Map, though authorship of the heart-shaped map itself is by no means certain (see pp. 68–70). In the Turkish text, Hajji Ahmed describes himself as a Muslim from Tunis, who had been captured and brought to Venice as a slave. Dallas Pratt noted:

> *Probably for this reason the woodblocks were confiscated by the government of Venice before anything was printed, since the maps might well have been of value to the Turks, with whom the Venetians were intermittently at war. The blocks were found 235 years later in the Secret Archives of the Council of Ten [from 1310 to 1797, one of the major governing bodies of the Venetian republic]. Only then, in 1795, was the map printed in twenty-four copies, of which about eight survive.*[11]

Another secret source of knowledge, which existed parallel to published maps, were portolans, or mariners' charts. These manuscript maps were drawn on a prepared animal skin, often retaining the shape and size of the slaughtered beast. At first limited to the Mediterranean and Black Sea, portolans are surprisingly accurate and display the names of ports and other landmarks set end-on to the coastal outlines. They were generally closely guarded for they represented seafarers' trade secrets, not unlike the 'mysteries' of medieval guilds. These maps, along with the pilots' rutters (logbooks containing details of tides, shoals, rocks and such like), were an indispensable practical aid to the seafarer plying the shores of the Inland Sea. They continued in use from after 1300 until the beginning of the seventeenth century. Few of these treasures exist today, due to mishaps at sea or general wear and tear. Being of great value to an enemy, some were undoubtedly lost when thrown overboard during an enemy attack, or hidden in some secret spot. Those that have survived were obviously valued by their owners, for aesthetic as well as for practical reasons: they are finely drawn; features and names are brightly coloured according to a set of conventions; and they are decorated with wind roses and other embellishments. The portolan acquired by Dallas Pratt is such an example (see pp. 26–7). It is on vellum and details the coastal towns and hazards of the Mediterranean; it also encompasses the Black Sea, the legendary 'Isle of Brazil' in the west and the Red Sea (typically, depicted in red). Produced by Baldasaro da Maiolo of Genoa in 1591, its good condition and fine decoration suggests that it may have been a presentation copy that never went to sea.

Medieval Maps printed in the Age of Discovery

In part contemporary with these practical seafarers' charts were two kinds of maps that would have been of very little use to a navigator: the medieval *mappae mundi* (world maps) and the curious diagrams known as 'T-O' maps. Whereas the *mappae mundi* retained vestiges of the geographical knowledge attained in classical times, the T-O maps were based entirely on information taken from the Bible, as befitted an audience that, for the most part, rejected science in favour of spiritual progress through a literal interpretation of the word of God. To church fathers such as Isidore of Seville who wrote his *Etymologiae* between 622 and 633 CE, the 'O' of the diagram represents the 'Ocean Stream' that surrounds the earth, the horizontal bar of the 'T' is the meridian along the rivers Don and Nile, and the vertical of the 'T' is the Mediterranean Sea. Medieval maps appear skewed sideways to a modern viewer used to orientation to the north; these maps have east at the top, towards Paradise, with Jerusalem usually at the centre. Such orientation is in accordance with Ezekiel V.5: 'This is Jerusalem: I have set it in the midst of the nations and the countries that are round about her.' There are only three continents: those apportioned to the sons of Noah (Shem, Ham and Japheth). Isidore's book was published

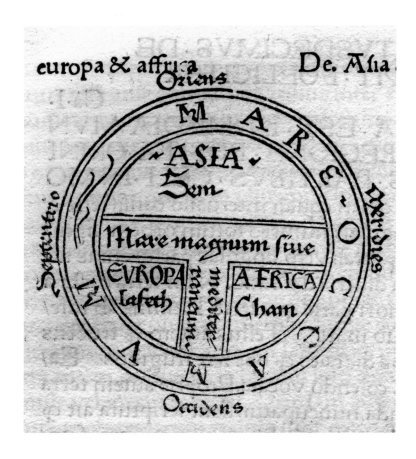

in 1472, and so its T-O diagrams can be said to be the first maps to appear in print . Since Dallas Pratt concentrated on printed maps, his collection contains several examples of these curiosities.

During the Middle Ages when much scientific knowledge was lost to the West, leaving the work of classical scholars to be conserved and studied by Islamic geographers, the world was described to the European faithful by means of the *mappa mundi*. A rare printed copy of a *mappa mundi* in the Dallas Pratt collection is the so-called 'Borgia Map' (see pp. 22–3). While holding to the three-continent, east-oriented principles of the T-O maps, these world maps contained information deemed useful for – or of interest to – the medieval worshiper or scholar. A *mappa mundi*, then, was a kind of graphic encyclopaedia of established beliefs about the world, a ragbag of Biblical history and superstitious beliefs based on travellers' tales from what survived from respected classical authors such as Herodotus (5th century BCE) or, notoriously, from one of the Latin world's great teller of tall tales, Gaius Julius Solinus (fl. 250 CE). The latter's own fabrications, coupled with his exaggerations of material from Pliny, ensured his popularity for over a thousand years. It is Solinus, for instance, who is mostly responsible for the obscure legends and monstrous images that appear on these early attempts in cartography.

One important link with the pagan world of classical times was provided by a widely read work written by the Late Latin encyclopaedist Macrobius Ambrosius Theodosius some time before 410 CE. His *De Somnio Scipionis* (Commentary on 'The Dream of Scipio') became one of the basic source books for the scholastic movement and for what counted as science in the Middle Ages.

Incorporated into the final section of Marcus Tullius Cicero's six volume *De re publicae* (On the Republic), written between 54 and 51 BCE, the 'Dream of Scipio' describes how Scipio, a young Roman, dreams that his late grandfather (Scipio Africanus, the victor over Hannibal in 202 BCE) appears to him and exhorts him to lead a life of virtue. In order to administer to his grandson a sense of his own relative insignificance, Scipio Africanus takes him to 'a lofty perch, among the radiant stars', some of which 'we have never seen from this region and all were of a magnitude far greater than we had imagined'. When they gaze at the earth, the grandfather remarks:

> *You see, Scipio, that the inhabited portions on the earth are widely separated and narrow, and that vast wastes lie between these inhabited spots…; the earth's inhabitants are so cut off that there can be no communication among different groups. You can also discern certain belts that appear to encircle the earth; you observe that the two which are farthest apart and lie under the poles of the heavens are stiff with cold, whereas the belt in the middle, the greatest one, is scorched with the heat of the sun. The two remaining belts are habitable; one, the southern, is inhabited by men who plant their feet in the opposite direction to yours and have nothing to do with your people; the other, the northern, is inhabited by the Romans. But, look closely, see how small is the portion allotted to you!*[12]

This medieval bestseller continued to be influential for centuries, discouraging southward exploration until the commencement of the Portuguese ventures around Africa. Hundreds of copies circulated in manuscript form, although relatively few exist today. No less than thirty-eight editions were printed by 1893. A beautifully illustrated twelfth-century French manuscript copy was bought by Dallas Pratt in 1971 at a Sotheby's sale (see pp. 20–1). Three printed copies were also added to his collection, which all contain 'zonal' maps that portray the earth as a flattened sphere with frigid, temperate and torrid zones. The southern temperate zone is labelled the 'antipodes, unknown to us'.

Ptolemy Rediscovered

Any faint echoes of scientific knowledge of the world that existed in medieval maps can be traced to the work of the most important geographer of classical times: Claudius Ptolemy (*c*.90–*c*.168 CE), a Greek-speaking Roman citizen of Alexandria in Egypt. From this city, conveniently placed at a crossroads of civilisations, he collected and

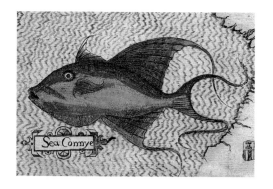

LEFT: 'Sea Connye', or trigger fish, from *The Famouse West Indian voyadge made by the Englishe fleet* (see pp. 92–3).

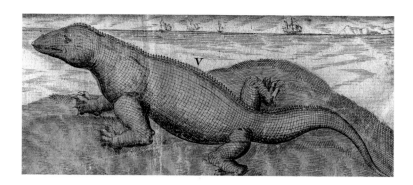

RIGHT: Iguana vignette from Plan of Cartagena (Colombia) (see pp. 96–7): 'caught by… the Indian people who sell them to the Spaniards… for a very delicate meat'.

compiled all the available knowledge of the known world. Ptolemy's two great works of theoretical knowledge are the *Geographia* and *Almagest*. His findings grew out of the teachings of earlier scholars, such as Eratosthenes, Hipparchus and Marinus of Tyre, who stated that the earth was a sphere, calculated the position of the equator and the tropics, and estimated with some accuracy the earth's circumference. These earlier scholars also used latitude and longitude (although separately) and trigonometry to calculate distances.

The Roman world in which Ptolemy lived was a busy one, with traders and legionaries constantly on the move. It also benefited from the rich heritage and knowledge of Greek culture, including history and geography from the journeys of conquest of Alexander the Great, plus mathematics and astronomy. It was these two last arts that, Ptolemy insisted in his *Geographia*, should be the foundation for 'a representation in pictures of the whole known world together with the phenomena which are contained therein'.[13] When he could not obtain data from celestial observation, Ptolemy had to be content with vague estimates of distances measured in so many days' travel 'towards the summer sunrise', for instance, or 'towards Africa'. Any errors that occurred in his writings were due to lack of correct information rather than the scientific methods he employed. He was aware from Marinus, for instance, that merchants 'through their love of boasting' tended to exaggerate distances travelled and so was inclined to underestimate them. Ptolemy's biggest mistake – the acceptance of Posedonius's smaller estimate of the earth's size, rather than the almost correct one of Eratosthenes – encouraged Columbus, relying on Ptolemaic maps printed centuries later, to set forth across the Atlantic in 1492, in the belief that it was not such an impossibly long voyage to the Orient.

The principal object of the *Geographia* was to instruct the reader in map-making. No map created by Ptolemy has survived – he may not even have ever drawn one – but he left tables of co-ordinates of latitude and longitude from which a reader could depict the shape of the *oekumene,* the known world, with its geographical features and principal cities. The area described by him extended 180° from the Fortunate Islands (probably the Canaries) at 0° longitude in the west to somewhere vaguely positioned in the middle of China, and 80° from Thule (Shetland?) in the north to beyond the Horn of Africa in the south. Some of Ptolemy's map-making principles are still in use today: maps should be oriented towards the north; the gazetteer of place names should be in geographical or alphabetical order with co-ordinates of both latitude and longitude; established symbols

for seas, rivers and mountains should be used; and 'terra incognita' (unknown land) should be treated as such and left blank, not filled with imaginary lands and creatures.

A globe, Ptolemy proposed, would give the best representation of the earth, but none could be made large enough to include details. To solve the essential problem of cartography – that of depicting a sphere on a flat surface without sacrificing too much in the way of shape, direction and distance – Ptolemy proposed a compromise: that meridians of longitude, equidistant at the equator, should be depicted as straight lines converging at the North Pole in a kind of flat cone but that this cone should be cut off at the parallel of Thule (a now unknown island in the far north). Other parallels where the imaginary cone touched land passed through Rhodes, Meroê (in Ethiopia) and Syenê (Aswan) on the summer tropic. Having explained his conical projection, Ptolemy expressed dissatisfaction with it. He commented that he had a better suggestion but had included the earlier version for 'the sake of those, who, through laziness, are drawn to that certain earlier method'. On this second modified spherical projection the meridians curve towards Thule and give a superior likeness of the earth. Ptolemy admitted, however, that it was far more difficult to compose. As for smaller areas, such as single countries, an easier cylindrical projection could be used.

During the Middle Ages, while the works of Ptolemy and other classical authors were taken up by scholars of the Islamic world, in western Europe they went underground. Secreted in various libraries and monasteries as unconducive to the salvation of one's soul, they were available to be read only by those who could resist such pagan influences. When a copy of *Geographia* was found in Mount Athos, Greece, and translated into Latin in 1406, it became one of the most valued items of the 'new learning' of the Renaissance. Printed versions appeared from 1477 onwards, first in Bologna with copperplate maps, then in a 1478 Rome version with superior printing. The Dallas Pratt collection contains a 1490 copy of the Rome Ptolemy, printed from the same plates as that of the 1478 edition, as well as a 1482 version in Italian verse by Berlinghieri, printed in Florence. Scholars and publishers seemed to delight in producing maps based on Ptolemy's instructions, even after it appeared that the earth was larger than he surmised and that the Indian Sea was not landlocked, as he had supposed.

Following on from Ptolemy's simple forms, cartographers became more and more inventive in their use of projections throughout the

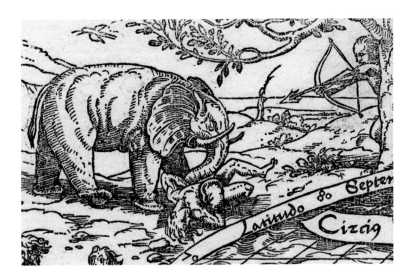

sixteenth century. Maps emerged based on stereographic, cordiform (heart-shaped), double cordiform, gore-shaped, planispheric and other projections. Each type attempted to provide a representation of the earth that was both accurate and pleasing to the eye. This interest in appealing to a wide and varied readership of scholars, seafarers and patriotic merchants wishing to beautify the walls of their homes and offices resulted in the 1569 world map of Gerard Kremer (1512–1594), also known as Mercator (the Latinised form of his surname). It was constructed according to the projection that bears his name. Mercator's huge map – made up of twenty-one separate sheets – survives in only three copies. A century passed before the projection gained general acceptance among mariners. A much smaller, oval version was constructed in 1570 by Mercator's friend and fellow cartographer Abraham Ortels (1527–1598), more commonly known as Ortelius, to be incorporated into various maps over the next forty years. The Dallas Pratt collection contains maps based on this reduced version, together with fine examples of other more visually spectacular projections.

Printing and the Map Trade

One of the pictorial engravings collected by Dallas Pratt is the title-page to *Nova Reperta* (New Inventions) by Jan van der Straet, known as Stradanus (1523–1605). It illustrates the new inventions and discoveries of the Renaissance, such as America, gunpowder and the magnetic compass. In pride of place at the centre of the composition is the printing press, flanked with drying lines draped with sheets of printed paper (see pp. 124–5). From its first appearance in the mid fifteenth century, Johannes Gutenberg's printing press with its movable type was certainly one of the prime movers in the dissemination of the new knowledge of the Renaissance. By 1480 there were 111 towns in Europe with printing presses.[14] The first printed map – a simple woodcut T-O map – appeared in 1472. Less expensive than manuscript documents and without copying errors, printed maps were available to an increasingly wide reading public by the end of the century and were also accessible to the greater audience of non-readers.

Made from pulped rags and extremely durable, paper was manufactured in folio sheets measuring about 710 mm by 610 mm –

the average size of a frame loaded with wet pulp that a papermaker could handle. The available technology thus limited the size of printed maps; huge maps such as those by Martin Waldseemüller (c.1470–1520) and Mercator were printed in segments, some of which were liable to be separated and lost. The awkwardness of handling printed maps – storing, unrolling, keeping components together – prompted clients of the Antwerp map-publisher Ortelius (1527–1598) to ask if it were possible to bind maps together in one volume. After ten years of collecting, licensing, editing, engraving and printing the maps, Ortelius produced *Theatrum Orbis Terrarum* (Theatre of the World) in the 1570s (see pp. 78–9, 82–3). This landmark publication was the first modern atlas. It was a co-operative venture, with Ortelius inviting comment and criticism from his correspondents beforehand. He also consulted his friend, the revered Mercator, on the problems of reducing large-scale maps to fit the pages of the atlas.

The favourable reception of the *Theatrum* resulted in other map-makers and publishers trying their hand. Eight years later, another citizen of Antwerp, Gerard de Jode (1509–1591), produced his two-volume atlas *Speculum Orbis Terrarum* (Mirror of the World). Mercator was the first to use the word 'Atlas' for a collection of maps, but, after many years of collating and editing, died before the first volume of his proposed three-part work appeared in 1594. Although adding to the general geographic knowledge of the time, these atlases were expensive and inconveniently large, often ending up as ornate additions to bookshelves. The wider publication of pocket-sized atlases from this time onwards was therefore greatly welcomed by a buying public, eager to learn.

Although at first somewhat crude and angular, woodcut maps developed a degree of refinement and sophistication in the hands of skilled craftsmen. Cut 'on the plank' from various woods – apple, cherry, beech or box among others – a woodcut map could be inserted alongside text and printed in the same impression. Since it is a relief method, carving the lettering for map labels proved difficult. Map-makers eventually had recourse to making slots in the wood for metal type to be inserted or to casting thin stereotypes to be glued into place for whole words.[15] With frequent use the lettering might shift vertically or even fall out, to be replaced, on rare occasions, upside down – the evidence of which on printed maps has delighted many a map collector! Some woodcut maps have a stark appearance because shading was difficult to accomplish. In the hands of a master such as Albrecht Dürer (1471–1528), however, the difficult process of cross-

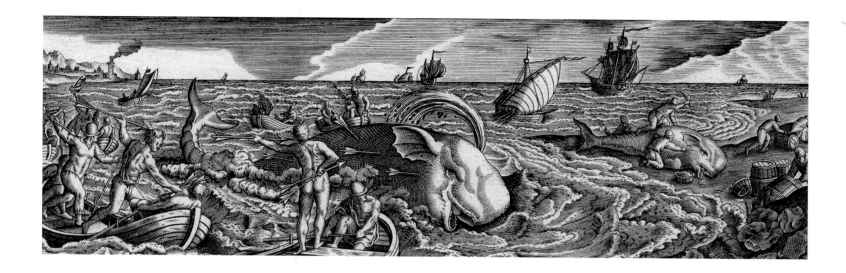

hatching to create tonality was used to great effect. The previously mentioned 'secret' Hajji Ahmed map was described by Dallas Pratt as 'no doubt the most spectacular piece in [the] collection, a world map, four feet square... a woodcut of incredible complexity'.[16] Another woodcut map that Dallas Pratt was pleased to acquire came from the London dealer R.V. Tooley's 'chaotic third-floor office crammed with maps'. Pratt related:

On one occasion he said he had the famous 1532 Münster map with decorations attributed to Holbein [the Younger]. 'Oh I want that,' I said, but when he looked for it he couldn't put his hand on it. On subsequent visits I asked for it but he could never find it. Finally after three years it turned up and now one can see it in the collection. It represents the world being cranked round by two angels, probably the first illustration in print, albeit symbolical, of Copernicus's postulate of the revolving earth. In addition to the 'angel motors', Holbein's images mix legend and science, with mermaids, dragons... an elephant hunt, spice plants of the East and a cannibal feast.[17]

In spite of these masterpieces of the woodcut medium, most maps were being printed from copperplate engravings by about 1550. Although the metal plates themselves were expensive and the engraving was labour intensive, the rise of public interest in the new geographical discoveries reproduced on attractively printed maps made the trade a profitable one for publishers. With the intaglio method of printing, the design was engraved on a prepared plate, which was heated so that ink could flow more easily into the grooves. The plate was then wiped clean of excess ink before the design was squeezed out onto dampened paper by means of a roller press. The printed sheet was then hung up to dry, with weights attached to prevent shrinkage. Although laborious, printing from copperplate had several advantages: with the flexibility offered by the burin and other engraving tools, fine detail and flowing designs were executed; depending on the size of the plate, larger maps could be printed. (Woodcut blocks were usually small because they were limited by the size of the cut that could be taken from the tree. Large woodcut wall maps were thus made up of several blocks.) When printing from copperplate, moreover, errors could be corrected

by means of the burnishing tool or hammering from the back to remove the offending item; and cursive lettering replaced the angular print of woodcuts.

With the development of the engravers' skill, virtuoso additions were made: curling strap-work imitating leather surrounded the text of cartouches; brilliantly executed pictures appeared in vignettes; and flamboyant heraldic devices were popular. In defiance of Ptolemy, the passion for filling empty spaces on maps – with ships, various forms of marine life and the occasional sea nymph or god – developed unabated. The custom of filling empty corners with explorers, islands and exotic scenes was enthusiastically pursued. Useful features – such as measurement scales with dividers – were finely depicted, while, as a further aid to navigation, rhumb lines radiating out from compass roses criss-crossed the open seas. These gave rise to Maria's remark in Shakespeare's *Twelfth Night* that Malvolio 'does smile his face into more lines than is in the new map with the augmentation of the Indies'. By carefully passing woodcuts twice through the press, it had been possible to print in two colours – black with the addition of red or blue – but this was more difficult with the intaglio method. To make the maps even more attractive and to define geographical features, map colourists instead employed many of the methods and pigments of manuscript illuminators. These materials ranged from eggs, gum Arabic, lampblack, minerals such as lapis lazuli and malachite, the cochineal beetle, plants, poisons (arsenic trisulphide gave a very nice yellow) and, for that special lustre, precious metals such as gold and silver.

As copperplate engraving became the preferred medium, the focus for the map publishing trade shifted from places such as Basel, Strasburg and Nuremberg to what was then the Spanish Netherlands, which had the best line-engravers in the world.[18] The two great cartographers and map-publishers of the time, Ortelius in Antwerp and Mercator in Louvain, carried on their business despite a background of religious strife and revolt against Spanish rule. In fact, Mercator was imprisoned as a Protestant heretic in 1544, later moving to Duisburg and thereafter steering clear of political and religious issues. He secured royal patronage by presenting the Emperor

Charles V with terrestrial and celestial globes and was awarded with the title *Imperatus Domesticus* (Member of the Imperial Household). Ortelius also received a title – Geographer to his Majesty Philip II of Spain – but only after his friend Montanus had declared him free of Protestantism. Whereas Mercator had brought rigour to cartography, making laborious scientific surveys, drawing maps exactly to scale and engraving them himself, Ortelius, the younger man, came to the map trade without the benefit of an academic background, but rather as a beautifier of maps. Having to support his family after his father's death, he had his sisters mount printed maps on linen for him to illuminate and then sell at fairs in Frankfurt and other cities. Ortelius went on to collect for decoration the best available maps from around Europe and was thus in an ideal position to collect, resize and bind together a series of maps in one volume, which eventually became his *Theatrum* – the first atlas.

The 'Map Bug' leads to a Map Museum

Dallas Pratt first caught the 'map bug' (as he referred to it) from the quirky characteristics of the maps he saw as a young man in Paris. There are examples in the maps Pratt collected that are distinctly eccentric, such as Hans Bunting's woodcut of Asia in the form of Pegasus (see pp. 88–9). These are quite plainly *jeux d'ésprit*, but other maps, even some by the most reputable cartographers, show flights of the imagination or wishful thinking. In some respects we can think of early cartography as the science fiction of its day: in maps by Hartmann Schedel (1440–1514) and Sebastian Münster (1488–1552), for example, undiscovered lands are peopled with monsters, centaurs, monocoli, hirsute women and anthropophagi (see pp. 30–1). The monsters were relegated to the extreme edge of the known world, such as the Arctic, as more of the seaways were explored. The Atlantic was scattered with floating islands, such as Hy-Brasil and Antilia, both of which gradually moved westward until finding a resting-place for their names in South America and the Caribbean. Another name in search of a territory was the huge southern land (*Terra Australis*) that appears on most world maps in the belief that a landmass in the south of the globe was needed to balance the northern continents.

Another misconception was popularised by Ortelius and Mercator, who each depicted South America with a bulge towards the southwest. Later maps quietly corrected this malformation. Moreover, the original perception of America as an inconvenient obstacle that stood in the way of a westward passage to the Orient is evident in the appearance on maps of a wide, easily navigable, ice-free sea route over the north of America. This hypothetical route was the much-sought Northwest Passage that seized the imagination of many otherwise sound cartographers. Another cartographical 'howler' was created by the aforementioned Giovanni da Verrazzano when sent by the French king, François I, in 1524 to seek a passage to China. Verrazzano was sailing along what are now known as the Outer Banks when he looked across 'an isthmus a mile in width' beyond which he saw 'el mare orientale' [the Pacific Ocean]. Unseen from a sailing ship, the coast of North Carolina lay across twenty to thirty miles of water, but his gross error (the so-called 'Sea of Verrazzano') appeared on subsequent maps for years to come. Finally in this list of misconceptions, it was many years before cartographers decided that California was not an island – another instance of what attracted Dallas Pratt's interest in early printed maps of America.

Many of these printed map treasures are shown crammed together on the walls of Pratt's New York bedroom in a 1968 portrait by world-renowned textile virtuoso Kaffe Fassett, then a little-known artist (see above).[19] The celebrated historian and collector of maps Rodney Shirley met Dallas Pratt soon afterwards, while researching his book *The Mapping of the World*. Shirley recollected his astonishment on being given access to what was, in his opinion, one of the finest private holdings of pre-1600 printed world maps:

RIGHT: Dallas Pratt at the ceremony marking the twenty-fifth anniversary of the American Museum in Britain in 1986, at which the foundation stone for the museum's new Exhibition Gallery and Map Room was laid by HRH The Prince of Wales (seated left).

[H]e showed me some of the maps in his [New York] house. I was astounded to see so many rarities including the huge… cordiform Turkish world map by [Hajji] Ahmed set into the under-canopy of an even larger four-poster bed![20]

Pratt became increasingly concerned about the eventual fate of his maps – the most personal of all the collections he had acquired independently or on behalf of the American Museum in Britain. Towards the end of his life, he announced his solution and bestowed his last and greatest gift on the museum he had co-founded many decades earlier:

The quest on which I had set out thirty years ago – to discover all the obtainable fifteenth- and sixteenth-century maps of America and of the world – has yielded one of the most complete collections in existence of what are essentially the first printed maps.

When I felt that it was time to introduce these cartographic messages from the past to a wider public, I was reluctant to entrust them to a library, the traditional repository of historical maps. Once there, I feared they would become a rarely seen study collection, buried in library stacks. Instead, to create a map museum may be novel and almost unheard of, but that is what I had in mind when, finally, I donated the maps to the American Museum in Britain, to have a permanent home in its New Gallery where a Map Room has been prepared for them.[21]

The foundation stone for the Exhibition Gallery of the American Museum in Britain was laid in July 1986 by HRH The Prince of Wales, and the building itself completed in October 1988. Since then various popular map exhibitions have been on view, including 'The Wild Surmise: Explorers after Columbus' (1993–4), 'Strangers in the Land: First Encounters' (2002–3) and 'Terror and Treasure' (2010). Dallas Pratt expressed the hope that visitors to these exhibitions would have 'as much pleasure as [he] did during the three decades [he] pursued, captured, studied and came to love the eloquent records of the discovery of the New World and of the unknown lands which lay beyond'. As the poet Robert Herrick (1591–1674) assured all of us armchair travellers in possession of a map:

> *…thou at home without tyde or gale,*
> *Canst in thy Map securely saile:*
> *Seeing those painted Countries; and so guesse*
> *By those fine Shades, their substances:*
> *And from thy Compasse taking small advice,*
> *Buy'st travel at the lowest price.[22]*

NOTES

1. Dallas Pratt, 'New World, Old Maps: The Adventures of a Collector', *America in Britain*, 27/1 (1989), 17.

2. Dick Chapman, *Dallas Pratt, A Patchwork Biography* (Cambridge: Mark Argent, 2004). See also the introductory essay in Laura Beresford and Katherine Hebert, *Classic Quilts from the American Museum in Britain* (London: Scala Publishers, 2009).

3. Obituary, compiled from those by James Ayres, Dick Chapman and John Huitson.

4. Pratt, 'New World, Old Maps', 17.

5. Dallas Pratt, 'Discovery of a World: Early Maps showing America,' *Antiques*, 96/6 (December 1969) 901.

6. Pratt, 'New World, Old Maps,' 18.

7. In fact the voyage took thirty-six days. Columbus sailed from the Canaries on 6 September 1492 and sighted land on 12 October.

8. Dallas Pratt combined his love of Keats with that of maps by referring to another line in the poem 'On First Looking

into Chapman's Homer' (1817) in the title of his 1993 map exhibition 'The Wild Surmise – Explorers after Columbus', mounted the year before his death.

9. Pratt, 'New World, Old Maps', 21.

10. Christopher Marlowe, *Tamburlaine the Great*, Part II, V.iii.123–5 (London: Everyman Paperbacks, 1999, page 142).

11. Pratt, 'New World, Old Maps', 19.

12. William Harris Stahl, tr., *Macrobius: Commentary on the Dream of Scipio* (New York and London: Columbia University Press, 1952), 74.

13. Quoted in John Noble Wilford, *The Mapmakers: The Story of the Great Pioneers in Cartography from Antiquity to the Space Age* (New York: Vintage Books, 1982), 30.

14. Lloyd A. Brown, *The Story of Maps* (New York: Dover Publications, Inc., 1979), 151.

15. Arthur H. Robinson, 'Map-making and Map-printing', in David Woodward, ed., *Five Centuries of Map Printing*

(Chicago and London: The University of Chicago Press, 1975), 7.

16. Pratt, 'New World, Old Maps', 19.

17. Pratt, 'New World, Old Maps', 18.

18. Brown, *The Story of Maps*, 158.

19. When he relocated to Britain from the United States in the early 1960s, Kaffe Fassett stayed in Bath. The artist has a long association with the American Museum and continues to be inspired by its diverse collections.

20. Rodney W. Shirley, 'The Dallas Pratt Collection at the American Museum, Bath,' *The Map Collector*, 59 (Summer 1992), 2.

21. Pratt, 'New World, Old Maps', 22.

22. Robert Herrick, 'A Country Life; To His Brother, M. Tho. Herrick' (*Hesperides*) quoted in Charles Bricker and R.V. Tooley, *Landmarks of Mapmaking* (Amsterdam and Brussels: Elsevier, 1968), 4.

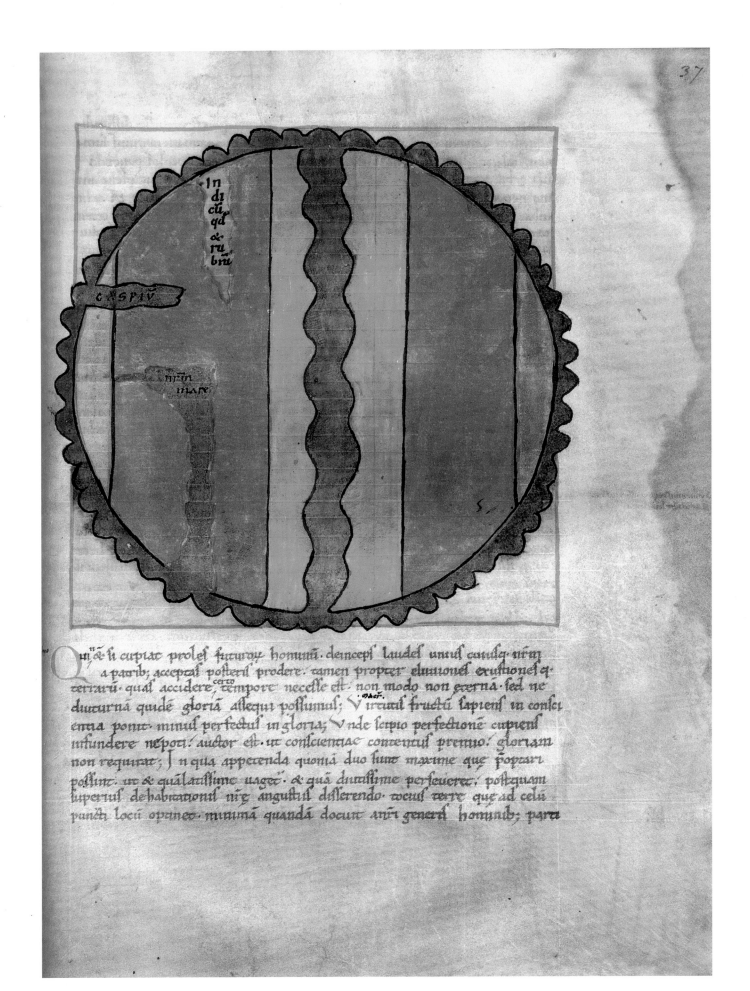

Qu; & si cupiat proles futuroƺ hominū. deinceps laudes unius cuiusdƺ nr̄ƺ
a patrib; acceptas posteris prodere. tamen propter eluuiones exustiones q;
terraƺ. quas accidere certo tempore necesse est. non modo non eterna. sed ne
diuturna quidē gloriā assequi possumus; Virtutis fructū sapiens in consci
entia ponit. minus perfectus in gloria; Unde scipio perfectionē cupiens
infundere nepoti. auctor est. ut conscientiae contentus premio. gloriam
non requirat; In qua appetenda quoniā duo sunt maxime que poptari
possunt. ut & quālatissime uaget. & quā diutissime perseueret. postquam
superius de habitationis nr̄e angustiis disserendo. totius terre que ad celū
puncti locū optineo. minimā quandā docuit anī generi hominib; parti

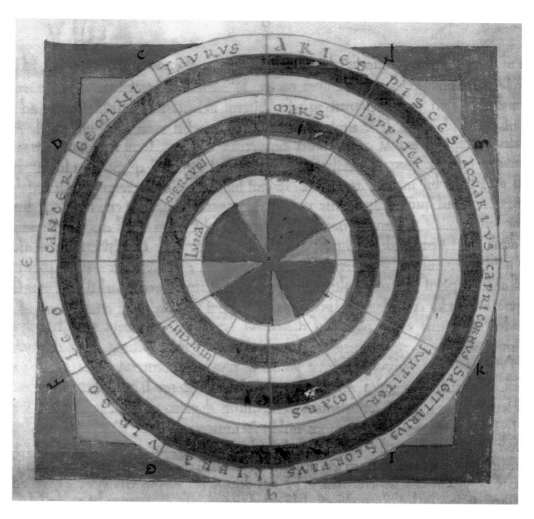

ABOVE: Female figure representing the 'World Soul'.

RIGHT: Concentric circles illustrate the orbits of the moon, Mercury, Venus, Mars and Jupiter. Zodiacal signs are inscribed around the outer rim.

De Somnio Scipionis (Commentary on 'The Dream of Scipio')

Macrobius Ambrosius (fl. early 5th century CE), author; unknown cartographer
Early 12th century
Hand-coloured manuscript on vellum
Page 285 × 215 mm
AMIB 1988.69

The world map pictured opposite is one of several maps and diagrams included in the American Museum's twelfth-century copy of Macrobius's popular book, first written early in the 5th century CE. It is a commentary on the final part of Cicero's *Republic*, namely 'The Dream of Scipio', which in turn echoes the 'Myth of Er' at the end of Plato's *Republic*. Both works attempt to explain the cosmos from a place 'among the radiant stars' from where it appears like a 'nest of bowls' with planets and other heavenly bodies circling the earth. In a dream, Scipio's heroic grandfather, Scipio Africanus, conqueror of Carthage, brings his grandson to an awareness of his essential unimportance when his existence is set against the motion of the turning universe. Macrobius, probably a pagan and a native of Africa, used the commentary to develop neo-Platonic ideas. Several of these are explained in the book's diagrams: a female figure represents the 'World Soul'; the orbits of the moon, Mercury, Venus, Mars and Jupiter are illustrated

by concentric circles, with zodiacal signs around the edge. Moreover, gravity is illustrated by waving rays centring on a blue disk, showing that 'all weights are drawn to the earth by their own inclination'.

Macrobius positively influenced medieval thought by upholding the idea that the earth was a sphere. Although vaguely correct in its depiction of frigid, temperate and torrid zones, the zonal map shown here confirmed the belief that no man could live in the southern hemisphere: it was thought that they would not be able to cross the torrid zone, which was 'scorched with the heat of the sun'. This belief discouraged exploration for almost a thousand years from the time Macrobius was writing in the fifth century.

The map itself has north to the left, with three seas depicted: 'Our Sea' (the Mediterranean), the Caspian and the Indian or Red Sea. The green wavy line around the edge and the middle is 'Ocean', an entity that further separated the different parts of the world.

Borgia World Map

Unknown cartographer
Paris, 1797 (metal map dated *c*.1430)
Engraving
Sheet 685 × 600 mm; map (diameter) 622 mm
AMIB 1988.94

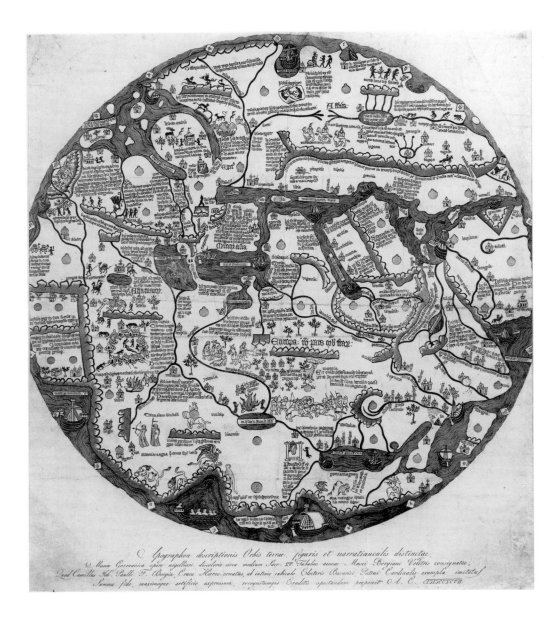

This fascinating depiction of the known world from the early fifteenth century is popularly called the Borgia World Map. While in Portugal in 1774, Cardinal Stefano Borgia chanced upon a map engraved on a metal sheet (now in the Vatican Library) and had prints made of the map's image, of which this is one. (Dallas Pratt traced only ten other existing copies.) As the original map on metal is a true map, not an engraved plate made for printing (where the map is drawn in reverse), an intermediate cast had to be made, in order to produce the printed copies. The map's authorship is unknown, but from internal evidence it has been dated to the first half of the fifteenth century. The inscriptions are in Latin but written in Gothic script, which suggests southern Germany as the place of its creation.

At first glance the map has some characteristics of medieval *mappae mundi*: the lands of the known world are squeezed into a disc and covered with graphic vignettes, in accordance with Pope Gregory's dictum that pictures were to the illiterate what the Scriptures described to those who could read. There are Biblical references (Paradise, Mount Sinai and the Three Magi), and the burial sites of Saints Matthew (near Lake Ysik-Kol, Kirghizstan) and Thomas (India) are given, but many of the other items are secular. By the time of its creation, the works of the classical geographer Ptolemy and Marco Polo's accounts of his travels in the East had become known. We thus see China, with its Great Wall and people collecting silk from a tree, on the left (the map is 'upside-down', with south at the top). Map-makers tended to make their own lands larger in comparison with those of others. Europe takes up a lot of space, with Italy disproportionately large. The kingdoms of Anglia and Scotia are at the lower right, but Ireland is not depicted.

The *mappae mundi* were the encyclopaedias of their day, and it is interesting to learn from the graphics and inscriptions what knowledge existed at the time of the map's creation. The further from Europe, the more bizarre and fantastic are the subjects depicted. The giants Gog and Magog inhabit the East. The Tartars (under their emperor Canis, possibly Genghis Khan) 'dwell in towns of many tents of skin', and their four-wheeled carts are pictured. Siberia is called 'the land of illustrious women', but further south the Scythians, 'through want, sell their children in the market' and worship a head placed on a pole.

Closer to home, Hannibal's victory at Cannae is recorded in an Italy 'beautiful, fertile, brave and proud', the southern part of which is tagged 'Labour District'. In France a caption refers to 'King John of France taken here in battle by the Prince of Wales'. This is a reference to the Battle of Poitiers in 1356 during the so-called Hundred Years' War between France and England.

RIGHT: The kingdoms of Anglia and Scotia are pictured on the lower right of this 'upside-down' map. Ireland is not depicted.

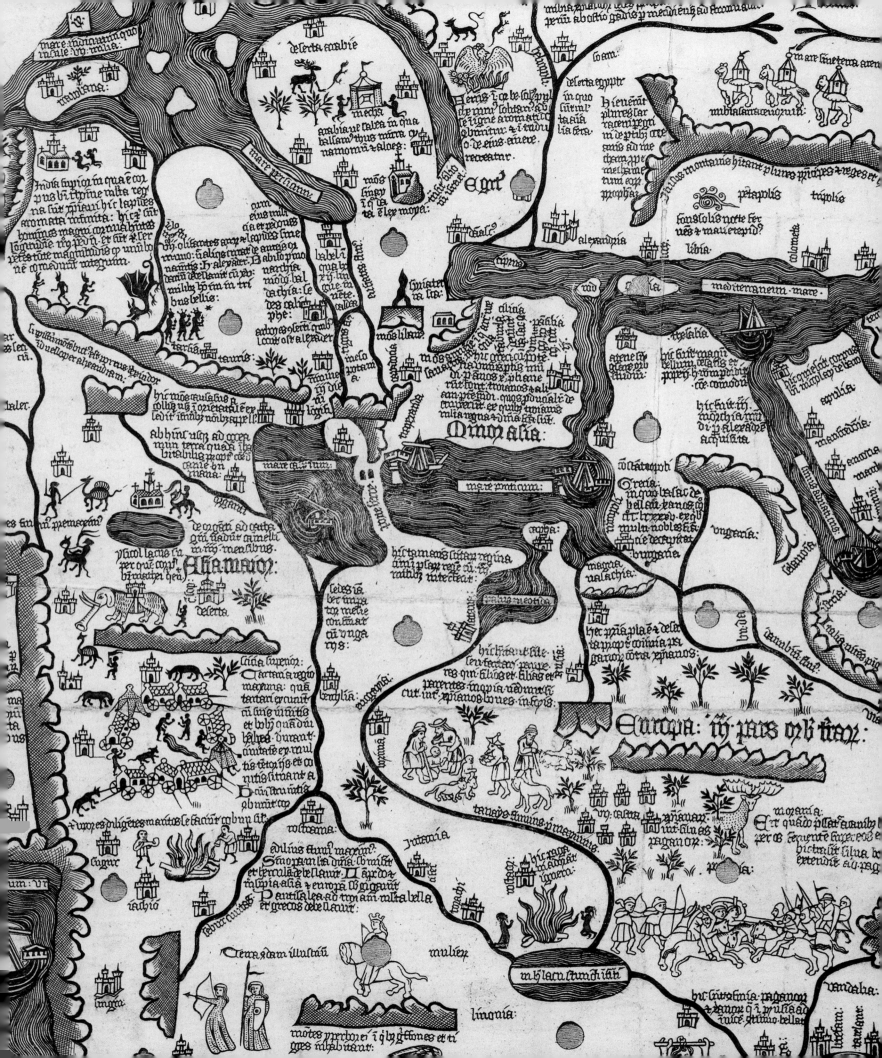

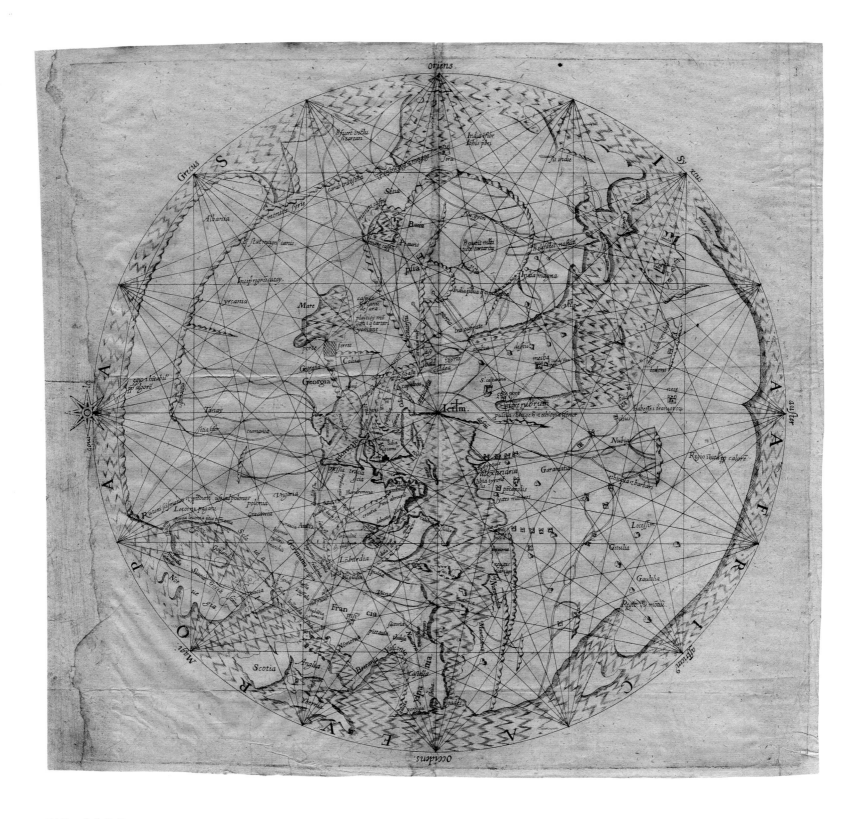

World Map

Pietro Vesconte (fl. 1310–1330), cartographer;
Johann Bongars (1554–1612), engraver
Hanover, 1611 (original map *c*.1320)
Copperplate engraving
Sheet (trimmed) 359 × 368 mm;
plate 349 × 355 mm
AMIB 1988.183

Johann Bongars produced only one edition of this depiction of the world, which is considered to be among the most important of European printed maps. Bongars engraved a plate from the manuscript copy that once belonged to the infamous Marino Sanuto (or Sanudo) of Torcello, a crusading Venetian statesman. Sanuto included this map in his inflammatory treatise

Opus Terrae Sanctae (On the Holy Land), which advocated papal support for a new crusade against the Turks. (The Avignon Pope, John XXII, remained unconvinced by Sanuto's arguments.) Sanuto's manuscript copy was, in turn, derived from a world map by Pietro Vesconte – the foremost map-maker of medieval Europe and the first to sign and date his works. Vesconte was

famed for his portolans, the mariners' charts drawn on animal skins that appeared after 1300. His expertise is demonstrated here in the accurate depiction of the coasts of the Mediterranean, the Black Sea (with the Sea of Azov) and Europe. Scandinavia, England, Scotland and 'Ybernia' (Ireland) are clearly shown. With east at the top and north at left, the map is criss-crossed by rhumb lines used in navigation.

Further afield there is less accuracy; two Caspian Seas, for instance, are illustrated. Nevertheless, working almost a hundred years before Ptolemy's *Geographia* was rediscovered and read by a European public, Vesconte avoided the classical geographer's error of joining southern Africa with East Asia and thereby making the Indian Ocean landlocked. Features of medieval *mappae mundi*, T-O and zonal maps appear: the world is compressed into a flat disc and around the periphery are the names of three known continents (Europe, Africa and Asia); it is oriented towards the east with Jerusalem at the centre, towards which all the main rhumb lines lead; and inscriptions allude to mythical figures and to 'a region uninhabited because of heat', the so-called torrid zone.

Another remarkable feature of this map is the reference to the mythical figure of Prester John, whose legend grew from the twelfth century – a wealthy and virtuous Christian king supposedly waiting to join battle with European crusaders to reclaim the Holy Land. Prester John's domain is here depicted in the Far East, rather than in Africa (as it was in the Borgia Map). Also in the East are the two cannibal giants, Gog and Magog, who wait to devastate Europe. Possibly a memory of the threatened invasion of Europe by the Mongols in the previous century, they were much feared during the Middle Ages. Even the celebrated empirical philosopher Roger Bacon (*c*.1214– 1294) believed in their existence and advocated the study of geography in order to be prepared for their attack.

RIGHT: With east at the top and north at the left, this map is criss-crossed by rhumb lines used for navigation. England, Scotland and 'Ybernia' (Ireland) are depicted on the lower left.

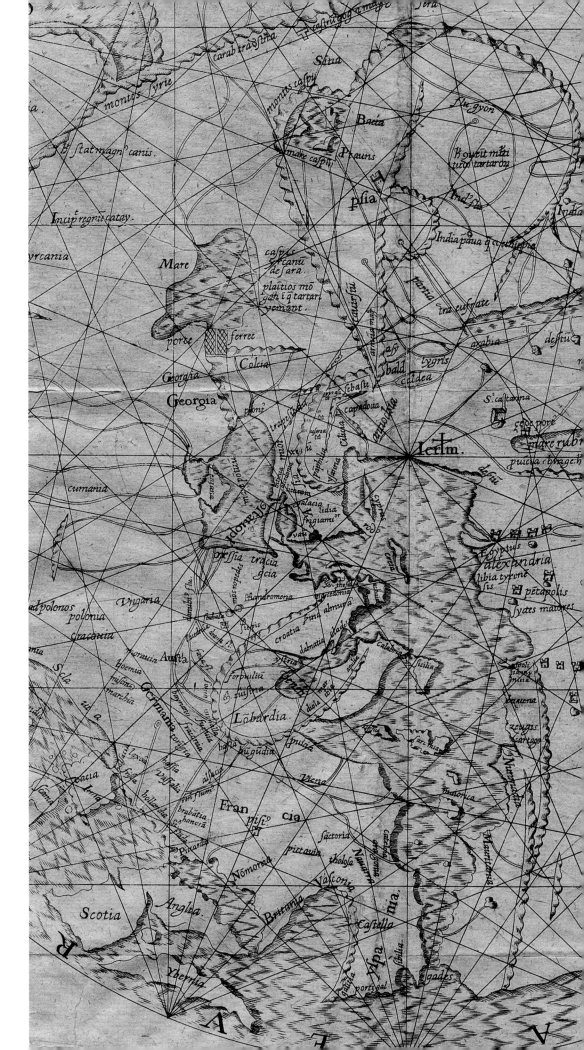

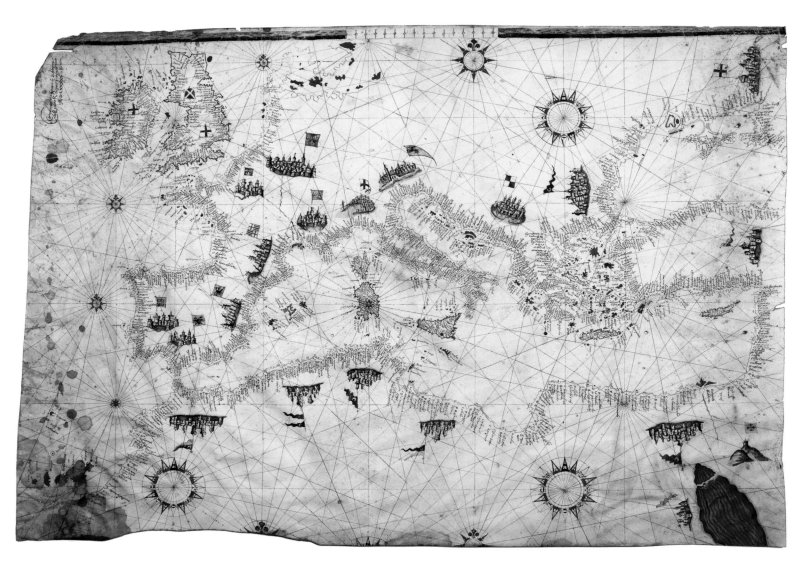

Portolan Chart

Baldasaro da Maiolo (fl. 1583–1605), cartographer
Genoa, 1591
Hand-coloured manuscript on vellum
Sheet (trimmed) 529 × 752 mm
AMIB 1988.131

The schools of hydrography located in Genoa and Majorca were the first to produce portolans (mariners' charts drawn on animal skins). Maiolo's portolan is one of the last of these mariners' maps, which first began to appear in about 1300 and continued in use up to 1600. Although portolan-makers were cautious about revealing their full knowledge of sailing directions, safe harbours, shoals and other hazards, they none the less influenced the shape of other maps produced during this period, including *mappae mundi*. Based on seafarers' direct observations, these charts were remarkably accurate. Since the portolan-makers could not convey the curvature of the earth, however, they mainly confined the areas depicted to the

Mediterranean and Black Seas and western European coastlines, with fewer attempts at world maps. The interiors of the countries were largely left empty, apart from elaborate wind or compass roses and the criss-cross of rhumb (navigational) lines emanating from them.

In the upper-left corner is an inscription saying that this is a nautical map made by the hand of 'Baldasaro da Mjaiolo' (spellings were variable) in 1591 in Genoa. Its fine condition suggests that it was a presentation copy, rather than one intended for use at sea. Unlike some portolans that retain the shape of the animal on whose skin the maps were drawn, this vellum map is rectangular. In other respects, this portolan is fairly typical: around the coastlines are the names of towns and harbours, the principal ports being marked in red; shoals and cliffs are indicated with symbols similar to those on modern maps; and small red dots mark coastal hazards.

Everything is depicted as if viewed from a ship. Important cities such as Genoa and Venice are among the eighteen vignettes that appear.

Whereas these are the 'right way up', cities such as Alexandria or Rostov-on-Don are portrayed upside-down or sideways. The pennants of Islamic cities bear the crescent, the French have their *fleur de lys*, and the Spanish Habsburgs have their double eagle. The cross of St George and the Scottish saltire signify the British Isles. The Red Sea is coloured as its name suggests and has a crossing for the Israelites. The island of Rhodes, which had been in Turkish hands since 1522, like-wise appears on this map in a solid red colour with a superimposed white cross. This cross is a symbol of the Knights of St John, who settled in Rhodes after serving in the Crusades. (They subsequently moved their headquarters to Malta, and hence the eight-pointed cross associated with the Knights of St John is known as the Maltese Cross.)

OPPOSITE: The cities of Paris and Venice can be seen on the upper left and upper right of this enlarged detail. These cities are identified by the emblems on their pennants: the *fleur de lys* on a blue background (France) and the winged lion of St Mark (the Venetian Republic).

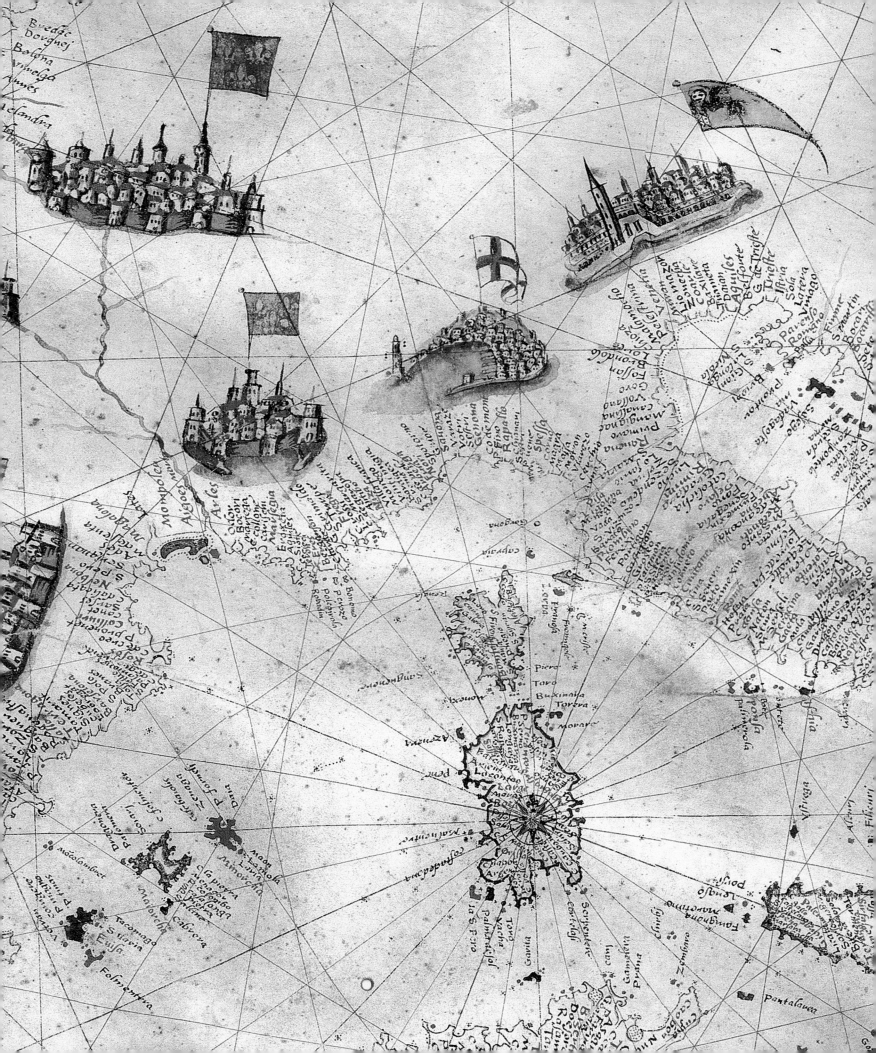

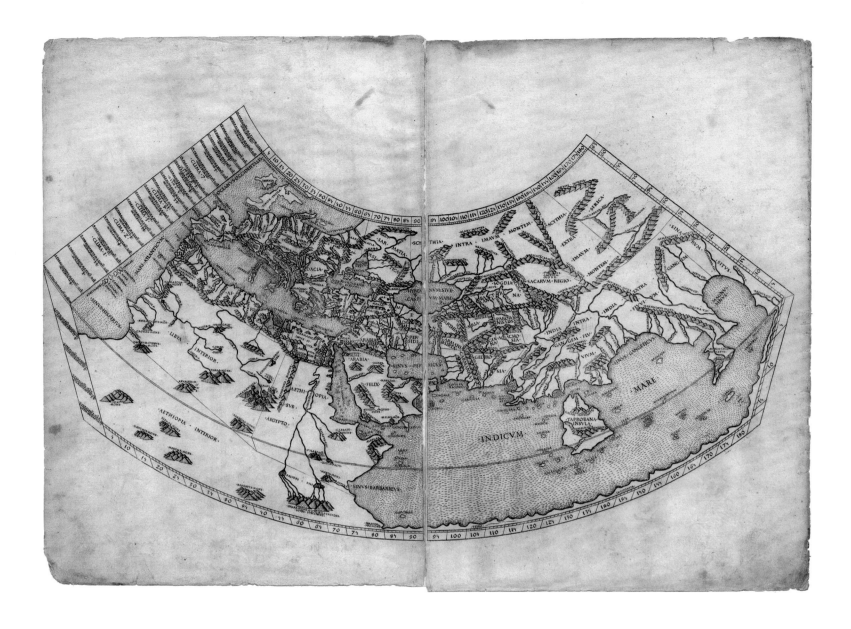

Two Ptolemaic Maps

When the works of the classical geographer, astronomer and mathematician Claudius Ptolemy began to emerge from obscurity in the early 1400s, his most famous book *Geographia* (sometimes called *Cosmographia*) was translated from Greek into Latin. So began a craze for constructing maps according to Ptolemy's scientific methods, using the ancients' system of locating places by their co-ordinates of latitude and longitude. Even after the great geographical discoveries of the Renaissance, cartographers were still constructing maps on Ptolemy's principles up to about 1570, or at least using them as a basis for authority.

World Map from *Geographia*
Claudius Ptolemy (*c*.90–*c*.168), author; Donnus
Nicolaus Germanus (*c*.1420–*c*.1490), cartographer
Rome, 1490
Copperplate engraving
Sheet 411 × 554 mm; plate 305 × 542 mm
AMIB 1988.63.2

Printed in 1490 from the same plates as the 1478 Rome edition of *Geographia*, this map shows the world as it was known to a citizen of Roman Alexandria: it extends from the Fortunate Islands (the Canaries) in the west to the middle of China (named *Serica* for 'silk' on the map) in the east, and from Thule in the north to the Horn of

Africa in the south. It is constructed according to Ptolemy's conical ('lazy man's') projection, and has degrees of longitude marked along the upper and lower edges, with latitude along the right. Arranged on the left side border are 'clima', by which latitude is measured in hours of daylight of the longest day, from twelve hours at the equator to twenty hours in the north.

Following Ptolemy's teachings, the map is plainly drawn and clearly legible, with place names in distinct Roman lettering. Also in obedience to Ptolemy, there are no monsters, wind heads or decorative borders. Typical anomalies none the less still appear: the land-locked Indian Ocean; the small size of India and

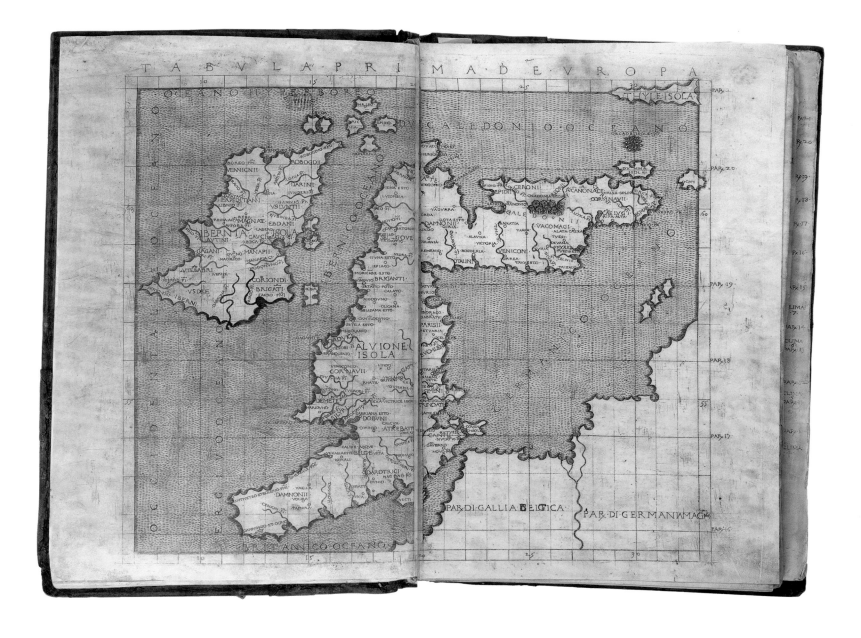

the overlarge island of Taprobane (Sri Lanka); and the horizontal stretching of the Mediterranean. A copy of this map was owned by Christopher Columbus, and it is thought that Ptolemy's adoption of Posedonius's measurement of the earth's circumference, instead of the more correct and larger one of Eratosthenes, caused the hopeful mariner to underestimate the distance he would have to travel west to reach the Orient.

Map of the British Isles from *Geographia*
Claudius Ptolemy (*c*.90–*c*.168), author; Francesco
Berlinghieri (1440–1501), cartographer
Florence, *c*.1480
Copperplate engraving
Single page 409 × 270 mm
AMIB 1988.71

'Modern' maps of Spain, France, Italy and Palestine were included in this edition of Ptolemy, which was translated by Francesco Berlinghieri into Italian verse and produced in Florence in 1480. This depiction of the British Isles – with Scotland lurching at an angle to embrace the 'German Ocean' – is based on Ptolemy's

cylindrical projection and uses Roman names to denote geographical locations and individual tribes. As with most printed Ptolemy maps of Britain, the ancient Caledonian Forest is shown.

Another remarkable feature of this 1480 edition is the alphabetical rather than geographical order employed for Ptolemy's index of names, along with their latitude and longitude – a system still used in a modern gazetteer.

29

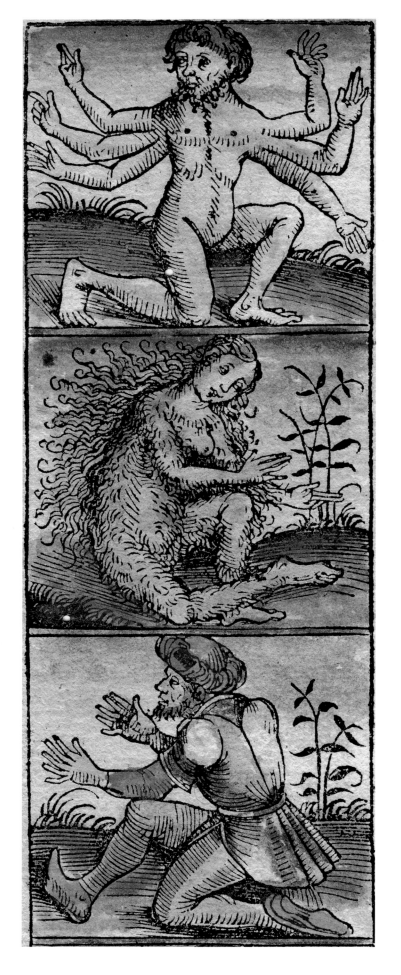
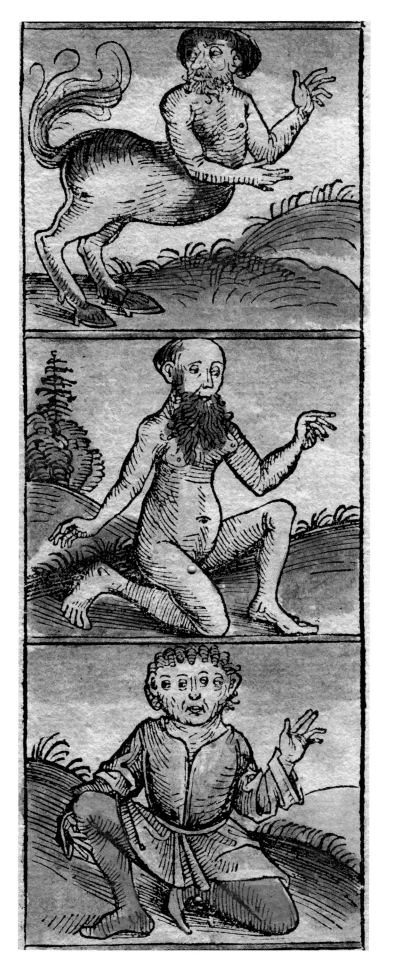

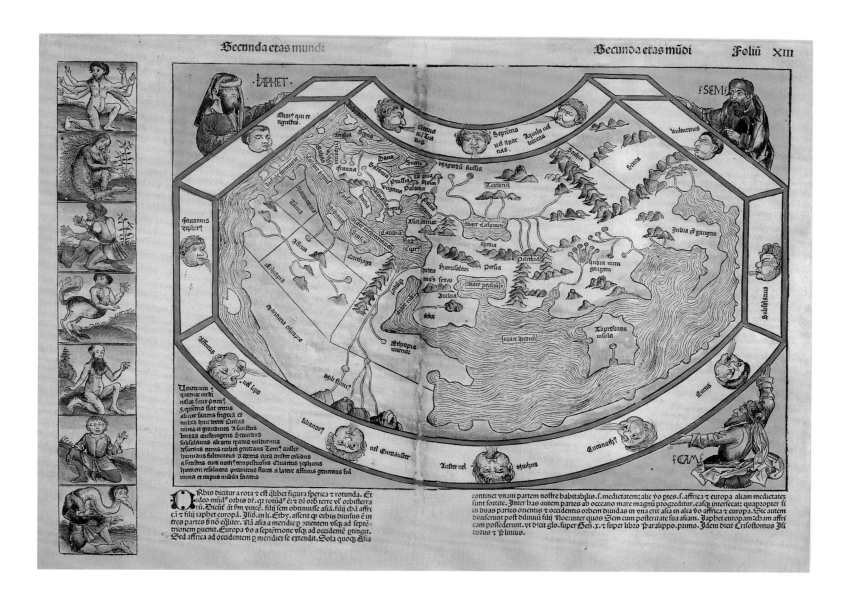

World Map from the *Nuremburg Chronicle*

Hartmann Schedel (1440–1514), author;
unknown cartographer; workshop of Michael
Wolgemut (1434–1519), illustrators
Nuremburg, 1493
Woodcut
Sheet 405 × 564 mm; plate 394 × 551 mm
AMIB 1960.177

Schedel's world map was produced only a few months after Columbus's return from the New World, but bears no hint of that momentous discovery. This is a view of the world as known to the ancients, based upon Ptolemy's guidelines, with an Indian Ocean enclosed by a projection of Africa that reaches the far end of Asia, and with an oversized island of Taprobane (Sri Lanka) at the tip of India. Hard-working wind heads puff away, and Noah's sons, Ham, Shem and Japhet, who populated the earth after the Flood, inhabit three corners. One senses that Schedel, the editor,

having overseen the production and placement of 1,800 woodcut illustrations (although many were duplicated), was in no mood for last-minute alterations.

The *Nuremburg Chronicle* is regarded as the most successful and sophisticated of printed works appearing before 1500. The woodcut illustrations could be placed within the printed text, and so there was variety and artistry in the layout of the pages. The book aspired to be a history of the world according to the Bible. It is divided into seven sections; the first tells of the Creation, the sixth narrates the birth of Christ and the Christian era, and the seventh focuses on the end of the world and the Last Judgement. Among the woodcut designers were Michael Wolgemut and Hanns Pleydenwurff, masters of the workshop where Dürer had been apprenticed. In the sixth (and largest) chapter concerning the present era, the histories of many important

Western cities are told with accompanying illustrations.

The reader's eyes drift towards the grotesque illustrations that run down the left-hand side of the map. Such mythological creatures, which become more monstrous the further away they are located, evolved from tales told by ancient story-tellers such as Herodotus, Solinus and Pliny the Elder. It is possible to disentangle the travellers' tales from which some derived: a returning member of Alexander the Great's forces may have described seeing Indian dancers simulating the multi-armed goddess Kali; the long-necked, beaked individual at the bottom may be based on a tribal ritual mask; the centaur may have been horse-riding Scythians of Central Asia; and great apes may be the source for tales of 'hairy women'. There were even more grotesque illustrations on the reverse of the map, to the amusement and wonderment of the *Chronicle*'s readers, no doubt.

World Map from Ptolemy's *Geographia*

Johann Ruysch (*c.*1460–1533), cartographer
Rome, 1507
Copperplate engraving
Sheet 420 × 585 mm
AMIB 1988.2

The multi-talented Johann Ruysch – monk, geographer, astronomer, explorer and painter – created a cartographic landmark with his world map; it was a last-minute addition to a 1507 reprinting of the 1490 Rome edition of Ptolemy's *Geographia* and the first 'modern' world map to be included in that revered work of classical geography. Its 'modern' features are based on Portuguese explorations around Africa to Asia: India is shown for the first time as a peninsula, and the size and positions of Madagascar and Sri Lanka are reconfigured. The Spanish were excessively secretive about cartography. Ruysch is thus vaguer about their New World discoveries, but he shows Greenland for the first time as separate from Europe, and Newfoundland as a single landmass, rather than a group of islands; however, he has these two parts of North America attached to Asia. Ruysch had actually visited these parts; hence this is the first printed map based on direct knowledge.

Ruysch was born in Utrecht, and became a Benedictine monk in Cologne, active as a manuscript illustrator. Records show that by 1507 (when this map was produced), Ruysch was working in the Vatican and later assisted Raphael in the decoration of the *Stanze della Segnatura*. When travelling between his domiciles in

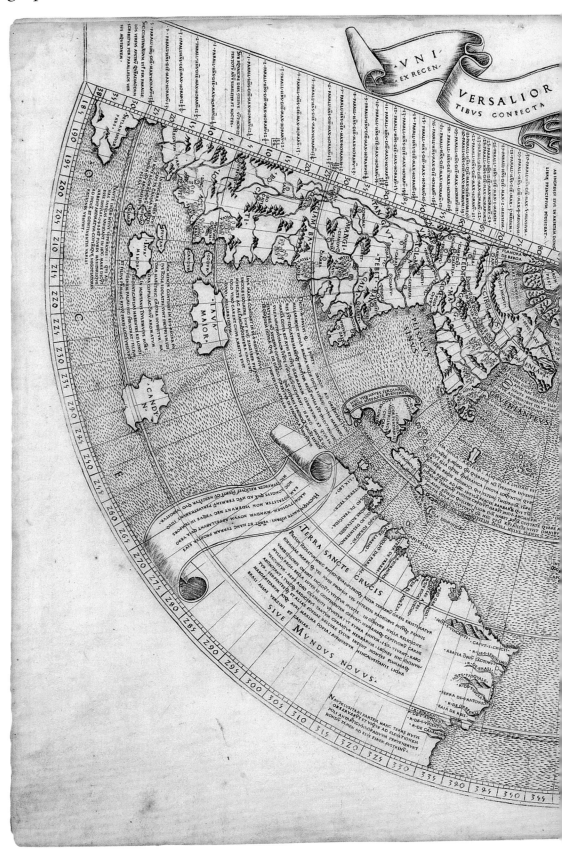

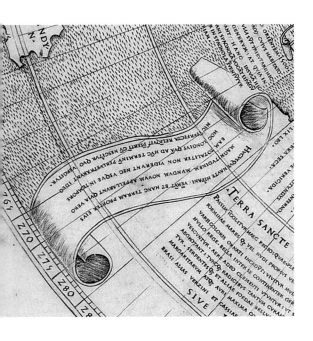

LEFT: The inscription on the scroll beside the Land of the Holy Cross (South America) states that the map is left incomplete in this section 'as we do not know in what direction it goes'.

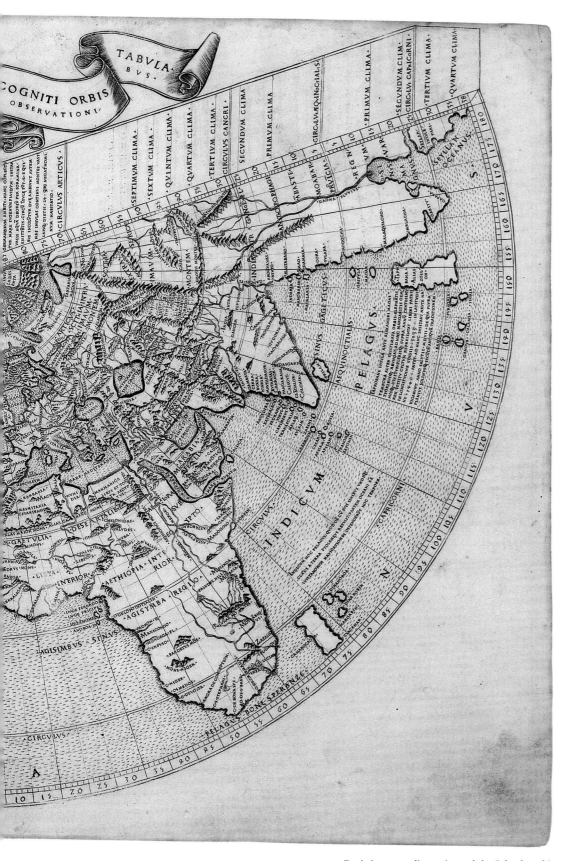

Cologne and Rome, he managed to visit parts of North America, sailing either with John Cabot in 1497 or with one of the Bristol-Portuguese syndicates voyaging between 1501 and 1505. A biographical note to the 1508 edition states:

Johann Ruysch,… a most experienced and diligent geographer, said that he had sailed from the southern part of England… and had reached 53° north and on that parallel had sailed through the angle of the night to the shores of the East and had observed many islands.

The puzzling phrase 'the angle of the night' is an astrological expression meaning that he sailed over the celestial horizon and travelled round the underside of the globe; in other words, he sailed westwards to reach the East.

The inscriptions on this map include an admission on the scroll beside the Land of the Holy Cross (South America) that it 'is here left incomplete, especially as we do not know in what direction it goes'. Other inscriptions seem from the realms of legend but may have a basis in fact. 'This island was entirely burnt in 1456,' Ruysch notes of a no-longer extant island between Iceland and Greenland, perhaps the scene of volcanic activity. The description of a high rock of magnetic stone at the entrance to a 'Sucking Sea' (probably whirlpools), where 'the ship's compass does not hold, nor can a ship with iron turn back', dates from Ptolemy and features in the *Arabian Nights*, but may reflect Ruysch's first-hand experiences of the dangers of sailing in those heretofore uncharted seas.

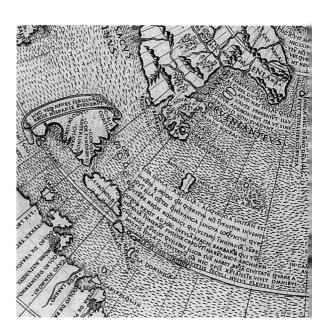

RIGHT: Depicting recent discoveries made by Columbus, this landmark map illustrates several of the islands of the West Indies. North America, which was unknown to Columbus, is represented by Newfoundland and a curling promontory, possibly Cape Cod.

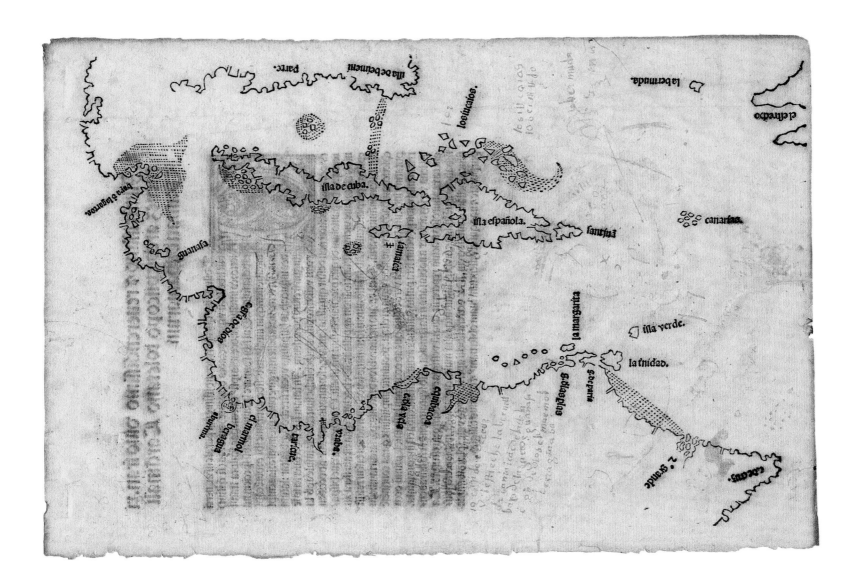

Map of the Caribbean

**Peter Martyr d'Anghiera (1457–1526), author;
unknown cartographer
Seville, 1511
Woodcut
Sheet 299 × 208 mm
AMIB 1988.92.1**

In 1494 Peter Martyr d'Anghiera – an Italian-born humanist scholar and chaplain to the Catholic monarchs Isabella and Ferdinand – was appointed tutor to the royal children, among whom may have been their youngest daughter, Catherine of Aragon, later to be queen of England. He was thus in a good position to meet and consult many of the early voyagers of the Age of Discovery, being a friend and contemporary of such seafarers as Christopher Columbus (1451–1506), Ferdinand Magellan (c.1480–1521), John Cabot (c.1450–c.1499) and Amerigo Vespucci (1454–1512), who all passed through the Spanish Court. Between 1511 and 1530 Peter Martyr

published collections of letters and reports concerning the first explorations in Central and South America. These compilations were grouped into sets of ten chapters called 'Decades'. Peter Martyr may have invented the phrases 'New World' and 'Western Hemisphere'. He also realised the significance of the Gulf Stream.

This map of the Caribbean was included in the first book of the 'Decades', but its publication displeased King Ferdinand, who in 1511 issued a decree that foreigners should not have access to maps of his new colonies. Later printings of the book do not include the map, which is now very rare. Although it is preceded by printed world maps partially depicting the New World territories, this is the first to be devoted to a specific region of America.

Most likely based on sea charts drawn by the explorers, the map is remarkably accurate. It shows the shape and position of such islands as Cuba, Hispaniola, Puerto Rico, Jamaica, Trinidad

and the newly discovered Bermuda; the Gulf of Maracaibo appears in the north coast of South America, and Yucatan is hinted at by marked shoals. At north appears the apparent 'isle' of Beimeni (Bimini), popularly believed to be the home of curative spring waters that could restore lost youth – although Peter Martyr himself dismissed such claims. The appearance of Beimeni on this map may have prompted Ponce de León in 1513 to set sail northwards from Puerto Rico and find the land he named 'Florida'. From here, the Florida Keys stretch across the sea to Cuba, and to the east are the Bahamas. The Strait of Gibraltar on the right of the map, however, is too far south, and the Canaries have drifted into mid Atlantic. The text on the *verso* of the map lists the 'very large provinces which are said to be the Indian continent', and describes Cuba as surrounded on all sides by islands, 'like a hen with her chickens'.

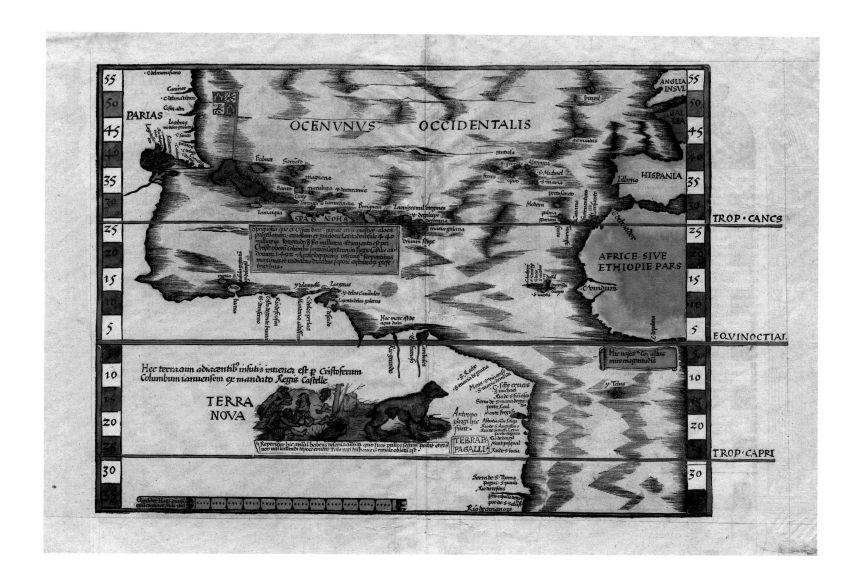

Oceanus Occidentalis Terra Nova (The Western Ocean and the New World)

Martin Waldseemüller (*c.*1470–1520), cartographer
Strasbourg, 1535
Hand-coloured woodcut
Sheet 393 × 518 mm; plate 295 × 428 mm
AMIB 1988.4

This map of the New World is a later version of the first edition of 1513, also in the Dallas Pratt collection, known as 'The Admiral's Map' – the Admiral being Christopher Columbus (1451–1506). The inscription above the words *Terra Nova* reads: 'This land with the adjacent islands was discovered by Columbus of Genoa under the mandate of the monarchs of Castile.' If one wonders why Waldseemüller 'protests too much', there is a reason: he had earlier attributed the discovery of 'a fourth part of the Globe' to Amerigo Vespucci, whose letters about his travels had been published in Waldseemüller's *Cosmographiae Introductio* of 1507. Indeed,

Waldseemüller coined the name 'America' for the new continent and included it on his huge wall map of the world made in the same year. Despite Waldseemüller's efforts to undo his mistake, the name 'America' stuck. (Ironically, even the picture of cannibals and an opossum depicted here is based on Vespucci's descriptions.) The upper inscription also states that 'Spagnola' (now Haiti and the Dominican Republic) was discovered by Columbus and that 'the natives there eat large serpents, and, instead of bread, sweet roots tasting like chestnuts'.

On his third voyage, Columbus sailed along the north coast of South America hoping to find a strait that would lead him through to the East Indies. When he discovered the huge freshwater flow of a river (the Orinoco), however, Columbus surmised that this was no island river, but that of a continent, and that that continent must be the Earthly Paradise 'because all men say that it is at the end of the Orient and that is where we are'.

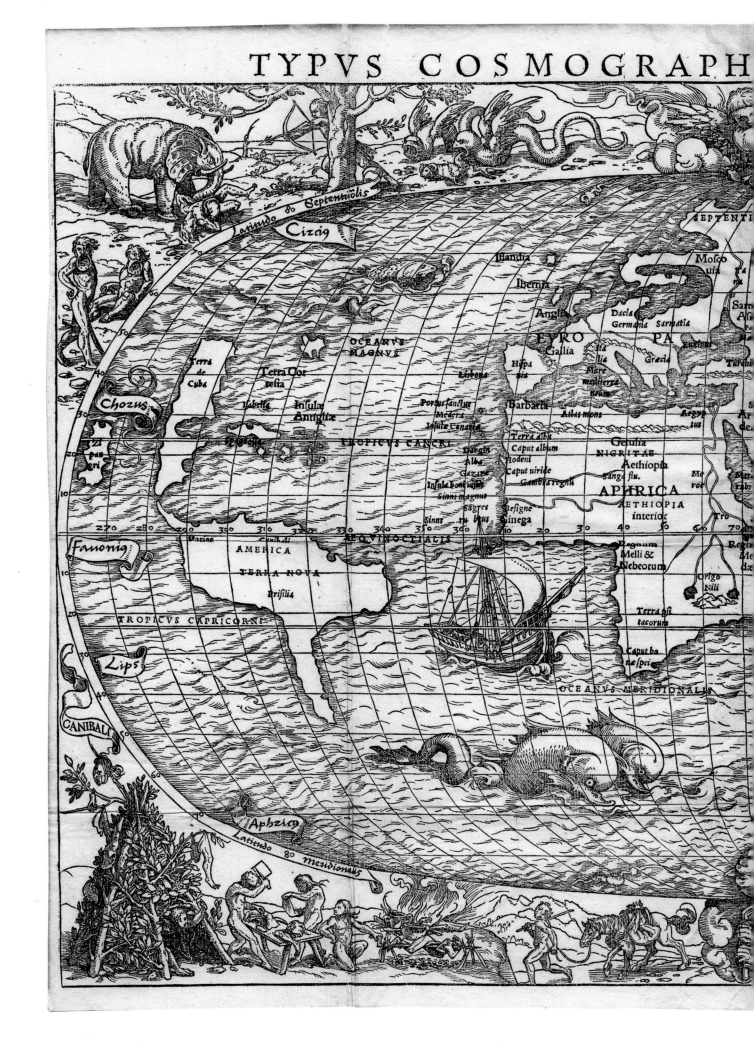

TYPVS COSMOGRAPH

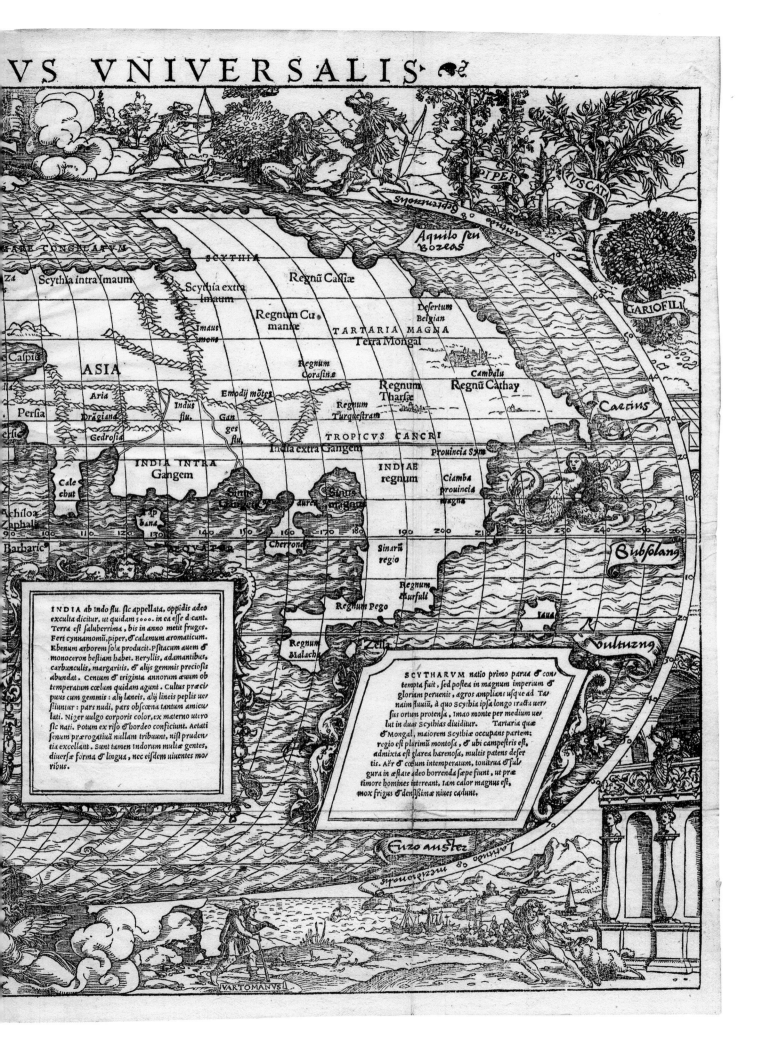

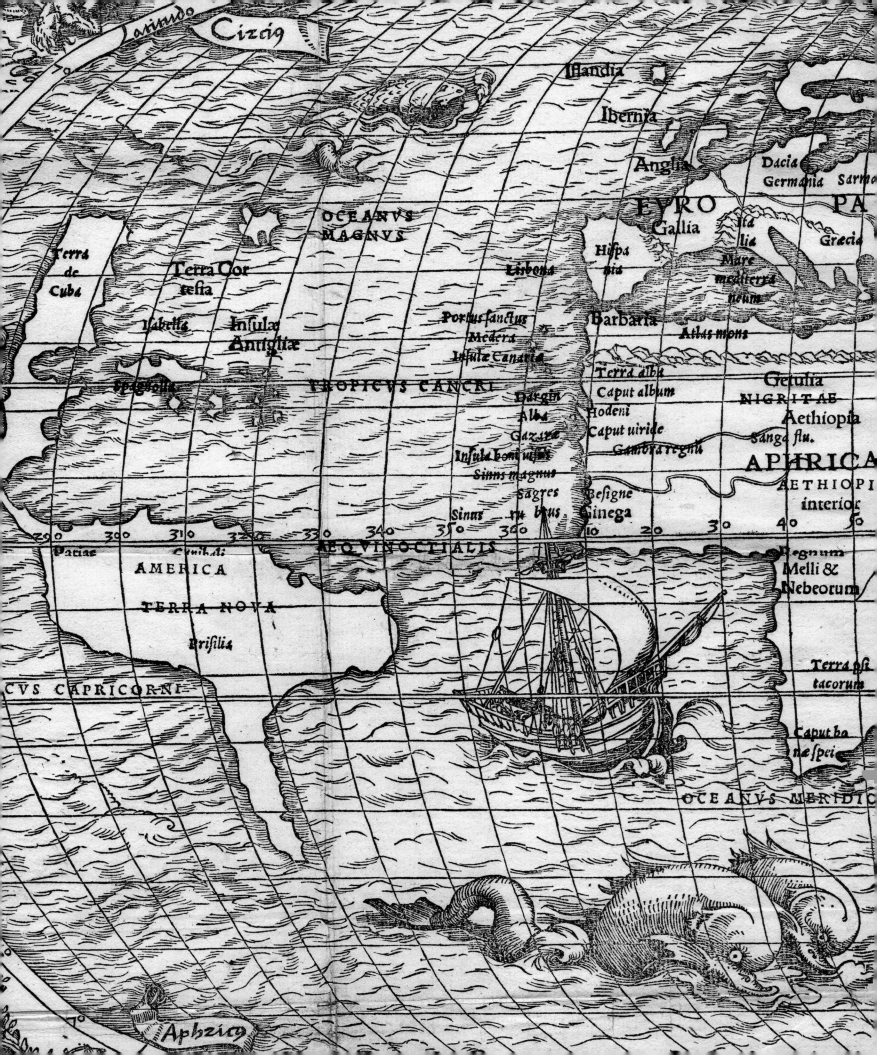

Cizig

Islandia

Ibernia

Anglia

Dacia
Germania Sarmo

EVRO PA

Gallia Italia Grecia

OCEANVS
MAGNVS

Hispania

Mare
mediterra
neum

Terra Cor
tesia

Lisbona

Barbaria

Atlas mons

Terra de
Cuba

Portus sanctus
Medera

Isabella Insulæ
Antigliæ

Insulæ Canariæ

Terra alba Getulia

Caput album NIGRITAE

Spagnolla

TROPICVS CANCRI

Hodeni
Caput uiride

Aethiopia
Sanga flu.

Margin
Alba
Gazara

Insula boni uesti

Gambra regnu

APHRICA

Sinus magnus

sagres

AETHIOPI
interior

Besigne
Ginega

Sinus ru bras

290 300 310 320 330 340 350 360 10 20 30 40 50

Patias Cunibali AEQVINOCTIALIS

Regnum
Melli &
Nebeorum

AMERICA

TERRA NOVA

Brisilia

Terra psi
tacorum

CVS CAPRICORNI

Caput bo
næ spei

OCEANVS MERIDIC

Aphzicg

SEPTENTRIO

Mofco
uia ta Tartari Za Scythia intra Im

See previous page:

Typus Cosmographicus Universalis (World Map)

Sebastian Münster (1488–1552), cartographer;
Hans Holbein the Younger (c.1497–1543),
illustrator
Basel, 1532
Woodcut
Page (trimmed) 386 × 561 mm
AMIB 1988.5

Dallas Pratt was delighted to acquire this world map by Sebastian Münster, not because it reveals new geographical discoveries – it is somewhat outdated – but because of its illustrative border, thought to be by Hans Holbein the Younger. Pratt was especially amused by the pair of cherubs at each pole, cranking the earth around on its axis.

In May 1972 Pratt wrote an article for *Columbia Library Columns* under the title 'Angel-Motors', in which he traced the evolution of the idea of the earth revolving around its own axis, propelled by heavenly beings in one form or another. Beginning with Plato's 'Myth of Er' (*Republic*, Book X), in which the stars and planets are turned on a spindle moved by the three Fates, Pratt traced the evolution of cosmic movers, from neo-Platonic 'emanations' to the more familiar form of angels conveying virtuous souls to heaven. Aware of the potential impact of postulating a heliocentric earth revolving on its axis, Copernicus did not agree to publish his *De Revolutionibus* until just before his death in 1543, but for years previously he had allowed friends to have access to a summary. Dallas Pratt believed that Münster had got wind of this new theory of the earth's rotation, humorously presenting it powered by two cherubs using crank handles at the North and South Poles to turn the world.

In each corner Holbein has illustrated the four known continents: Africa has an elephant and a winged serpent; Asia, the land of spices ('piper' and 'muscata'), has hunters with bows in Tartar headgear; in America the usual cannibal feast is under way; and the Italian traveller Varthema is shown entering Europe, where a man is about to club a goat beside a classical temple. Not to be outdone, Münster has included dolphins, a galleon, a sea monster and a mermaid on the seas of his world map.

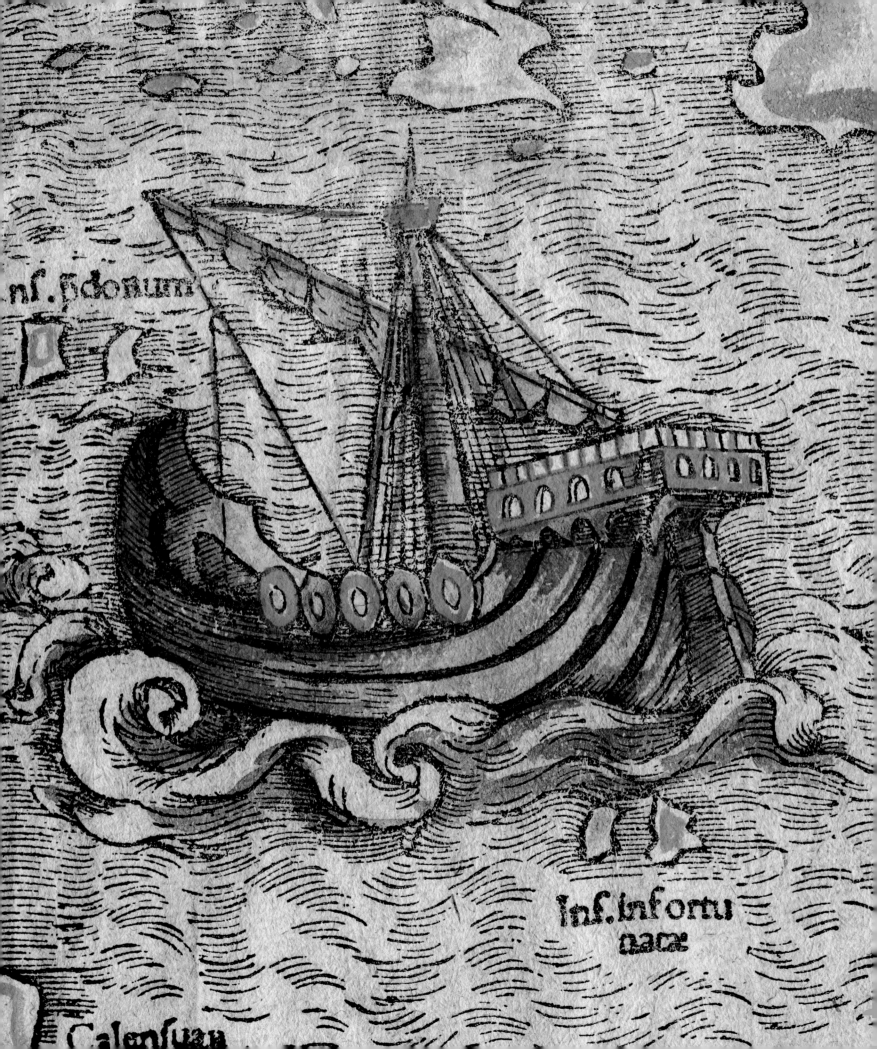

nf. fidonum

Inf. Infortu
natæ

Calenfuau

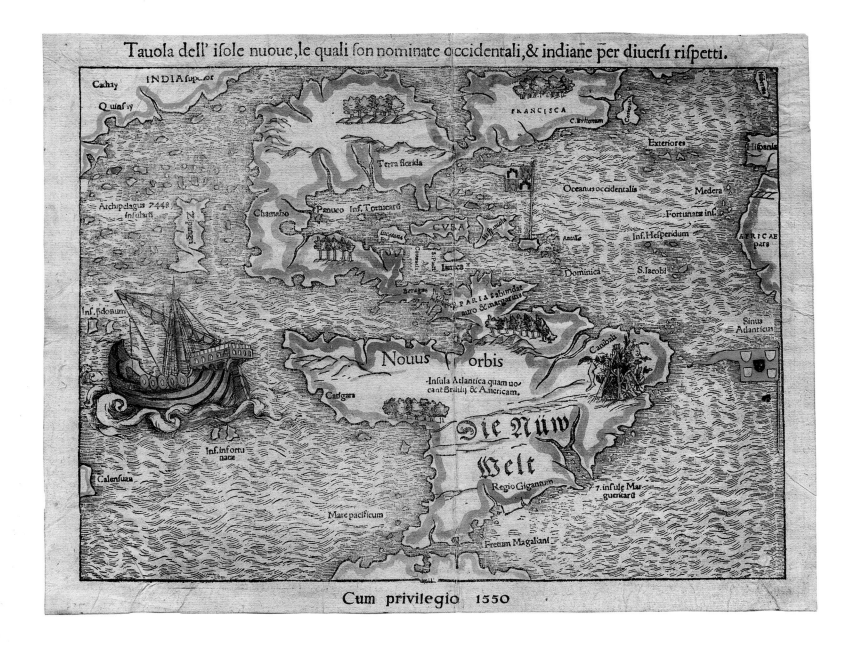

Tauola dell' isole nuoue, le quali son nominate occidentali, & indiane p̄er diuersi rispetti.

Cum privilegio 1550

Tavola dell' isole nuove… (Map of the New Islands…)

Sebastian Münster (1488–1552), cartographer
Basel, *c.*1550
Woodcut
Sheet 286 × 366 mm; plate 254 × 334 mm
AMIB 1988.11

Münster's gloriously eccentric woodcut map of the New World, complete with a depiction of cannibalism in Brazil, was one of the three maps that caught Dallas Pratt's eye when, aged eighteen, he was strolling along the Left Bank of the Seine. As well as being one of the first maps purchased for the collection, it is the earliest to show the Americas as a separate landmass joined by an isthmus. From its first publication in 1540 the map was hugely popular, with many editions appearing over the next hundred years. These are distinguishable from one another by the languages and typefaces used.

Münster was one of the first map-makers to leave spaces on the block for the insertion of moveable metal type, which accounts for the ability to vary the lettering according to the market. He obviously anticipated a wide international audience for this edition: the title is in Italian in roman lettering, the place-names and inscriptions are in Latin, but the large inscription *Die Nüw Welt* (The New World) in South America is in German with gothic lettering.

The Spanish flag flies near the Caribbean, and a Portuguese flag points to Brazil. France is acknowledged in the name 'Francisca' (Canada), and Cabot's explorations for the English by the inscription *C.Britonum* near what is now Cape Breton. Magellan's circumnavigation is commemorated by the placing of his ship *Victory* in the Pacific and the naming of his strait. There are interesting errors: the north of Yucatan appears as an island to the west of Cuba; the so-called 'Sea of Verrazzano', one of the great fallacies of exploration, which sprang from the explorer's belief that he had found a sea route to the Orient, is shown as a great gulf on this map; and Zipangu (Japan) appears improbably close to America's west coast, where later map-makers placed their 'island' of California.

Mostri marini & terrestri…
(Monsters of Sea & Land…)

Sebastian Münster (1488–1552), illustrator,
after Olaus Magnus (1490–1557)
Basel, 1550
Woodcut
Sheet 313 × 405 mm; plate 258 × 345 mm
AMIB 1988.146

This curious illustration is included in Sebastian Münster's *Cosmographia* – one of the most popular works of the sixteenth century, with nearly forty editions in several languages. Münster lived a life as convoluted as this intricate design, first training as a Franciscan but later converting to Protestantism, after which he gained renown as a Hebrew scholar and cartographer.

Letters near the monsters refer to an explanatory text, here translated from the Latin by Dr M. Beaty. Above, on the land, there are reindeer that 'can pull carriages faster than any horses, especially in the snow', trees whose fruit produces duck and, in the centre, a revolting creature who is 'an insatiable glutton. By squeezing itself between trees it empties its belly and then rushes back to continue eating.' In the sea 'huge fish the size of mountains are sometimes seen close to Iceland. They overturn ships unless frightened away by the sound of trumpets, or they may play with empty barrels thrown in the water, a game which amuses them greatly.' An unfortunate mariner is caught in the claws of a giant crab while another, possibly female, swimmer escapes. Below the crab is 'a horrible sea monster… which devours seals', and close by is a pelican that, so it is claimed, 'can fill its throat with water and let out a noise as loud as the braying of a donkey'. At top right a hydra, or sea serpent, is overturning a ship: 'they are extremely troublesome to sailors, especially in strong northern winds.' To its left swims a dolphin-like creature with tusks.

Münster had taken his inspiration from the fantastical creatures depicted in a 1539 travelogue, the title of which translates as 'A Marine Map and Description of the Northern Lands and Their Marvels', by the Swedish scholar and cleric Olaus Magnus. After the success of *Cosmographia*, it was Münster's monsters that became the pictorial inspiration of later maps, whose sea beasts enlivened and terrified generation upon generation of landlubbers.

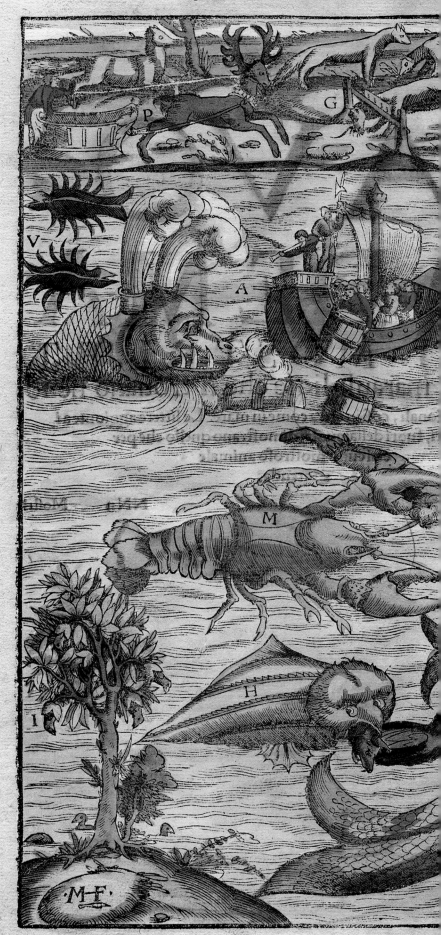

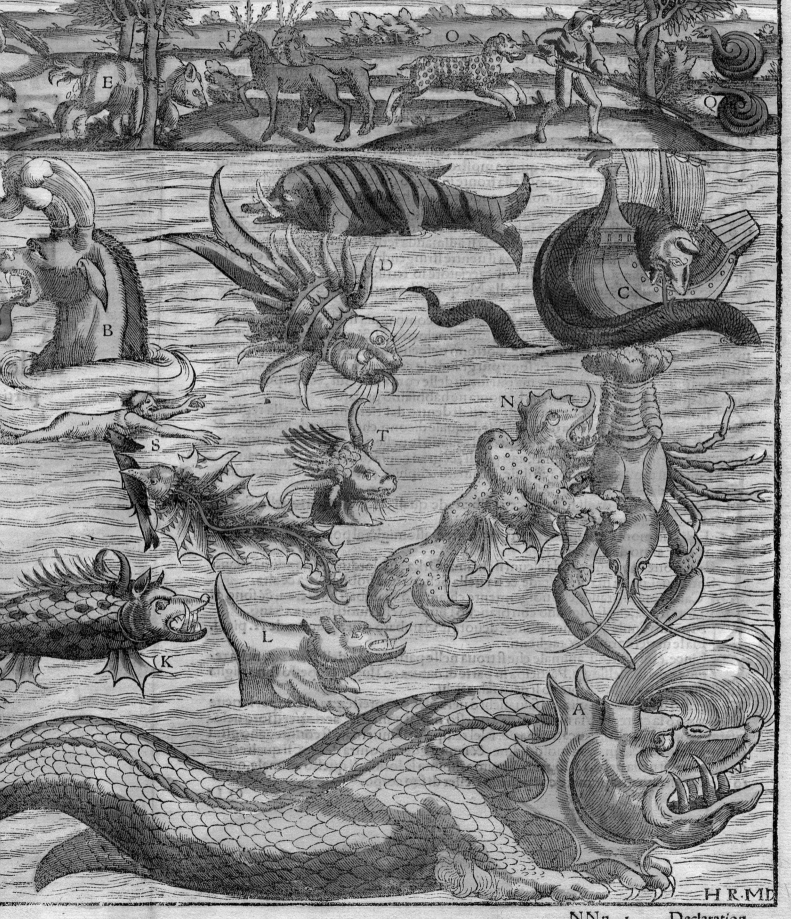

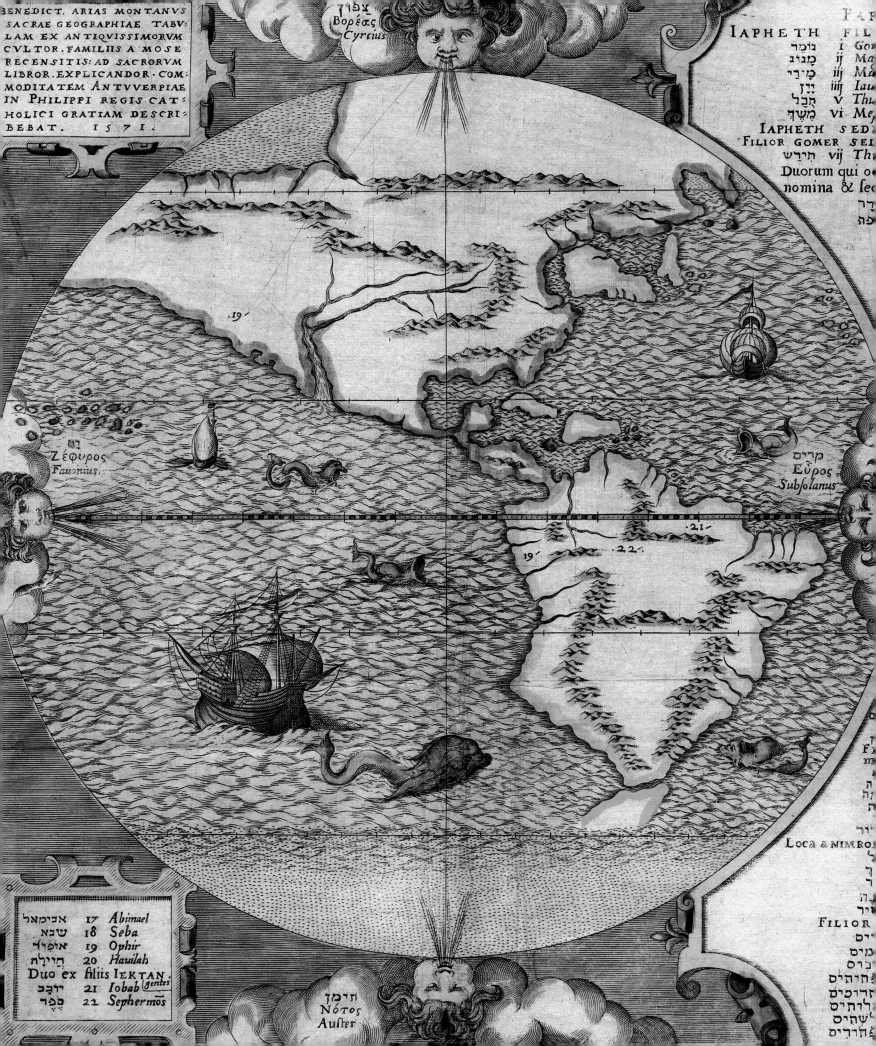

BENEDICT. ARIAS MONTANVS
SACRAE GEOGRAPHIAE TABV
LAM EX ANTIQVISSIMORVM
CVLTOR. FAMILIIS A MOSE
RECENSITIS: AD SACRORVM
LIBROR. EXPLICANDOR. COM
MODITATEM ANTVVERPIAE
IN PHILIPPI REGIS CAT
HOLICI GRATIAM DESCRI
BEBAT. 1571.

צפון
Βορέας
Cyrcius

Ζέφυρος
Fauonius

מזרח
Εὖρος
Subsolanus

תימן
Νότος
Auster

אבימאל	17	Abimael
שבא	18	Seba
אופיר	19	Ophir
חוילה	20	Hauilah
Duo ex filiis IEKTAN gentes		
יובב	21	Iobab
ספר	21	Sephermōs

IAPHETH FIL
גמר i Gom
מגוג ii Ma
מדי iii Ma
יון iiii Iau
תבל v Thu
משך vi Me,

IAPHETH SED
FILIOR GOMER SE
תירש vij Th
Duorum qui o
nomina & se

LOCA a NIMRO

FILIOR

Wind Heads and Compass Roses

Among Columbus's many troubles with his crew, as he sailed into the unknown on his first transatlantic voyage, was the declination of the ships' compasses. Not understanding why the direction of the compass needle should vary – that the earth has a magnetic pole which digresses from true north – the sailors became alarmed when, far from the familiar waters of the Mediterranean and the shores of western Europe, the ships' compasses began behaving erratically when crossing the 'Ocean Sea'; a near mutiny ensued. The magnetic compass had been in use in Europe from about 1300, but its use still carried an air of mystery and superstition. No self-respecting pilot or steersman, for instance, would eat onions or garlic, because noxious odours on the breath were said to destroy the power of the loadstone and the compass needle.

Before acceptance of this mysterious device became universal, mariners had relied on the sun and stars to navigate and on the direction from which winds blew to describe sailing routes. At first the winds had local names, often referring to the weather they brought, and it was some time before generally accepted names were used. Biblical texts refer to only 'four winds from the four quarters of heaven', and Homer also considered four winds (Boreas, Eurus, Notus and Zephyrus) enough. By Roman times a twelve-point wind rose had been developed; it continued in use until the sixteenth century, to be replaced by the sixteen/thirty-two points of direction used today. The winds were renamed several times: Boreas became Septentrio, named for the seven stars of the constellation of the Bear in the northern part of the sky; Notus became Meridies,

the direction of the midday sun; and Oriens and Occidens became Levante and Ponente, after the rising and setting sun. It was the Emperor Charlemagne (*c*.742–814 CE) who adopted the names Nord, Est, Sund and Oëst, with their intermediate points, which are the origin of those we now use.

Given the chance, map-makers and engravers took the opportunity to indulge their creativity and sense of humour when embellishing their maps with wind heads. Gregor Reisch (*c*.1467–1525), for instance, gives his winds strongly defined characters; those by Paolo de Forlani (fl. 1560s and 1570s) look rather bored; on the map included in the polyglot edition of the Bible produced by Benito Arias Montano (1527–1598), the cherubic wind atop the western hemisphere puffs so hard that his eyes cross, while the eastern

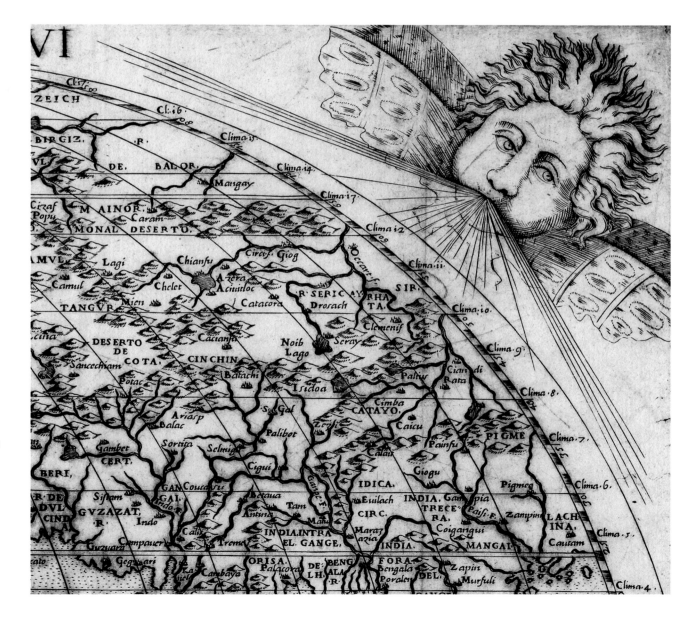

OPPOSITE: Detail from *Pars Orbis*, produced in 1571 by Benito Arias Montano (1527–1598) to show the geographic placement of Noah's sons and their offspring (AMIB 1988.24). The eyes of the wind head above North America are crossed through exertion.

RIGHT: A rather bored wind head from a 1565 world map engraved by Paolo Forlani (fl. 1560s–70s), a prominent map-maker based in Venice (AMIB 1988.104).

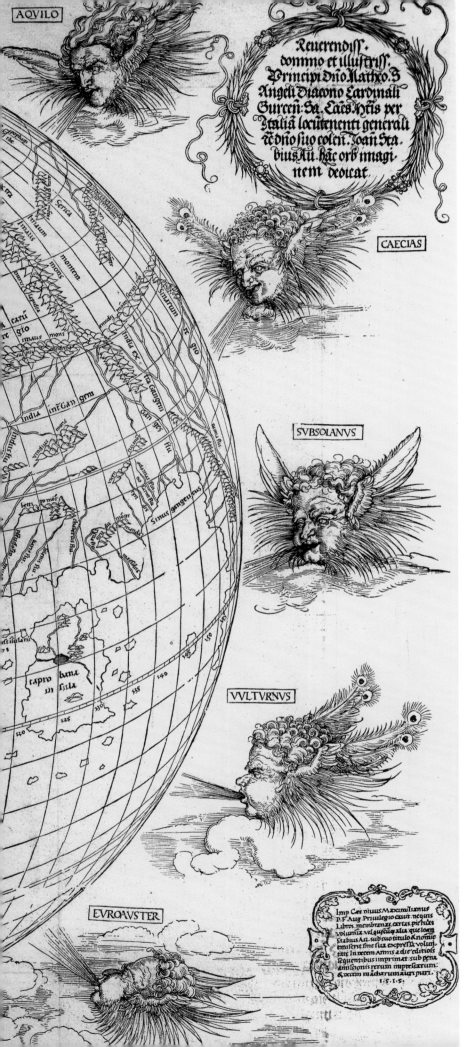

cherub looks askance; and the beauty of the wind heads by Albrecht Dürer (1471–1528) shows the master at his best.

More useful to the mariner, wind roses and the later compass roses provided further opportunities in map decor. The original quartering and further division of wind directions produced an attractive basic design to which embellishment could be added. Traditionally the principal, half and quarter winds were drawn in different colours with sometimes gold or silver additions. After 1500 the *fleur de lys* or 'Prince of Wales feathers' was adopted to designate north and a cross sometimes pointed to the east (to Jerusalem). The beautifully drawn wind rose of the portolan chart (see detail opposite below right) shows the individual letters of six Mediterranean winds: S (Sirocco or south-east); O (Mezzogiorno or south); L (Libeche or southwest); P (Ponente or west); M (Maestro or northwest); and G (Greco or northeast). The black pointer shows the north, or Tramontana, and the east wind is marked with a cross as it blows from the Holy Land.

LEFT: Wind heads adorned with peacock feathers, attributed to Albrecht Dürer. Detail from a 1515 map of the eastern hemisphere (AMIB 1988.93.2).

BELOW: Detail from a 1503 woodcut map of the ancient world by Gregor Reisch (AMIB 1988.89). The wind heads are drawn for humorous effect.

OPPOSITE: Compass roses could be highly embellished (clockwise from above, see pp. 104–5, 26–7 and 120–1).

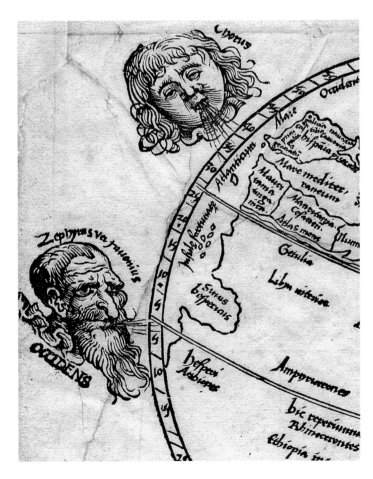

Pasquenoke

Trinety harbor

OCCIDENS

MERDIES

ORIENS

SEPTENTRIO

C.Frio

J. de

Baixos dos Castellanos

st Argenteus fluuius qui ab incolis
Parana vocatur.

25

30

35

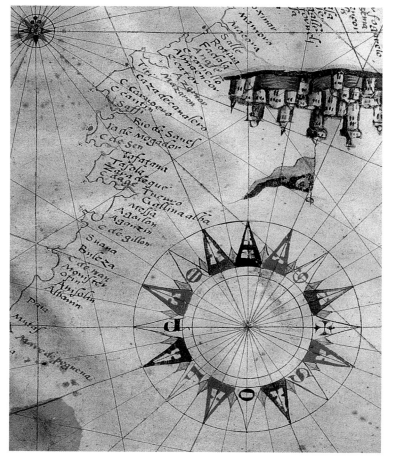

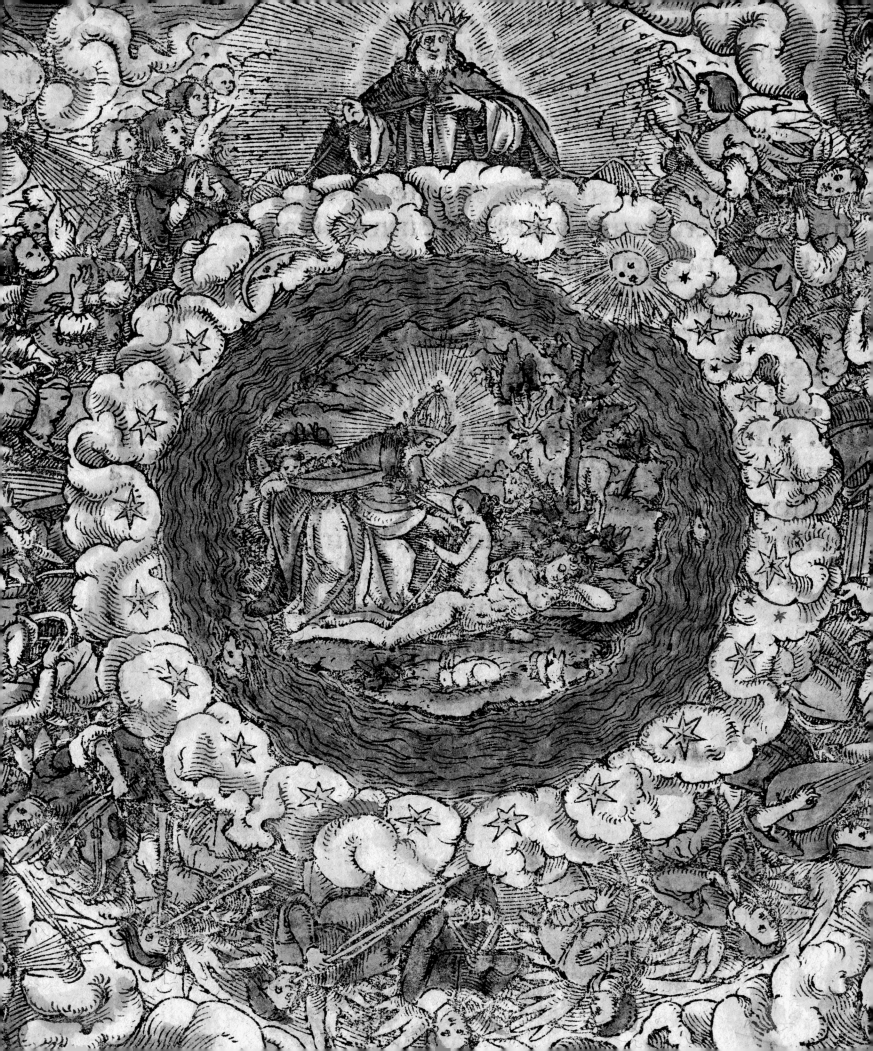

Map of the Universe from *Margarita Philosophica* (Pearl of Wisdom)

Gregor Reisch (*c.*1467–1525), **cartographer**
Basel, 1583
Woodcut
Sheet 203 × 183 mm; plate 141 × 145 mm
AMIB 1988.199

I f ever there was a student 'crib' for the
aspiring Renaissance scholar, Gregor Reisch's
compilation *Margarita Philosophica* – a
compendium of contemporary knowledge –
served the purpose. First published in 1503, the
text is written as a dialogue between a student
asking questions and a teacher giving answers.
It is divided into twelve chapters: grammar, logic
and rhetoric (the *trivium*); music, arithmetic,
geometry and astronomy (the *quadrivium*);

natural philosophy, the origin of natural objects,
animal sensation and intellect, and moral
philosophy.

A friend of Erasmus and foe of Lutheranism,
Reisch was noted for his geniality as well as scholar-
ship. The mini-encyclopaedia with its concise and
accurate style was illustrated by various woodcuts,
including anatomical drawings, depictions of
Limbo, the Ptolemaic system, an alchemist at work,
creatures of the sea and different types of fire.

Reisch was abbot of the Carthusian monastery
in Freiburg and confessor to the Holy Roman
Emperor Maximilian I (1459–1519). Reisch's
humanist view of the Universe places man (and
woman) firmly in the centre of things, where the
Creator is raising Eve from the side of a sleeping

Adam. Animals browse in the surrounding
Garden of Eden. Then the ocean with fish is
pictured, encircled by a cloudy, starry sky with
the sun and moon above. An orchestra of angels
follows, while God presides in a sunburst at top,
and – in the corners – the four winds represent
the *primum mobile*, or Prime Mover, in a geo-
centric model of the Universe. The concept of the
Prime Mover had been put forward by the Greek
philosopher Aristotle (newly rediscovered in
medieval Europe) and was reinterpreted by later
readers. The outermost sphere (Heaven) was thus
rotated by the God of Christian theology, the
Prime Mover, prompting the concentric universal
spheres within to rotate in unison.

Page from *Sphaera* (Sphere)

**Johannes de Sacrobosco, also known as John
of Holywood (*c.*1195–*c.*1256), author**
Venice, 1537
Woodcut
Page 198 × 137 mm
AMIB 1988.83

A suggestion that would provoke a patient
sigh from Dallas Pratt was that 'everyone' in
medieval times believed that the earth was flat;
only a couple of churchmen, he would explain,
seriously believed in a flat earth, and there were
plenty of scholarly texts that proved otherwise.
From Aristotle, Ptolemy's *Almagest* and other
classical texts preserved by the Arabs, European
scholars attempted an explanation of the working
of the cosmos that, although geocentric, had
some mathematical and scientific basis. Like his
predecessors, the author of *De sphaera mundi* (as
it was called in the first, Latin version) adhered
to the Ptolemaic system of heavenly bodies
revolving in orbit around the earth in the
following order: the moon, Mercury, Venus, the
sun, Mars, Jupiter, Saturn, the fixed stars and, at
the outer limit of the cosmos, the Prime Mover.

Sacrobosco is the name given to a scholar
whose translated name, John of Holywood,
suggests that he came from somewhere in the
British Isles; England, Scotland and Ireland have
laid claim to him and to his reputation for being
the author of one of the most important texts
studied in medieval and Renaissance universities.
It is known that he arrived in Paris in 1221,
where he taught mathematics at the university,
introducing Arabic numerals and methods of
calculation there. He was described as a
computist, an adept at calculating the date of
Easter. He had issues with the Julian calendar,
pointing out that it was delayed by ten days, but
hesitated to suggest changes, leaving that problem
to his superiors in the Church.

The Sacrobosco book once owned by Dallas
Pratt and now in the American Museum's
collection – the first Italian version and one of the
many manuscript and later printed copies to be
perused by diligent students – has several fine
illustrations, including the one of a geographer
(supposedly the author himself) at work. He rests
his text on a globe showing Europe, Africa and
'Ametrica'. Two caravels sail in the background,
while studies of scientific instruments – such as
dividers, a quadrant and a compass (the first
depiction in print) – create a pictorial border to
frame the central image.

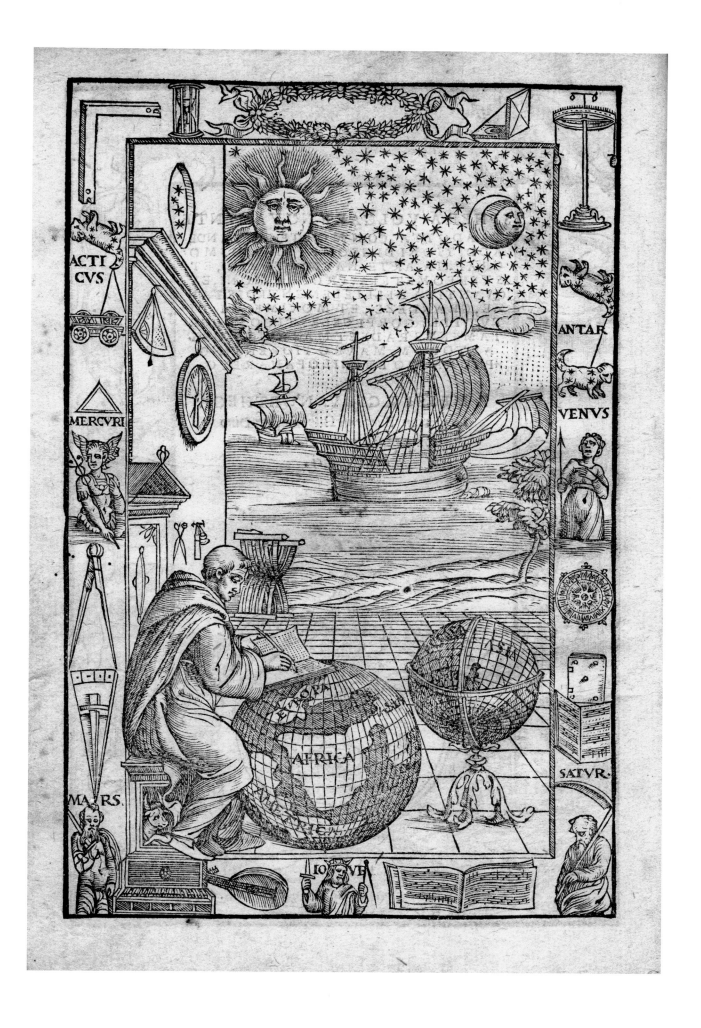

51

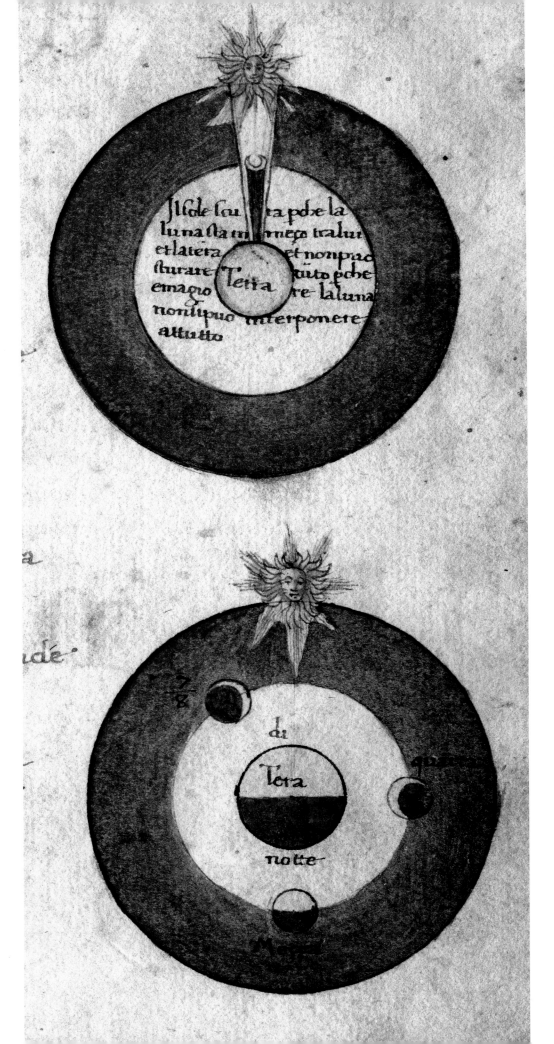

Illustrations from *La Sfera* (The Sphere)

Gregorio Dati (1362–1436), author
Florence, 15th century
Hand-coloured manuscript on paper
Page 280 × 200 mm
AMIB 1988.70

Florentine merchant and diarist Gregorio Dati wrote his highly popular 1,152-line poem *La Sfera* as a textbook for children of the merchant class. In eight-lined rhyming verse, it was the first geographic primer to be written in the vernacular, unlike the more serious *Sphaera* (see pp. 50–1) of Johannes de Sacrobosco (*c*.1195–*c*.1256), on which it is based. Sacrobosco's work was intended for university students and written in Latin; Dati's simplified description of the cosmos is divided into four parts, the second of which is devoted to astronomical phenomena. Explanatory diagrams (such as the pair illustrated here, which depict the eclipse of the moon and its phases) have the earth at the centre of the cosmos, but it is shown as definitely spherical.

Florence derived its wealth from the manufacture of luxury goods, importing raw materials (such as silk) and exporting finished goods abroad as far as England and Flanders. With powerful cities like Venice and Milan as trading rivals, it was important for young Florentines to be educated in cosmography, geography and history; hence Dati's book is illustrated with diagrams of the cosmos, pictorial maps of the Mediterranean coastline and water-colour pictures of Troy in flames and the Tower of Babel. The survival of existing copies is probably due to their lavish illustrations. Plainer manuscripts intended for school-room use would have been treated with less reverence.

LEFT: Gregorio Dati's poem *La Sfera* was written as a general primer for the children of wealthy Florentine merchants to help them learn more about cosmography, geography and history. This manuscript of Dati's text features many colourful illustrations. The phases of the lunar eclipse are illustrated here.

OPPOSITE: To entrance his young readers further, Dati's elegantly penned book is embellished with delicate drawings of the Tower of Babel (top) and Troy in flames (below), as well as diagrams of the cosmos and the Mediterranean coastline.

TURE BABEL

O Allaltra parte persia parche chessia
illito diquelmare dimeço di
et daquel ponente uerso laturchia
ellagran terra et richa deltauri
dalla qual adomasco et tantauia
quanta datrebasonda fino alli
chesson dauenti giorni Nelsodima
Sauallo Ancona firenze ladima

P Oi son montagnie chepergran paese
stendon lebarna et sondigrandaltura
famose inscbritture et poco intese
chedisaper lagiente apoco cura
onde ecoro igranturmi oue suprese
antcha mente perla giente pura
essere ilparadiso de deliça
perche laterra dimolta diuina

O Ltutti gluelementi soma mente
et dogni cosa molto ben dotata
intorno dogni parte parimente
dimolte buone terre circbundantea
et disopra datutte sta eminente
chettuttol mondo dintorno seguata
dico chessi potesse in maginare
questo paese soleua abondare

O Vesta montagnia et tanta grande etale
cheuede lociteano alloriente
elmar cbauldeo e dindia ad australe
et uede queldisiria adoccidente
et quel ditrabesonda ad maestrale
et quel dipersia cheglie piu rasente
et uede tutta assira ella cbaldea
et alalocho terra disabea

U Ede oue fu lanticha et gran attade
dininue sul tigris chessu prima
dona dimpero dimolte contrade
poco piu otra doue ilsume adima
sta ota lacbaldea et piu ladoue cbade
in mare ilsume uede lalta cima
della grantorre chenebotte fe
dopo eldiluuio dellarcha dinoe

I Llito delmar dindia aman sinestra
iuenendo ingiu diuerso loriente
collito dellegitto daman destra
sono munfilo dritto ogualimente
presso aquello su lagran palestra
desuperbi giganti onde lagiente
tanta linchuaggi parla esono uede
ancor ladetta torre eritta impiede

TROIA

tenedo

metilino

sco

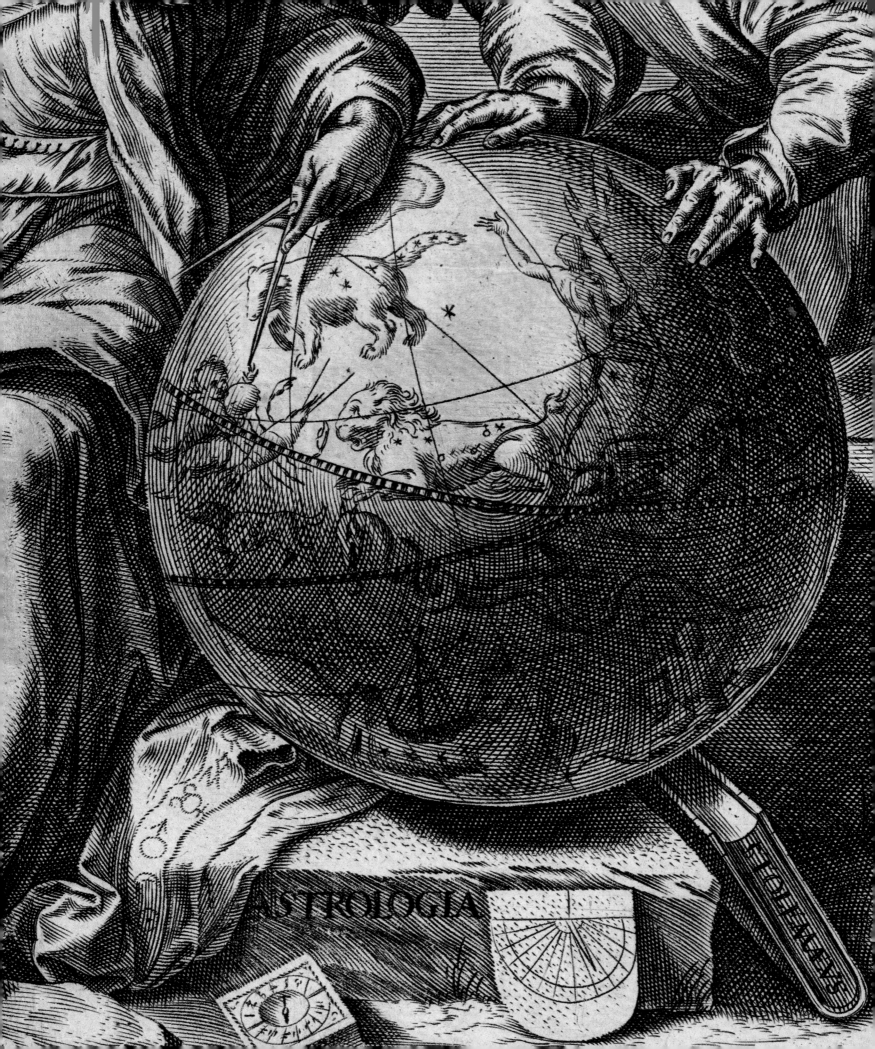

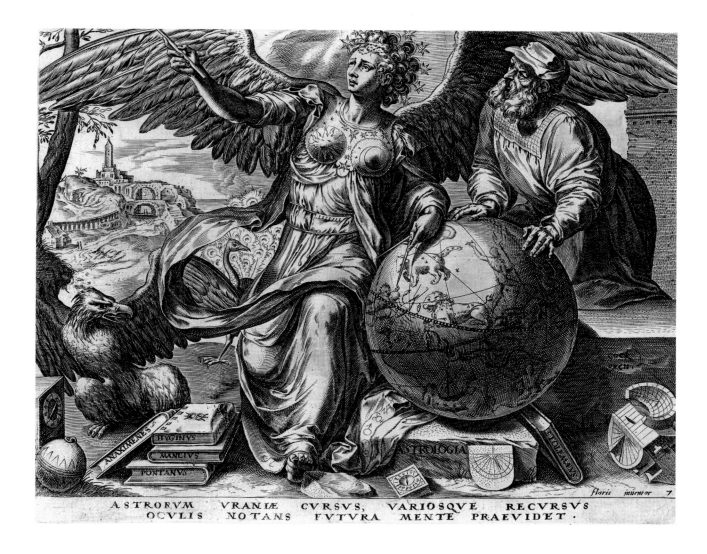

ASTRORVM VRANIÆ CVRSVS, VARIOSQVE RECVRSVS
OCVLIS NOTANS FVTVRA MENTE PRAEVIDET ·

Allegory of Astronomy

**Cornelius Cort (*c.*1533–1578), illustrator
and engraver, after Frans Floris (1517–1570)
Antwerp, *c.*1565
Copperplate engraving
Sheet (trimmed) 226 × 285 mm
AMIB 1988.133**

Born in Antwerp, Frans Floris studied art in Rome, where he saw Michelangelo's works in the Sistine Chapel; admiring their boldness and monumentality, he later incorporated them into his own productions. The celebrated Dutch engraver Cornelis Cort likewise spent much of his working life in Italy. In this engraving – part of a set illustrating The Seven Liberal Arts – Astronomy appears in the guise of a winged goddess and is accompanied by an attentive navigator. She is crowned with stars, while her breasts are adorned with the sun and the moon. She is pictured measuring a celestial globe, which is marked with signs of the Zodiac and constellations, as well as

the equator and the ecliptic (the sun's path across the sky).

The Latin words at the base of Floris's engraving state: 'Urania [the muse of Astronomy], by knowing the courses of the stars with her eyes, predicts the future with her mind.' This illustrates the age-old propensity to confuse the respectable, scientific pursuit of astronomy with the pseudo-science of astrology. The astrologer-priests of the Babylonians divided the sky into twelve parts through which the sun and planets passed and assigned to them various deities. This system, known to us as the Zodiac, passed through Persian, Greek and Arab civilisations to appear on the star charts of Renaissance Europe. Offshoots (such as horoscopes and 'birth signs') are today part of our popular culture.

In 1543 Nicholas Copernicus – on his deathbed, it is said – received into his hands a copy of his newly printed *De revolutionibus orbium coelestium* (On the Revolutions of the Heavenly Spheres).

Copernicus had hesitated to publish his findings because he had not wished to incur violent opposition to his 'novel and incomprehensible thesis' that the movements of heavenly bodies could be better explained by placing the sun at the centre of the solar system, rather than the earth. After 1543, with confirmation from astronomers such as Galileo Galilei and Johannes Kepler, the heliocentric model of the solar system became generally accepted. Astrology thus lost credibility as a science. In his *The Advancement of Learning* (1605), the English empirical philosopher Francis Bacon attempted to reconcile old and new beliefs: 'there is no fatal necessity in the stars; but that they rather incline than compel.'

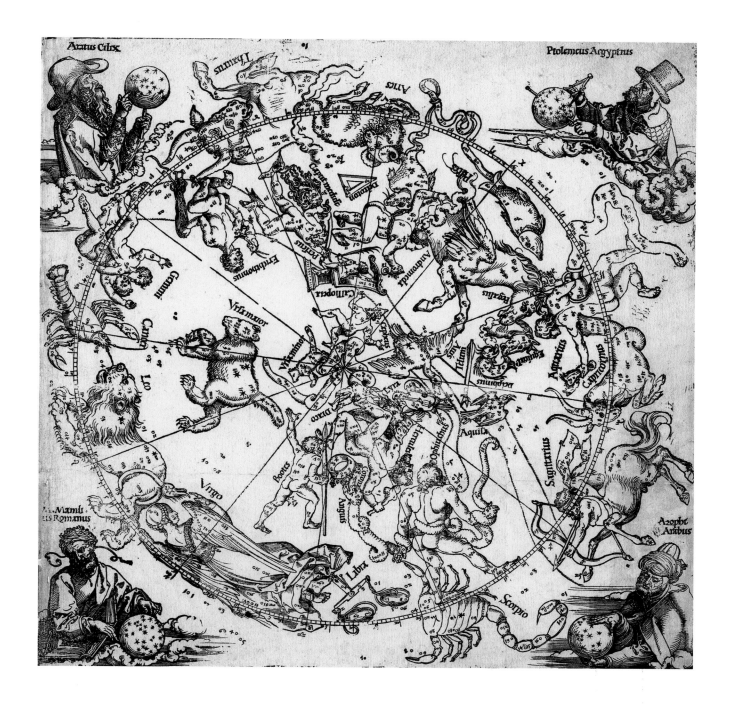

Imagines coeli Septentrionales cum duodecim imaginibus zodiaci (The Constellations of the Northern Sky with the Twelve Signs of the Zodiac)

Albrecht Dürer (1471–1528), illustrator
Nuremberg, *c.*1515
Woodcut
Sheet (trimmed) 424 × 425 mm
AMIB 1988.182

Cut from a wooden block rather than engraved on a metal plate, Dürer's detailed star chart of the northern sky is one of a pair, the other being of the southern hemisphere. Together they are the first printed celestial maps, although information on the location and magnitude of the stars depicted is taken from the four earlier astronomers illustrated in the corners: Aratus the Cilician, Ptolemy the Egyptian, Azophi the Arab and M. Manilius the Roman.

Following classical tradition, the constellations are positioned as if seen from above. This means that they are seen mainly in rear view as they proceed anti-clockwise around the ecliptic (the path of the sun across the sky). The heroic figures of Boötes, Hercules, Ophiuchus the Serpent-holder and Perseus, with the head of the Gorgon, crowd together in the centre. Andromeda is dressed in only her chains. The Milky Way stretches from Sagittarius at lower right to Gemini at upper left.

The beauty of this exceptional star chart and the fact that the mythological figures are portrayed with their correct attributes prompted subsequent map- and globe-makers to follow Dürer's bold pictorial style with its attention to scholarly detail.

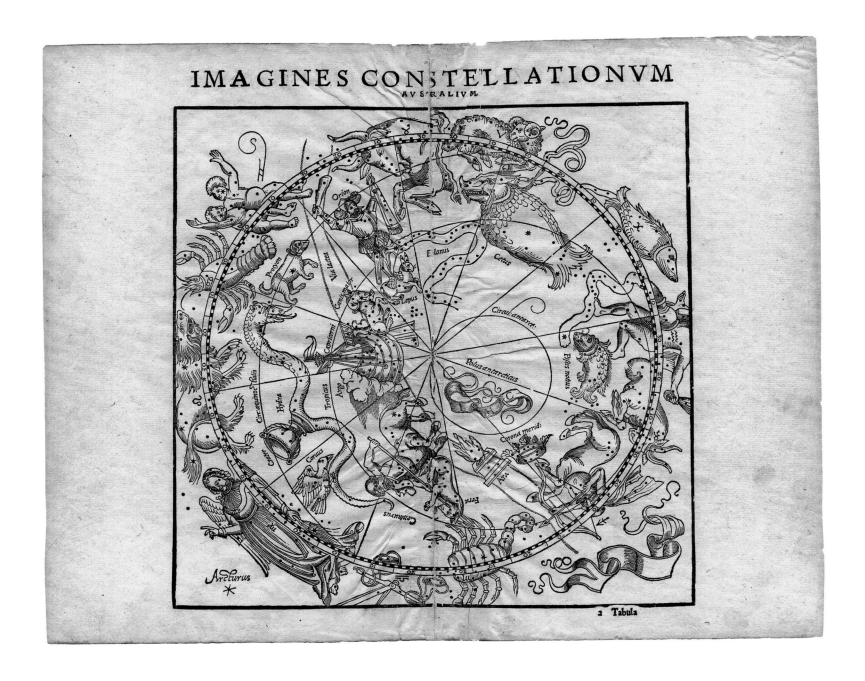

Imagines Constellationum Australium (Southern Celestial Planisphere)

Jan Coronensis Honter (1498–1549),
celestial cartographer
Basel, 1532
Woodcut
Sheet 324 × 403 mm; plate 271 × 270 mm
AMIB 1988.143.2

Transylvanian Saxon humanist and theologian Jan Coronensis Honter used woodblocks to create his paired star maps, as did Albrecht Dürer before him. Honter's lively depiction of the southern hemisphere is illustrated here and was bound (with its partner) in a 1541 publication produced in Basel of the first collected works by

Ptolemy, *Omnia, quae extant, opera, Geographia excepta* (All the Extant Works, excepting *Geographia*). Unlike Dürer, Honter shied away from portraying the constellations in a state of undress; in Honter's star charts they are expensively attired in modish European fashion with slashed doublets, hose and flamboyant hats. In another departure from Dürer, the constellations are here positioned as if seen from earth, with the zodiacal figures proceeding clockwise around the ecliptic and in front view. Honter's charts are the first printed star maps to use this method.

The more southerly constellations, some of which were known to the ancients, are shown:

Cetus (the Whale), the Southern Crown, the ship *Argo*, the Centaur and Hydra, surmounted on this map by the Crater and Corvus (the Raven). Orion wields a club and animal skin, but is fashionably dressed, while under him is Lepus (the Hare) and a pyramid of six dots to indicate the Large Magellanic Cloud (a nearby galaxy first recorded in 964 CE by the Persian astronomer Abd al-Rahman al-Sufi, known in Renaissance Europe as 'Azophi the Arab'). The Milky Way extends from Orion to Aquarius, with a break in the unexplored south polar region.

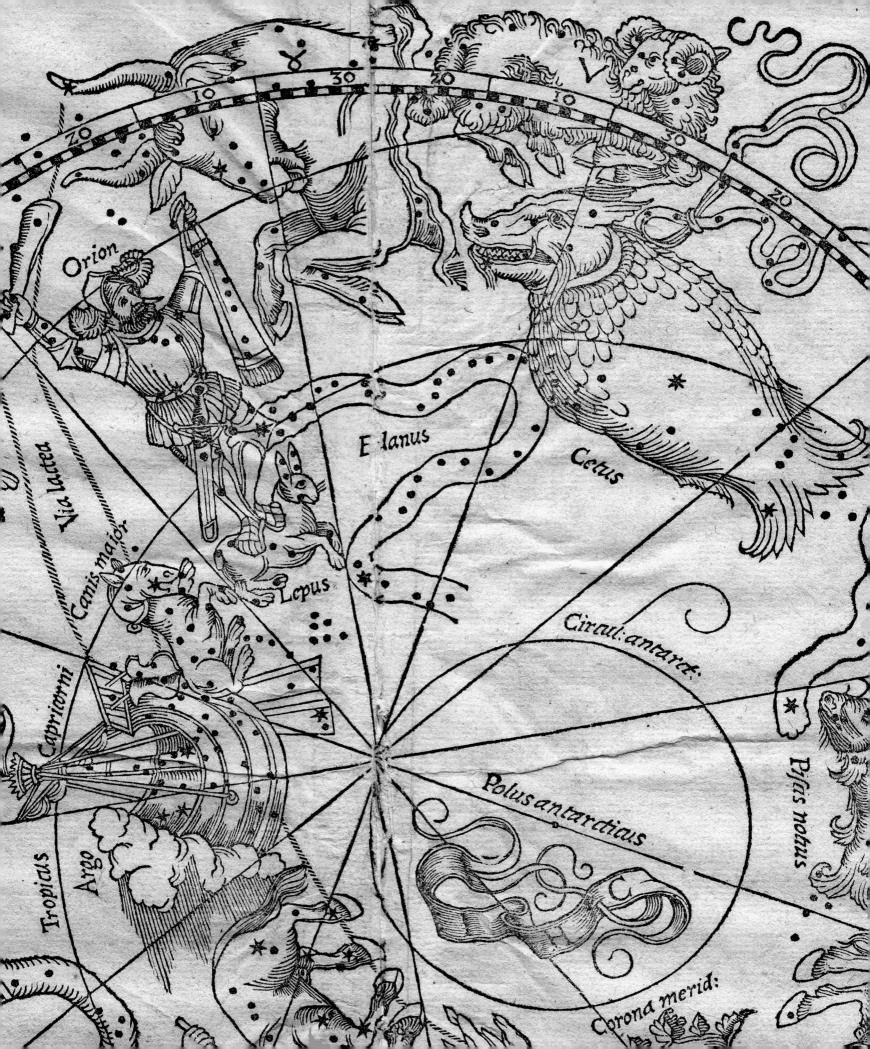

Orion

Via lactea

Canis maior

Lepus

E lanus

Cetus

Capricorni

Circul. antart.

Pisis notus

Tropicus

Argo

Polus antarcticus

Corona merid:

Astrolabium. Americus Vespuccius cum quattuor Stellis…
(Astrolabe. Amerigo Vespucci with Four Stars…)

Stradanus, also known as Jan van der Straet
(1523–1605), illustrator
Antwerp, 1600
Copperplate engraving
Sheet (trimmed) 204 × 279 mm
AMIB 1988.128

The name 'America' is derived from the feminised Latin first name of the Florentine explorer and cartographer Amerigo Vespucci. It was Vespucci who demonstrated that Brazil and the West Indies were not, as had been claimed by Columbus, part of Asia, but parts of another continent previously unknown in Europe.

In a letter he wrote to fellow countryman, and *de facto* ruler of the Florentine Republic, Lorenzo de Medici, Vespucci described an incident off the coast of Brazil during his voyage to the New World in 1499. Vespucci's ship had crossed the equator, and he had lost sight of the Pole Star. Staying awake all night with sleeping sailors beside him, Vespucci examined the heavens, taking readings with his quadrant and astrolabe; he could not find the Pole Star but observed new constellations. In doing this, Vespucci was put in mind of verses from Dante's *Purgatorio*, in which Purgatory is located on a mountain in the southern hemisphere. These verses are printed in Italian and Latin at the side of this engraving, along with a picture of the celebrated Florentine poet and republican. Dante pities northerners who will never see southern star patterns such as the constellation of the Southern Cross, depicted here as a Maltese Cross.

This illustration of Vespucci measuring latitude, using the Southern Cross as his point of reference, is popularly thought to be the first recorded illustration of the use of an astrolabe. The Bruges-born Mannerist artist Stradanus, who studied in Italy and worked with Vasari and the Medicis, has drawn a planispheric astrolabe as a spherical object akin to an armillary sphere. Although early examples date from the thirteenth century, mariner's astrolabes (with a distinctive pierced circular frame construction) became more widely used only from the middle of the sixteenth century – long after Columbus and Vespucci had lost sight of the safety of the shore-line to venture across the vastness of the ocean.

Ophiuchus the Serpent-holder from *Uranometria*

Johann Bayer (1572–1625), uranographer (celestial cartographer)
Augsburg, 1603
Hand-coloured copperplate engraving
Sheet 369 × 462 mm; plate 345 × 435 mm
AMIB 1994.6.2

When the ancient Greeks wished to honour Asklepios, their god of healing, they placed him in the sky with his serpent-entwined staff as a constellation known as 'Ophiuchus the Serpent-holder'. This is one of the forty-eight constellations known to Ptolemy. It is included in Johann Bayer's *Uranometria*, an atlas of star charts based on the Danish astronomer Tycho Brahe's listing of 1,005 stars; additions from other sources bring the total to over 1,200. *Uranometria* contains fifty-one star charts, including recently discovered constellations from the southern skies. It also corrects observations made by earlier explorers, such as Amerigo Vespucci.

Bayer is known for his system of designating the order of magnitude of stars, which continues to be used: the stars were named by Greek letter in order of importance (alpha, beta, gamma, etc.) followed by the genitive of the Latin name of the constellation. Thus we have 'Alpha Centauri' or, on this chart, 'Alpha Ophiuchi' on the figure's head.

Since the discoveries made by Galileo Galilei (1564–1642) with his telescopes did not yet figure prominently in the astronomical world, it was difficult to estimate the brightness of stars with the naked eye. Bayer's measurements were therefore undertaken, somewhat arbitrarily, by listing the stars in order of their rising in the east, or by counting from the head to foot of the human figure of the constellation.

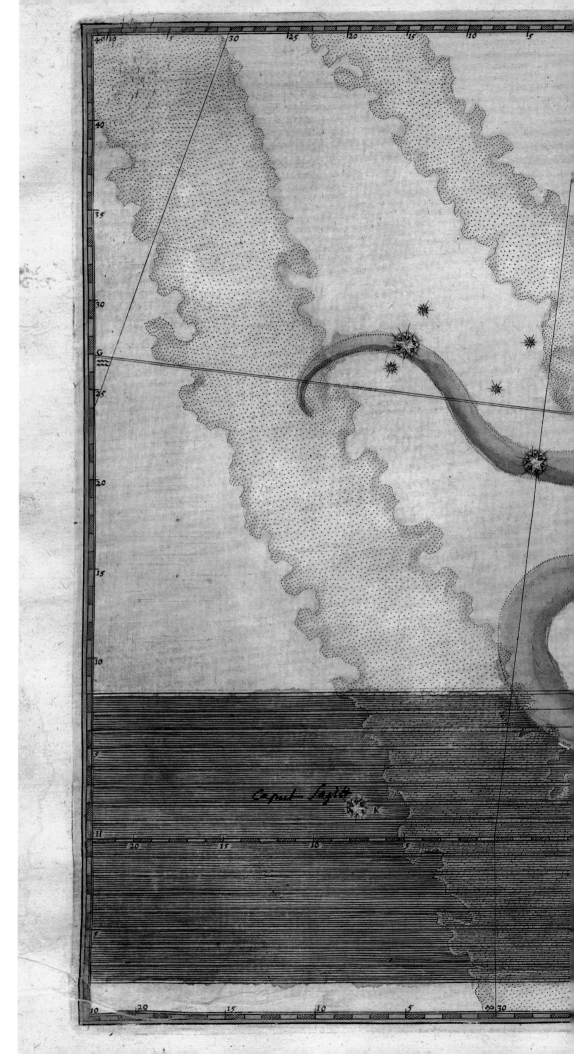

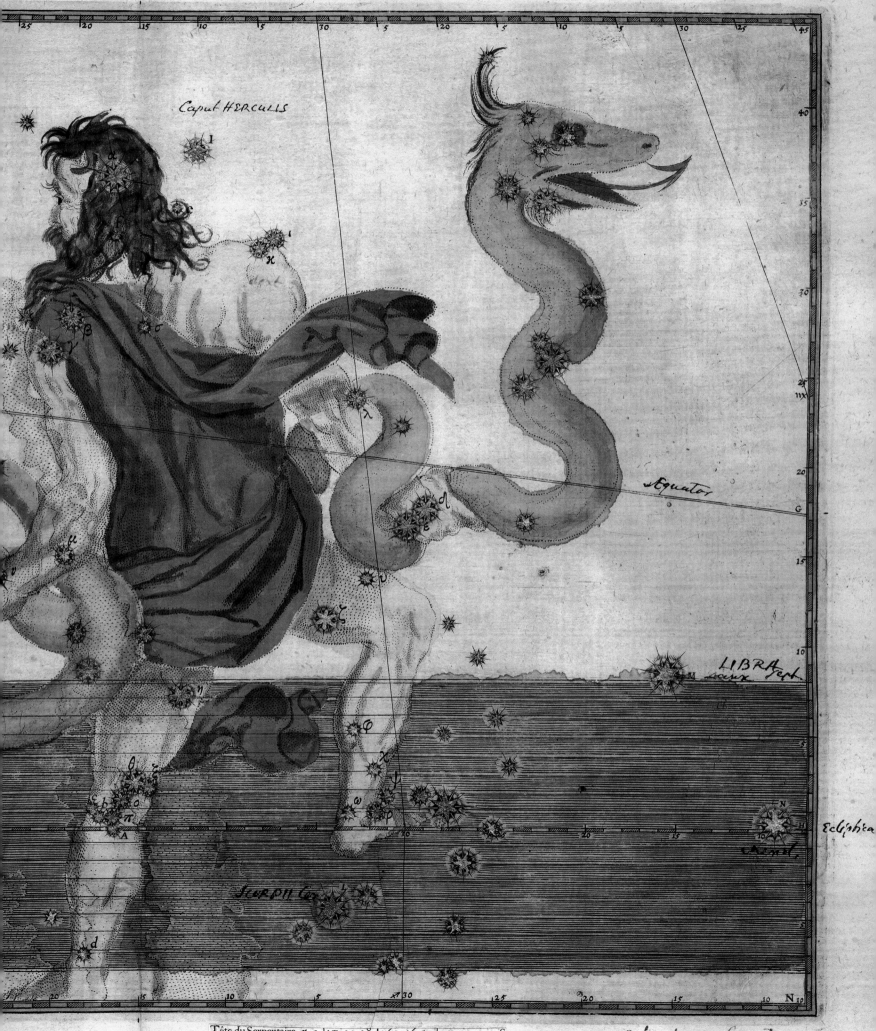

Caput HERCULIS

Æquator

LIBRA

Eclyptica

SCORPIO

Tête du Serpentaire. α 2.|17.20.18.|260.46.50.|12.45.42. S.

Ophiuchus e. Serpente.

obseruare volueris. Voluello itaque inuariato manente, verte aut cir-
cumuolue paruam rotulam horarum, donec cacumen indicis horæ me-
ridianæ adamussim istius oppidi situm respiciat, & alhidada cũ sua li-
nea fiduciæ ostendit in parua rotula horam istius regionis aut oppidi à
meridie vel à media nocte computatam, quod fuit optatum.

Finis primæ Partis Libri Cosmographici.

MEDIA NOX.

OCCIDENS. ORIENS.

MERIDIES.

H iiij

Illustrations from *Cosmographia*

Gemma Frisius (1508–1555), author,
after Peter Apian (1495–1552)
Paris, 1551
Woodcut
Page 237 × 156 mm
AMIB 1988.52.1

Born Reiner Gemma in Dokkum, Friesland, Frisius took his last name from his native province in the northern Netherlands. After a difficult start in life as an orphan with crippled legs, which were later cured by an apparent miracle, he went on to become professor of mathematics and medicine at the University of Louvain. In 1529 he published a corrected version of Peter Apian's *Cosmographia* – an introduction to subjects such as astronomy, geography, surveying, navigation and the use of scientific instruments. Gemma's improved version had a long and useful life, going through thirty-three editions in five languages. Also known as a maker of scientific instruments and globes, Gemma numbered Mercator among his assistants.

Gemma's main contribution to cartography is the information he set out (in a booklet distributed with his globes) on how to determine the longitude of a place. This was done by travelling a certain distance (having noted the time at departure) and then 'tarry[ing] until the point or style of the clock do exactly come to the point of some hour: and at the same moment… ought we to seek the hour of the place where we be… And so shall the longitude be found.' This process, of course, was not easily accomplished – especially at sea – until the invention of accurate time pieces in the eighteenth century. Another of his great contributions to cartography was included in a 1533 enlarged edition of *Cosmographia*: a description of trigonometric surveying, which resulted in the whole of the Netherlands being accurately mapped within a few years, and is still used in map-making today.

The two pages illustrated here (first printed in 1544) are from the 1551 edition of *Cosmographia*. The volvelle (opposite) has moving parts and, although made of paper, is rather like an astrolabe or a wheel chart. At the base is a planispheric projection of the earth, on which turns a circle following the annual path of the sun; signs of the zodiac appear on the inner side of the circle. Two moving pointers help to show the relationship between geographical location, local time and date. The other illustration (right) demonstrates the use of an astronomical instrument to locate north. This was done by taking sightings of the 'pointers' and the 'guards' of the Great Bear and Little Bear constellations, which revolve around the Pole Star.

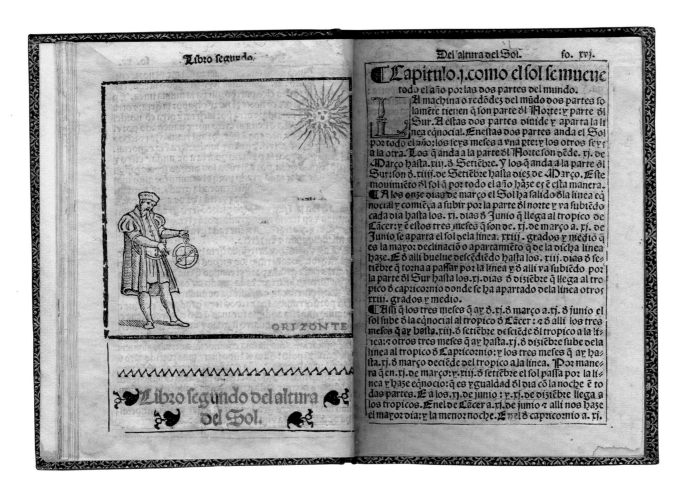

ABOVE LEFT: Using a mariner's astrolabe, the well-dressed pilot of a ship measures the altitude of the sun.

LEFT: The influence of the phases of the moon on the ebb and flow of Atlantic tides is explained in this landmark book on navigation.

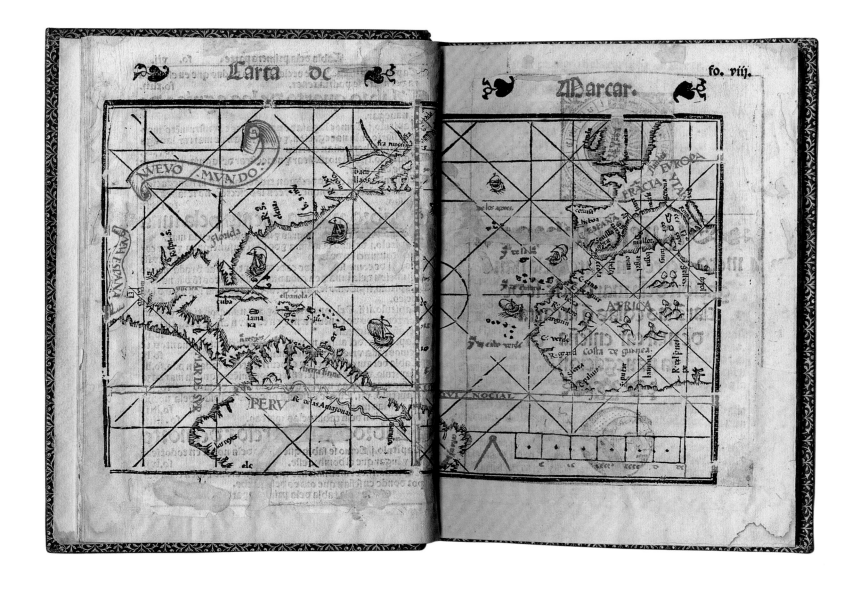

Nuevo Mundo (New World) from *Regimiento de Navegación* (Rules of Navigation)

Pedro de Medina (1493–1567), author
Seville, 1563
Woodcut
Page 197 × 137 mm
AMIB 1988.54

Having sailed with Hernando Cortés to the New World, Pedro de Medina, cleric and librarian to the Duke of Medina-Sidonia, was charged by the Holy Roman Emperor Charles V to prepare charts and navigational aids for would-be pilots and voyagers who planned to venture westwards. Pedro de Medina also debriefed mariners on their return. For this work, he was awarded the title *cosmografo de honor* in 1549. His first handbook on navigation, *L'Arte de Navigar* (published in 1545), became a seminal work on navigation and was translated into several languages. Francis Drake is said to have possessed a copy in French. The *Regimiento* (first published in 1552) contains the same map of the New World but is more specific in purpose, supplanting the *Arte* for Spanish pilots. Both books are extremely rare.

This map is striking for its correct delineation of the isthmus of Panama and the peninsula of Yucatan. Even more interesting is the inclusion of the Papal Line of Demarcation. This was established by the Treaty of Tordesillas, promoted by Pope Alexander VI in several bulls and eventually signed in 1494. The line, which divided New World spheres of influence between Spain (westwards) and Portugal (eastwards), was placed at 100 leagues west of the Azores or the Cape Verde islands. Since a reliable means of establishing longitude had not yet been discovered, however, it was not strictly adhered to. Ships, presumably Spanish, are shown making the voyage southwest by the trade winds and then following a route northeast with the help of the Gulf Stream.

Regimiento contains chapters on finding the altitude of heavenly bodies such as the sun, the moon and the Pole Star in order to ascertain latitude for sailing; a ship's pilot is illustrated measuring the altitude of the sun by means of a mariner's astrolabe. As seafarers gradually became more adventurous and left the Mediterranean for the shores of the Atlantic, they were confronted with higher tides; a chapter in the handbook gives an explanation of the influence of the moon on their ebb and flow. The printing in red and black is rare, as the pages had to be accurately passed through the press twice – not an easy undertaking.

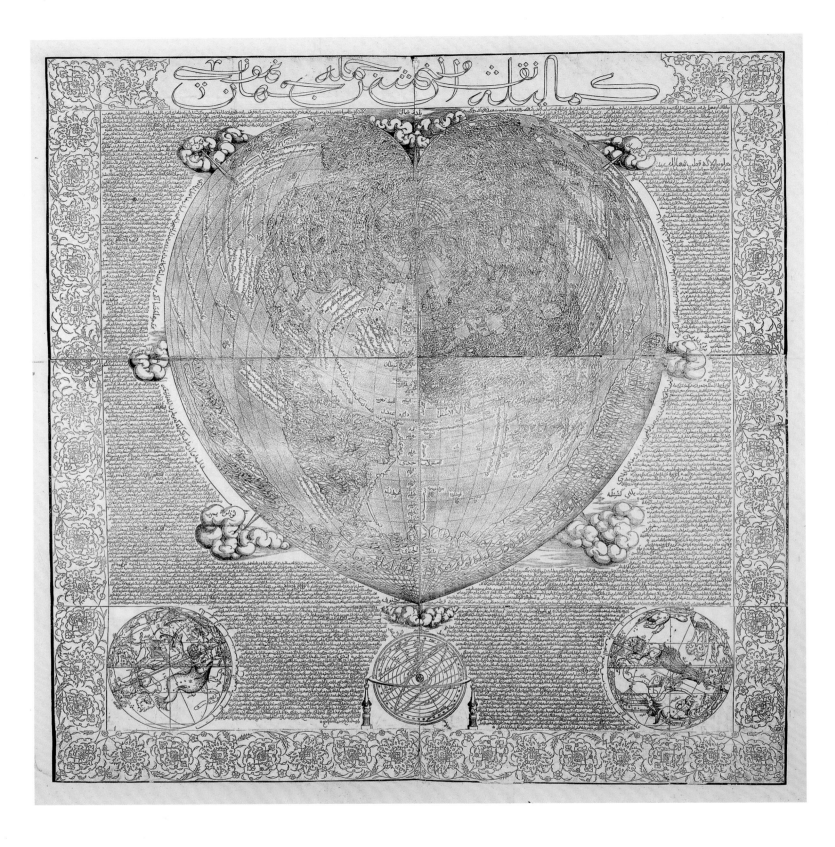

Two Heart-shaped Maps

During the sixteenth century, cartographers of a mathematical inclination applied their knowledge and ingenuity to the task of representing a spherical earth on a flat surface. As the world known to Europeans increased in size, so did the variety of the shapes they chose to enclose it. From Ptolemy's conical projection came fan-shaped maps of the world, but circles, double hemispheres, gores, ovals and rectangles were also used. Heart-shaped (cordiform) maps were among the most attractive of these.

RIGHT: Forbidden by custom to depict living things, Islamic artists reworked European visual motifs. The wind head illustrated here is thus shown as a mass of clouds, rather than as a cherub.

BELOW: Illustration of an armillary sphere – an early astronomical device made of fixed and movable rings.

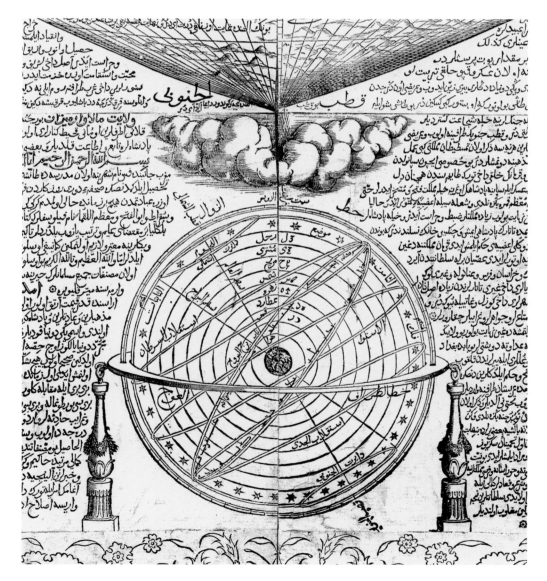

World Map
Hajji Ahmed (16th century), cartographer
Venice, map 1559–60; print 1795
Wood engraving
Joined sheets 1123 × 1095 mm
AMIB 1988.103

The so-called Hajji Ahmed World Map printed with Turkish text was considered by Dallas Pratt to be the pride of his collection. As such, Pratt hung the large framed map in the canopy of his four-poster bed. There is much speculation about the map's genesis. It has been suggested that the map's author was a Tunisian enslaved by Venetians, who bought his freedom by engraving the map on six blocks of pear wood. It has also been argued that the map was prepared for the Ottoman market, since the text is in Turkish. When relations between the Venetian Republic and the Ottomans worsened, the wooden blocks – being of potential benefits to the Turks – were sequestered in the Doge's secret archives. They were rediscovered in 1795, and twenty-four copies were then printed; only about nine or ten of these are thought to have survived.

The Hajji Ahmed World Map impresses not only for its rarity but for its size. The cartography is based (with some additions) on a cordiform woodcut map of 1534 created by the French cartographer and mathematician Oronce Finé for the French king, François I. The imposing Arabic script above the map opens with the words 'Whoever wishes to know the true shape of the world, their minds shall be filled with light and their breast with beauty.' The text summarises the geographical knowledge of the time; for instance,

69

Peru is described as a rich kingdom, and Mexico as being abundant in gold and silver. Matters of navigation and commerce are discussed, and locations of trading destinations, such as Malacca, are noted. The borders are embellished with floral arabesques, while below are an armillary sphere and two celestial charts. All these elements add to the impression of great artistry on the part of the engraver, whoever he may have been.

RIGHT: Celestial chart illustrating stars of the southern skies.

BELOW: Celestial chart of the northern hemisphere.

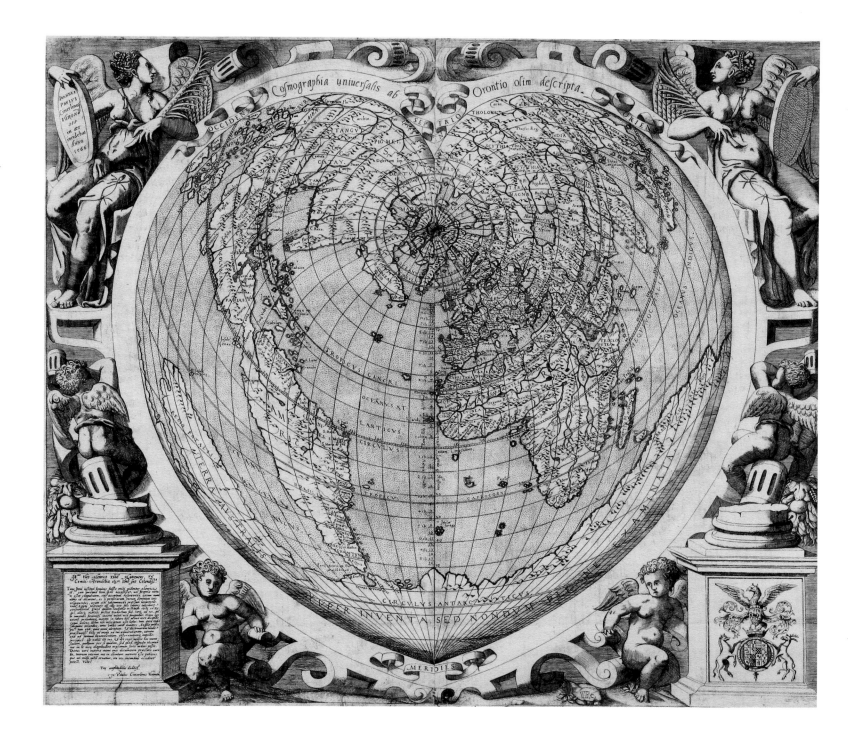

World Map
Oronce Finé, also known as Orontius Finaeus
(1494–1555), cartographer; Giovanni Cimerlino
(c.1534–c.1609), illustrator and engraver
Venice, 1566
Copperplate engraving
Sheet (trimmed) 524 × 591 mm
AMIB 1988.105

In 1566 Henry FitzAlan, 19th Earl of Arundel, was in Venice. A survivor of the vicissitudes of the Tudor succession, he was a powerful figure at the Court of Queen Mary, and no doubt this is

why, as a highly placed visitor to Venice, he was able to sponsor this superbly engraved map. A lengthy dedication in praise of the Earl appears as an engraved inscription on a plinth in the lower-left spandrel; FitzAlan's coat of arms decorates a corresponding plinth on the right.

The engraver of the map and its Renaissance borders was Giovanni Cimerlino of Verona (who also penned the dedication to FitzAlan). Unusually for maps published in Venice, acknowledgement of the map's source is given. The inscription above the map states that it had formerly been drawn (*olim descripta*) by Oronce Finé. There are

fewer changes from the French cartographer's cordiform of 1534 than in the slightly earlier Hajji Ahmed Map. The geographical features of the map are fairly conventional for the period: Asia and North America are joined; South America is named simply 'America'; and Australia and Antarctica (as yet undiscovered, except for Tierra del Fuego) are joined in a huge landmass labelled 'recently discovered but not yet explored'.

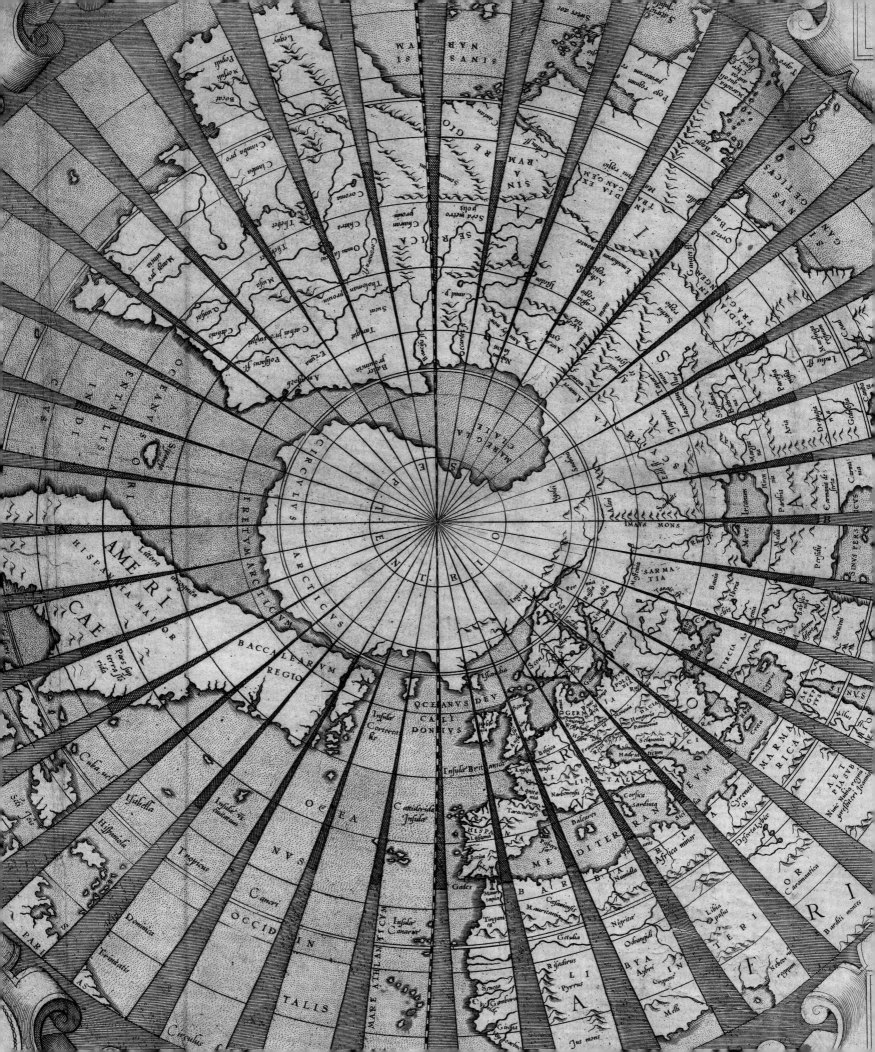

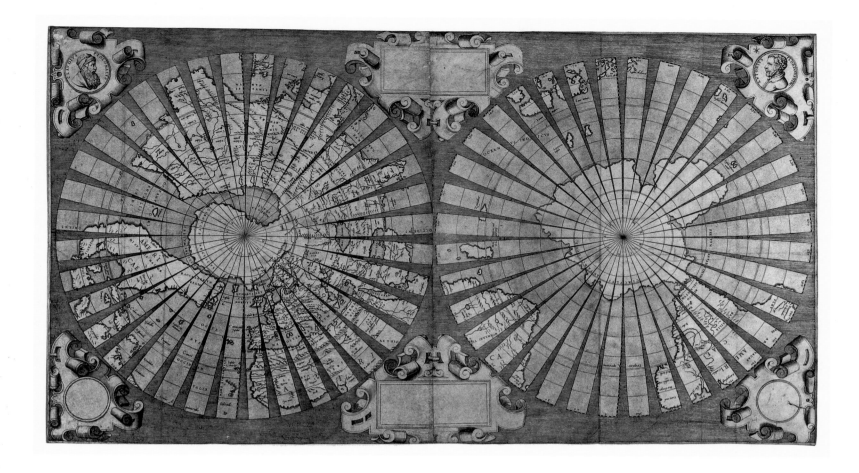

Gored World Map in Two Hemispheres

**Gerard Kremer, also known as Mercator
(1512–1594), cartographer; Antonio Florian
(fl. 1545–c.1570), illustrator**
Venice, 1556
Copperplate engraving
Sheet (trimmed) 459 × 830 mm
AMIB 1988.102

Addressing the Doge of Venice, in his 1555 application for the exclusive privilege of printing a world map, Antonio Florian mentions that it had caused him 'so much drudgery and sweat, with more heavy toil [than] Your enlightened judgement can imagine'. With its two hemispheres centred on the poles, and its thirty-six gores, each comprising 10° of longitude, to make up a sphere of 258 mm in diameter, this map, says Florian:

has never been made before, with the aid of which one can easily study and learn cosmography and see the entire picture of the world, since it can be reduced to spheric form as Your Highness can ascertain with Your own eyes and have of it whatever information You like.

Although an earlier date has been ascribed to this map, the reference in the quotation above to

'spheric form' indicates that this is indeed the map that Florian was granted the right to print in 1556.

Antonio Florian was, according to the painter-biographer Giorgio Vasari, an 'excellent painter and architect', as was his brother Francesco. Vasari notes that Antonio, the younger brother, 'by his rare quality in this profession serves his Imperial Majesty the Emperor Maximilian'. Florian, however, was not an engraver, and his 'drudgery and sweat' were prompted by the mental effort needed to create the pioneering design of the map. On the top-right cartouche, opposite Claudius Ptolemy, is an image of Florian with a monogram that Dallas Pratt and others optimistically conjectured may be that of the accomplished engraver Giovanni Cimerlino (c.1534–c.1609).

This gored map became popular in the sixteenth century. When Florian claimed that the map had 'never been made before' he was referring to the form of the map and not to the geographical information in it. In circumstances that would in today's courts be ruled a breach of copyright, Florian replicated a world map by the Roman publisher Antonio Salamanca, who had in turn copied one produced by Mercator in 1538. Indeed, this map includes errors made by Salamanca when copying Mercator.

ABOVE: Medallion portrait of Antonio Florian, whose pioneering design for this map caused him 'much drudgery and sweat'.

La Nuova Francia (New France)

Giovanni Battista Ramusio (1485–1557), author;
Giacomo Gastaldi (1500–1566), cartographer
Venice, *c.*1565
Woodcut
Sheet 313 × 409 mm; plate 266 × 372 mm
AMIB 1988.20

The first printing of a map of early New France (now part of Canada) appeared in Ramusio's *Delle navigationi et viaggi* (Some Voyages and Travels) in 1556, but the woodblock was destroyed by fire the following year. An identical block was cut and maps printed from it in 1565, although the eminent artic explorer and map historian A.E. Nordenskiöld (1832–1901) haughtily remarked that these maps seem to be 'ornamented in [Sebastian] Münster's style by some ignorant woodcutter, from originals of Gastaldi'.

Whatever the standard of the engraving, map collectors and historians have endless entertainment identifying the locations on an area extending from what is now New York to as far as Labrador. Ramusio's volume includes a precise account of Cartier's second voyage to the Gulf of St Lawrence in 1535, but the map seems to be largely based on Giovanni da Verrazzano's voyage of 1524 (also under the patronage of François I) in whose honour the region is named.

From Columbus onwards, European explorations had been primarily concerned with seeking a westward passage to the Orient, constantly probing any likely looking inlet, bay or river that might lead the way. The strange river system presented on the map, whereby the Hudson and St Lawrence rivers are connected, may be the result of their frustration at finding so many 'dead ends'. An exception to the search for a Northwest Passage was the lure of the codfish, which had enticed mariners to that area even, possibly, before Columbus; so the label *isola delle rena* attached to the long, snaking structure in the south-west most likely means 'island of sand' and corresponds with the Grand Banks, where codfish were found in great plenty. The area named *Terra de Norumbega* is New England; according to Verrazzano, its Abenaki Indian name translated as 'quiet waters between two rapids'. Other locations have been provisionally identified: the western promontory, named 'Angoulême' after the king's birthplace, is the Upper Bay of New York; the coast of Flora is the south of Long Island; *Port de Refuge* is Narragansett Bay; and the island named 'Brisa' (possibly a corruption of 'Louisa', the king's mother) is the roughly triangular island of Martha's Vineyard.

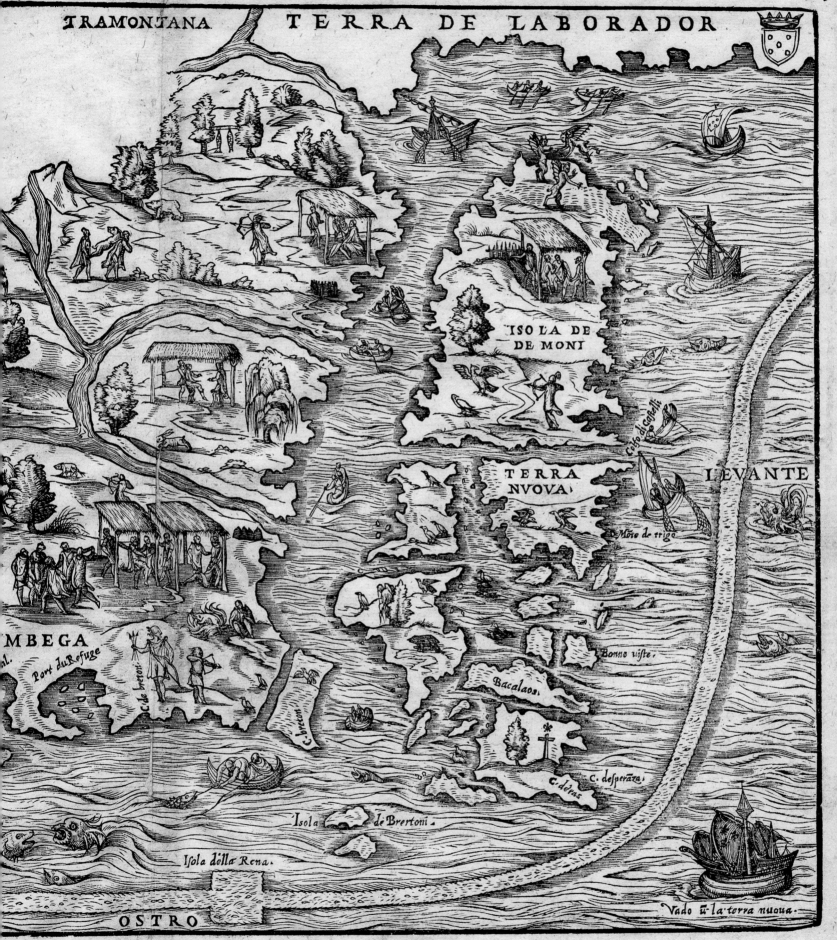

TRAMONTANA TERRA DE LABORADOR

ISOLA DE
DE MONI

TERRA
NVOVA

LEVANTE

Corfo di Caftelli

Mote de trigo

MBEGA

Port du Refuge

C. de breton

Bonne vifte

Bacalaos

C. de bretoni

C. defperata

C. de ras

Ifola di Bretoni

Ifola della Rena

OSTRO Vado ü la terra nuoua

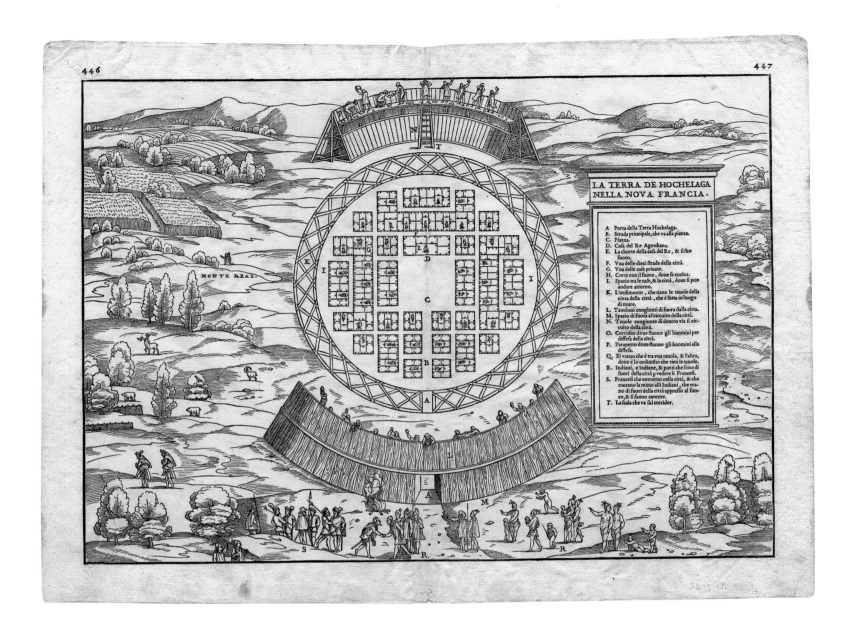

LA TERRA DE HOCHELAGA
NELLA NOVA FRANCIA.

A: Porta della Terra Hochelaga.
B: Strada principale, che va alla piazza.
C: Piazza.
D: Casa del Re Agouhana.
E: La chorte della casa del Re, & il suo fuoco.
F: Vna delle dieci strade della città.
G: Vna delle case priuate.
H: Corte con il fuoco, doue se cucina.
I: Spacio tra le case, & la città, doue si puo andare attorno.
K: L'ordimento, che tiene le tauole della cinta della città, che é fatta in luogo di mure.
L: Tauoloni congionti di fuora dalla città.
M: Spacio di fuora al circuito della città.
N: Tauole congiunte di dentro via il circuito della città.
O: Corridor doue stanno gli huomini per diffesa della città.
P: Parapetto doue stanno gli huomini alla diffesa.
Q: El vacuo che é tra vna tauola, & l'altra, doue é lo ordimento che tien le tauole.
R: Indiani, e Indiane, & putti che sono di fuori della città p vedere li Francesi.
S: Francesi che entrorno nella città, & che toccano la mano alli Indiani, che erano di fuori della città appresso al fuoco, & si fanno carezze.
T: La scala che va sul corridor.

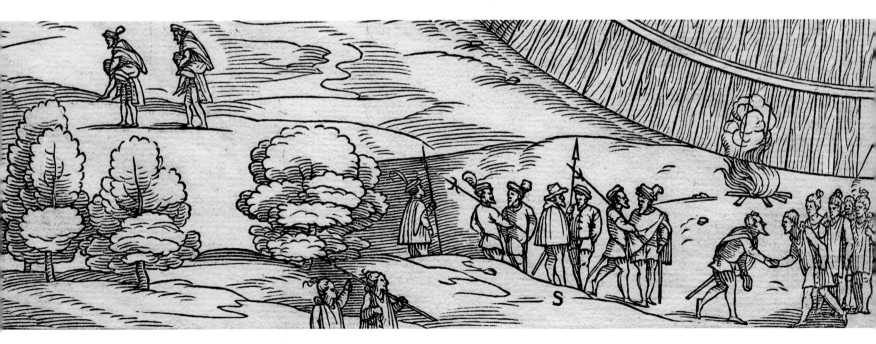

La Terra de Hochelaga nella Nova Francia (The Land of Hochelaga in New France)

Giovanni Battista Ramusio (1485–1557), author;
Giacomo Gastaldi (1500–1566), cartographer
Venice, 1556
Woodcut
Sheet 320 × 424 mm; plate 276 × 382 mm
AMIB 1988.168

This ground plan of the Iroquois village of Hochelaga appeared in volume three of Ramusio's *Delle navigationi et viaggi* (Some Voyages and Travels), and is the first published diagram of a settlement in North America. Gastaldi is said to have based the woodcut illustration on Cartier's account of his first and second voyages, which he presented to his patron François I in 1545, ten years after the second voyage of 1535. Since so much time had elapsed before the Venetians, in their search for an alternative route to the East, became sufficiently interested in Cartier's travels to have them published, it is not surprising that this illustration's authenticity has been questioned. The fifty communal houses described by Cartier, for instance, are here arranged in an idealised European-style grid pattern; and the palisade is roofed with boards – a construction unknown to the indigenous people.

Cartier's account of his journey up the St Lawrence River makes lively reading. Leaving their ships, and with their Captain Cartier 'gorgeously attired', the party progressed upriver in boats 'accompanyed with manye gentlemen' and twenty-eight mariners till they reached the 'place of Hochelaga, and all the waye we went, we were met with those countrimen, who brought us fishe, and suche other victualles as they had, still dauncing and greatly rejoicing at oure coming'. After the distribution of gifts and, on request, laying hands on the sick, Cartier 'commaunded Shawmes, and other musical instruments to be sounded, which when they heard, they were very merrie'.

A feast of fish, pottage and beans was offered, but the fastidious French declined: 'because the meates hadde no flavoure at all of salte, we liked them not, but thanked them and with signes gave them to understand that we hadde no neede to eat.' A trip to the local mountain, with those appearing fatigued being offered a piggy-back 'as on a horse' (see detail), resulted in its being named 'Monte Real' ('Mount Royal') in honour of the French king. In spite of being the site of the future Canadian city Montreal, Cartier did not mention visiting Hochelaga on his fourth voyage, and no trace of it has been found by archaeologists.

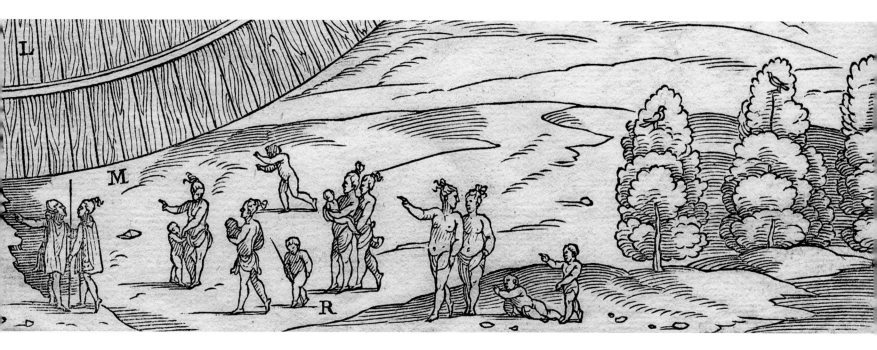

The following title-pages (here and overleaf) are from two of the most influential publications of the Age of Discovery, bearing witness to the importance of printed matter in the sixteenth century.

BELOW: The naked figure of America is portrayed as both desirable and dangerous. An accompanying poem notes that she is armed with weapons for slaying 'fat and bloody humans'. She holds aloft the head of her latest victim (significantly a bearded European man). The bare-breasted woman on the fiery plinth symbolises Tierra del Fuego (Land of Fire).

Theatrum Orbis Terrarum (Theatre of the World)

Abraham Ortels, also known as Ortelius (1527–1598), cartographer and illustrator
Antwerp, 1570s
Hand-coloured copperplate engraving
Sheet 433 × 306 mm; plate 370 × 228 mm
AMIB 1988.149

Although the title-page of the *Theatrum* – the first modern world atlas – would have been considered fittingly majestic for Ortelius's grand undertaking, to modern eyes it expresses the prejudices about other nations held by Europeans: Europe is in top position as Queen of the World; below, to her left and right, are female figures representing Asia and Africa; and 'Miss America' at bottom is shown naked, except for cap and ankle chain, and bristling with weapons.

In a commendatory poem accompanying the *Theatrum* (written by the Flemish diplomat and humanist Adolf van Meetkercke and translated from Latin by Marcel P.R. van den Broecke), America is described as 'Forgetting herself and her virtue as she sits there… She holds a wooden cudgel, used for slaying fat and bloody humans as well as those captured in war… In her left hand you see a human head, gory because of recent decapitation… Once tired of chasing of humans, she will put her weary limbs to rest, and climb into her bed, made of a net full of holes attached to poles on both sides.' Such representations of the inhabitants of the New World – some of whom were indeed cannibals – fed European preconceptions about 'savages'.

The strange figure on the fiery plinth beside America represents Tierra del Fuego (Land of Fire), at the time thought to be part of the theoretical southern landmass *Terra Australis*, which was first imagined by Aristotle and drawn on European maps from the fifteenth century to balance the continents of the Northern Hemisphere.

THEA
TRVM
ORBIS
TERRA
RVM

Opus nunc denuò ab ipso Auctore recognitum, multisquè locis castigatum, & quamplurimis
nouis Tabulis atquè Commentarijs auctum.

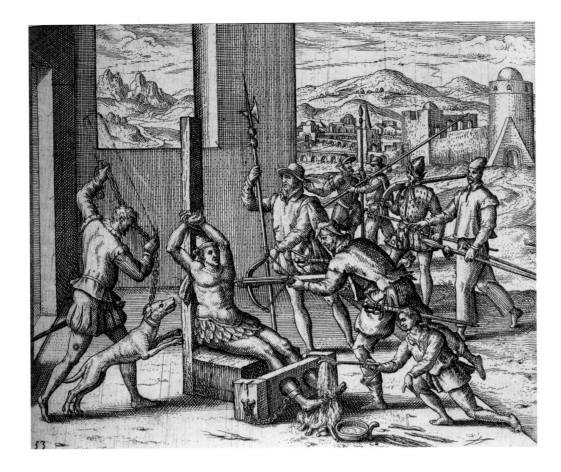

Narratio Regionum Indicarum per Hispanos quosdam Devastatarum Verissima (A Very True Account of the Destruction of the Indies by the Spanish)

Bartolomé de las Casas (1484–1566), author; Johann Theodor De Bry (1561–1623) and Johann Israel De Bry (1565–1609), illustrators and engravers
Frankfurt, 1598
Copperplate engraving
Sheet 190 × 146 mm
AMIB 1988.206

When Columbus first landed in Hispaniola in 1492, Bartolomé de las Casas estimated that the island's population was three to four million, ruled by chiefs and supported by highly productive agriculture; by 1516 only twelve thousand remained, thanks to the *encomienda* system of semi-slavery introduced by Columbus, and infectious diseases also brought by Europeans. These dire casualties slowly dawned on de las Casas, who had first travelled to the Indies at the age of eighteen to manage land and Indians granted to his father by Columbus. At first keen to make his fortune, de las Casas became increasingly troubled by the fate of the Indians. He accompanied Columbus's older brother to Rome

to inform Pope Julius II of the opportunities in the New World for spreading the faith; there he became a priest, after which he returned to Cuba to run various agricultural and stock-raising enterprises. Having renounced his properties, he was back in Spain by 1516 and eager to inform King Ferdinand of the exploitation of the Indians. He had better luck with Ferdinand's grandson, Charles I (Charles V of the Holy Roman Empire), who was concerned with curbing the increasing power of the conquistadors.

Throughout the ensuing years, de las Casas with his supporters promoted the right of the Indians to retain their land and to self-government. Becoming known by the title 'Protector of the Indians', he argued that the Indians had their own comprehensive (and commendable) society and made a comparative study of civilisations worldwide. His famous book recounting the mistreatment of the native peoples of the Americas – *Brevissima relación de la destruición de las Indias* (Very Brief Account of the Destruction of the Indies) – was first published in Spanish in 1552 and took its title from the first of its nine

parts. It was dedicated to Charles's son, Philip II, in the hope of his support; in need of money, however, this king ironically increased the burden of tribute paid to the Crown by the indigenous population. Although increasingly disillusioned, de las Casas continued to support the cause of the Indians and was fearful of 'God's force and wrath', which might be vented on Spain for the sins of the colonists.

By 1626 the *Brevissima relación* had been translated into six other European languages. It was seized upon by northern, mainly Protestant countries as propaganda against the Spanish and gave rise to the 'black legend' of Spanish atrocities. The edition acquired by Dallas Pratt is the first to have illustrations. Apart from the title-page, which depicts a chieftain being captured and his vassals bringing tribute, many of the illustrations are of the most lurid kind. The publishers, Johann Theodor and Johann Israel De Bry, nevertheless disavowed any intention to defame the whole Spanish nation and declared that, without super-vision, any of us 'would doubtless be equal to the Spaniards in savagery, cruelty, and inhumanity'.

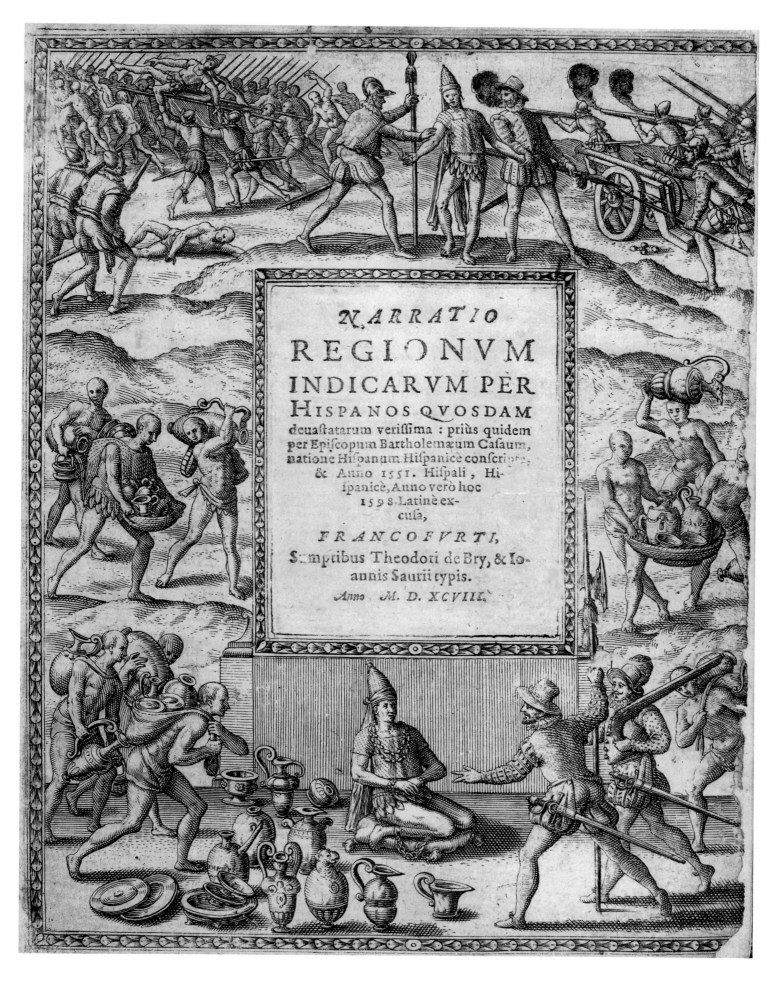

NARRATIO
REGIONVM
INDICARVM PÈR
HISPANOS QVOSDAM
deuastatarum verissima : priùs quidem
per Episcopum Bartholemæum Casaum,
natione Hispanum Hispanicè conscript.
& Anno 1551. Hispali , Hi-
spanicè, Anno verò hoc
1598. Latinè ex-
cusa,

FRANCOFVRTI,
Sumptibus Theodori de Bry, & Io-
annis Saurii typis.
Anno M. D. XCVIII.

Typus Orbis Terrarum (World Map)

Abraham Ortels, also known as Ortelius
(1527–1598), cartographer and illustrator
Antwerp, 1586
Hand-coloured copperplate engraving
with gold leaf
Sheet 412 × 522 mm; plate 330 × 485 mm
AMIB 1988.123

Ortelius produced the first modern atlas – *Theatrum Orbis Terrarum* (Theatre of the World) – in 1570. Although a later edition from 1586 (see date under right side of lower cartouche), the world map illustrated here (engraved by Frans Hogenberg) is one of the fifty-three maps included in this ground-breaking publication, which marked the beginning of the golden age of Dutch cartography.

Gerard Mercator, Ortelius's friend and fellow cartographer, had created a large twenty-one-sheet map projection of the world in 1569. It was drawn to the projection used to print standard maps today – still known as the 'Mercator projection' – whereby the latitudes grow further apart nearer the poles, enabling mariners to plot a straight course that does not go round in spirals. Mercator was happy for his map to be used as a basis for Ortelius's world map in the *Theatrum*, and so it was reduced in size and set in an oval rather than a rectangle, with decorative clouds in each corner spandrel. Mercator's text-filled cartouches were omitted, and instead a quotation from Cicero was used across the bottom: 'What can seem of importance in human affairs to one who knows all eternity and the vastness of space?'

In taking the overall shape of the world from Mercator's map, Ortelius incorporated some of the misconceptions of the age: South America has a bulge in the southwest (not appearing in later issues of the map); Asia and North America are separate, but both continents are 'rounded off'. Ortelius inscribes the lower part of the map *Terra Australis nondum cognita* – 'the southern land not yet discovered', which it was thought at the time had to exist in order to balance the large land-masses in the north. Tierra del Fuego appears as a promontory. In spite of its geographical errors, the map was much copied by other cartographers. A visible channel of clear water around the Arctic on this map and later copies tempted explorers such as Martin Frobisher to attempt a northwest passage to the Orient.

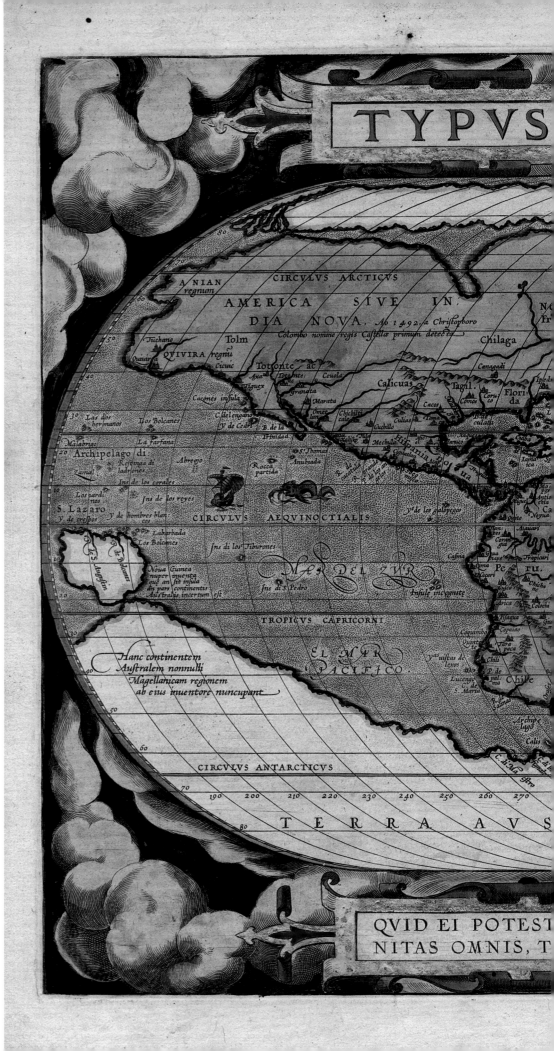

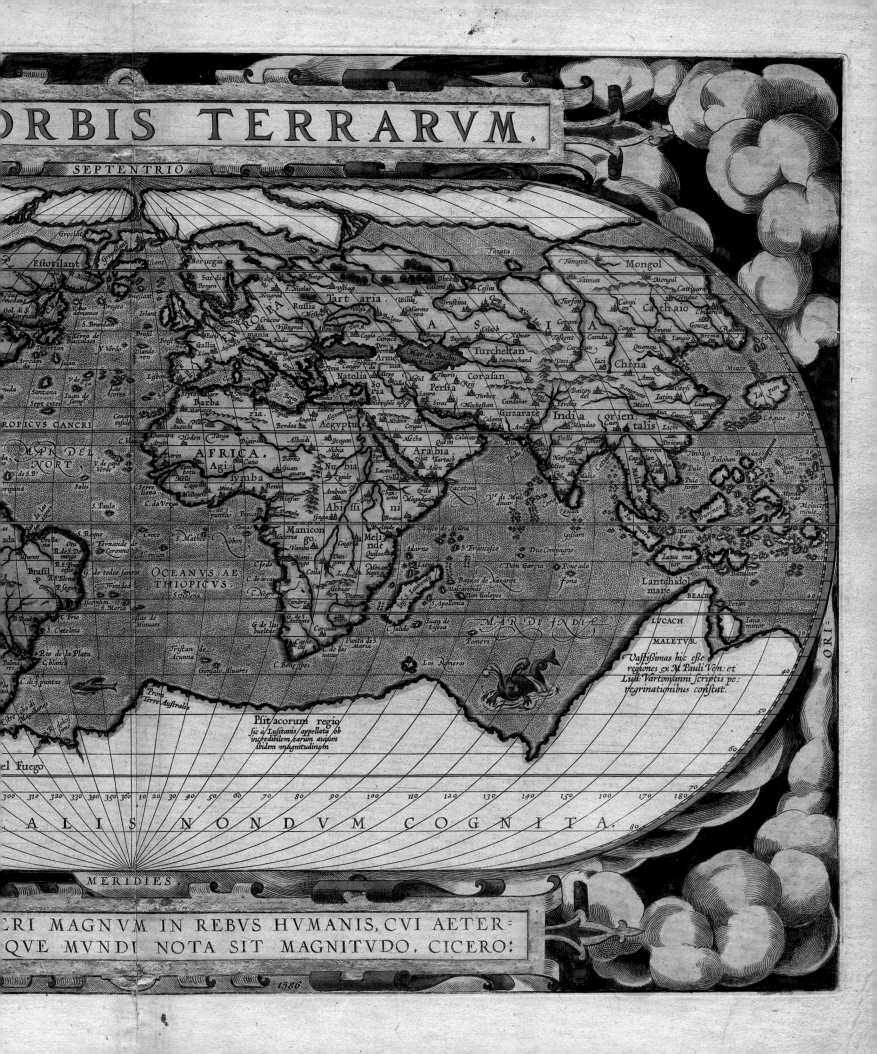

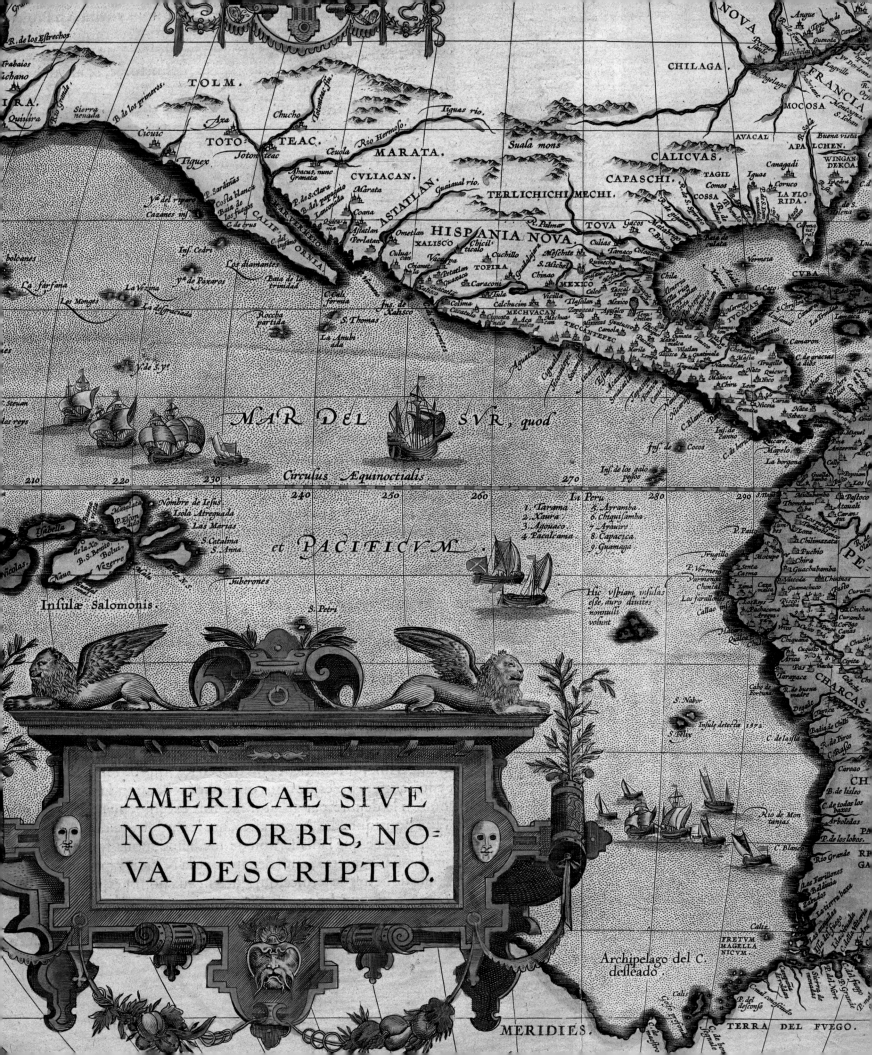

AMERICAE SIVE NOVI ORBIS, NOVA DESCRIPTIO.

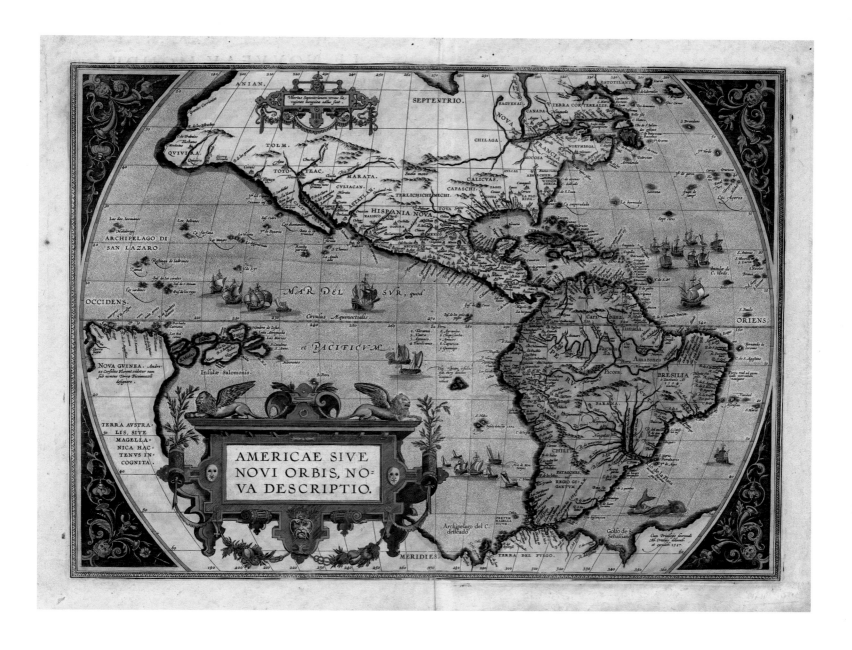

Americae Sive Novi Orbis... (The New World or America...)

Abraham Ortels, also known as Ortelius (1527–1598), cartographer and illustrator
Antwerp, after 1587
Hand-coloured copperplate engraving
Sheet 419 × 563 mm; plate 359 × 488 mm
AMIB 1988.31

The date of this later issue of Ortelius's map of the Americas, 1587, is stated in the inscription in the bottom right-hand corner – on the edge of *Terra Australis*, the hypothesised continent in the Southern Hemisphere that acted as a counterweight to the known lands of the north. This map is easily distinguishable from the earlier world map produced in 1570, on which the southwest corner of South America had a large protuberance – a distinctive error on the cartographer's part.

The 1570 version of the map had presented information based mainly on accounts of campaigns by the conquistadors, from the expedition of Pánfilo de Narváez along the Gulf of Mexico in 1521 to Juan Rodríguez Cabrillo's exploration of the Californian coast in 1542. As well as removing the aforementioned bulge on South America, Ortelius has made additions to this later depiction of the Americas in the light of intervening discoveries and explorations.
On the east coast of North America, the name 'Wingandekoa' has been added, just below an inlet. It is thought to be based on accounts of attempted English settlement in 'Virginia' on Roanoke Island on the Outer Banks of North Carolina; the inlet may be Chesapeake Bay.
On the west coast the name 'California' appears on what is now Baja California, correctly shown

as a peninsula, not an island (as on some maps produced after *c.*1626).

At north, the inscription 'Regions further north from here are unknown' appears now in a grand cartouche not previously present. The even grander one below at left (with the map's title) had been incorporated earlier and served to hide the fact that map-makers had no idea what was in that region. For the first time after their discovery, the Solomon Islands, somewhat enlarged, are depicted to the east of New Guinea. This version of the New World map continued to be included in the *Theatrum* until its last edition in 1612.

Views of Mexico City (formerly Tenochtitlán) and Cusco from *Civitates Orbis Terrarum* (Cities of the World)

Georg Braun (1541–1622), author; Frans
Hogenberg (1535–1590), illustrator and engraver
Antwerp, 1575
Hand-coloured copperplate engraving
Sheet 418 × 546 mm; plate 274 × 479 mm
AMIB 1988.167

After the 1570 publication of Ortelius's *Theatrum Orbis Terrarum*, Georg Braun and Frans Hogenberg embarked on a publishing venture intended as a companion work to the atlas and to be named *Civitates Orbis Terrarum* (Cities of the World). Hogenberg had engraved many of the maps included in the *Theatrum*, among these the much-copied world map (see pp. 82–3), but the pair may not have realised what a massive undertaking the *Civitates* was to become. The first volume of the work was published in 1572 and the sixth, final volume in 1617. The books contained 546 views of cities, drawn from one of three different panoramic viewpoints: prospect view (seen from ground level); bird's-eye view (from an angle above the ground); and overhead view, with buildings in profile. Braun did the soliciting, collecting and editing of the material and wrote the text; Hogenberg undertook most of the engraving. The images pictured here are partly based on woodcuts by Antoine du Pinet (*c.*1510–*c.*1565), which were published in 1564.

LEFT: Tenochtitlán was founded by the Aztecs on an island in Lake Texcoco. An architectural marvel connected by bridges and canals, it fell to the Spanish in 1520.

When the Spanish conquistador Hernán Cortés (1485–1547) first set eyes on the Aztec city of Tenochtitlán in 1519, he declared it 'the most beautiful thing in the world'. Bernal Díaz Del Castillo (*c.*1498–*c.*1580), who served under Cortés, observed: '[it] seemed like an enchanted vision... Indeed some of our soldiers asked whether it was not all a dream.' The splendour of the city on the lake with its causeways, squares, palaces and temples is shown in this overhead view. Braun's text refers to the 'quite incredible magnificence', but also mentions the Aztecs' sacrifice of human hearts to their 'heathen images' – a custom which the conquistadors took as a justification for razing the city to the ground, and building Mexico (City) in its place.

Cusco, in the language of the natives of Peru, meant 'navel of the world'. Braun's text describes how the streets 'are very straight with numerous crossroads and a stream flows down most streets'. 'There is,' he says, 'a wonderful palace that lies on a steep hill and has no compare in Europe.' In this bird's-eye view, Atahualpa the Inca is being borne aloft in a litter, both in front of the palace and in the foreground. After being deprived of his throne and his gold, Atahualpa was murdered on the orders of the conquistador Francisco Pizarro.

RIGHT: Cusco had been founded by the legendary Manco Cápac (d. 1107), the first Inca. Georg Braun was struck by the city's 'wonderful palace', shown here, which 'has no compare in Europe'.

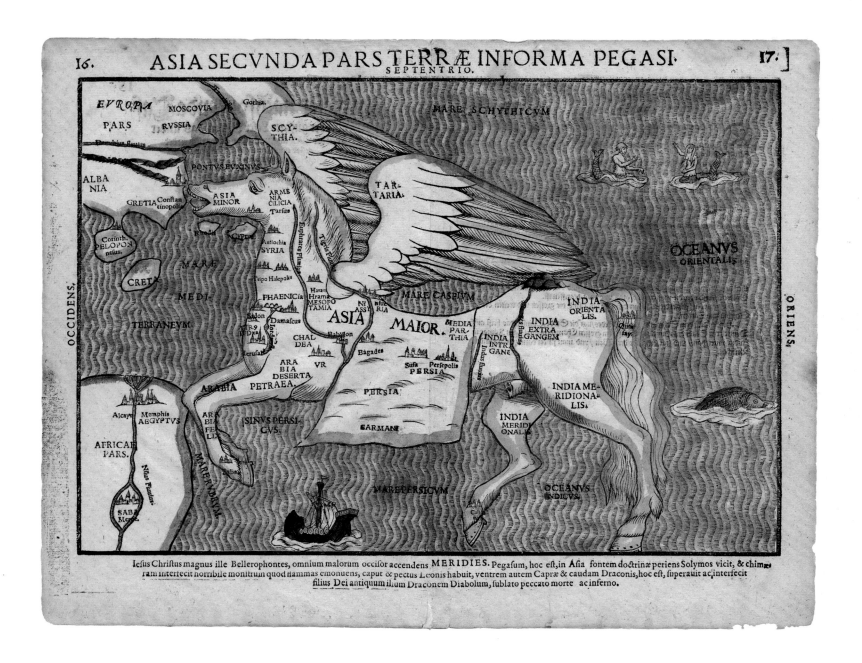

ASIA SECVNDA PARS TERRÆ INFORMA PEGASI.
SEPTENTRIO.

Iesus Christus magnus ille Bellerophontes, omnium malorum occisor accendens MERIDIES. Pegasum, hoc est, in Asia fontem doctrinæ periens Solymos vicit, & chimæ ram interfecit horribile monstrum quod flammas emonuens, caput & pectus Leonis habuit, ventrem autem Capræ & caudam Draconis, hoc est, superauit ac interfecit filius Dei antiquum illum Draconem Diabolum, sublato peccato morte ac inferno.

Asia secunda pars terrae informa Pegasi (Asia in the Form of Pegasus)

**Heinrich Bünting (1545–1606), author
and illustrator
Magdeburg, 1581
Hand-coloured woodcut
Sheet 302 × 385 mm; plate 245 × 350 mm
AMIB 1988.208**

Figurative maps such as this example occasionally appeared after the advent of printing and were meant to be either items of whimsy or of symbolic significance. Heinrich Bünting's map illustrated here was probably intended as the latter. Bünting was a Protestant theologian from Hanover whose book *Itinerarium Sacrae Scripturae* (Travel in Holy Scripture) was published in 1581. Describing the journeys of

figures from the Old and New Testaments, it is a kind of geography of the Bible. Alongside crudely drawn but conventional maps, the book contains three figurative maps: one of Europe personified as a crowned queen; a world map with three continents in the shape of a clover leaf, signifying the Trinity and honouring Hanover 'my dear fatherland', whose crest it was; and Asia in the form of the mythological winged horse Pegasus, the offspring of Medusa and Poseidon, God of the Sea and 'tamer of horses'. Pegasus was himself captured and ridden by Bellerophon so that the Greek hero could kill the monstrous chimera.

The inscription below the map explains the symbolism. Bellerophon is identified as Jesus Christ and Pegasus as Asia 'where Jerusalem is

and where his teaching originated. Dying there he conquered the chimera, a horrible monster breathing flames, with the head and breast of a lion, the body of a goat and the tail of a dragon; thus the Son of God killed that old dragon the Devil doing away with sin, death and hell.'

In spite of – or perhaps because of – its oddity, the book was printed at least ten times during the next seventy years. Moreover, it was translated into English, Danish, Dutch and Swedish. Copies are now rare, but it is one of the best-known cartographical curiosities.

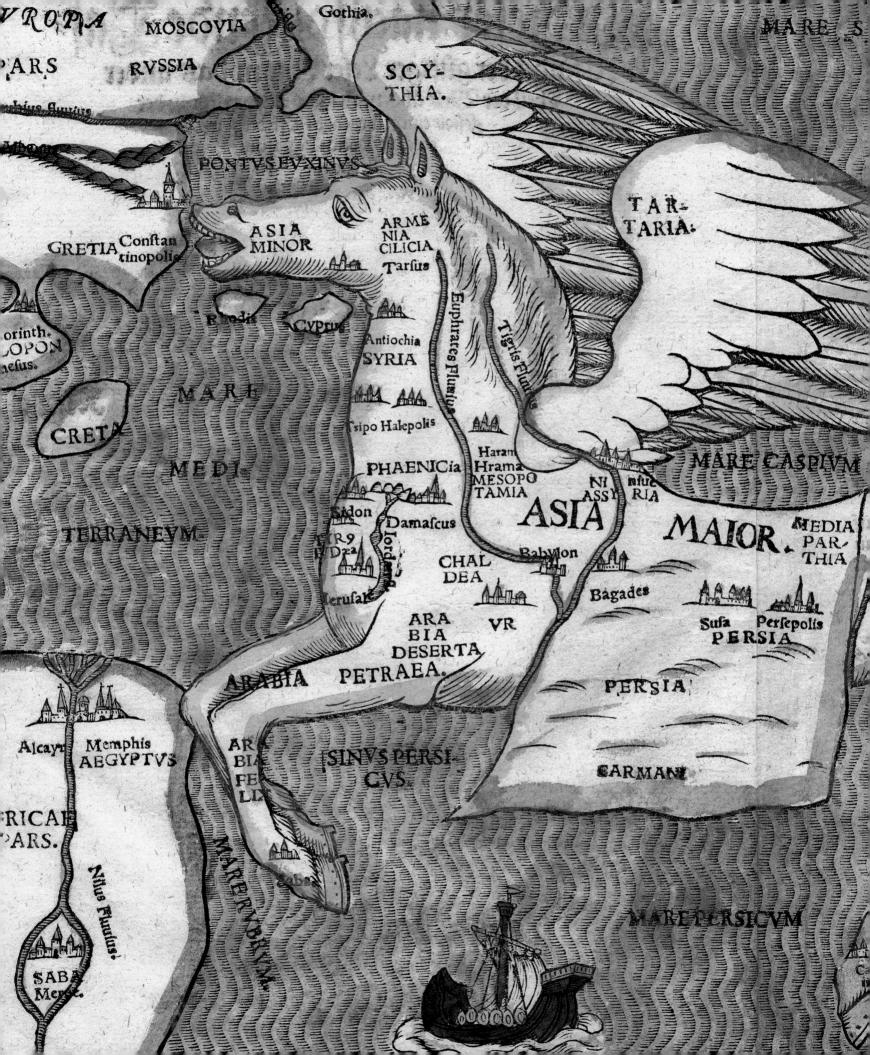

EUROPA PARS

MOSCOVIA

RVSSIA

Gothia.

MARE S

SCY-THIA.

PONTVS EVXINVS

Danubius fluuius

Albona

GRETIA Constantinopolis

ASIA MINOR

ARMENIA CILICIA

Tarsus

TARTARIA.

Rhodis

Cyprus

Corinth. OPON nesus.

MARE

Antiochia SYRIA

Euphrates Fluuius

Tigris Fluuius

CRETA

MEDI.

Tsipo Halepolis

PHAENICIa

TERRANEVM

Sidon

Damascus

TYR9 Dea

Iordan

Haram Hrama MESOPOTAMIA

ASIA

NI ASSY sue RIA

MARE CASPIVM

MAIOR.

MEDIA PARTHIA

Babylon

CHALDEA

VR

Bagades

Persepolis Susa PERSIA

Ierusalé

ARABIA DESERTA PETRAEA.

ARABIA

PERSIA

FRICAE PARS.

Alcayr

Memphis AEGYPTVS

ARABIA FELIX

SINVS PERSICVS.

CARMANI

MARE RVBRVM

Nilus Fluuius

Saba

MARE PERSICVM

SABA Mene

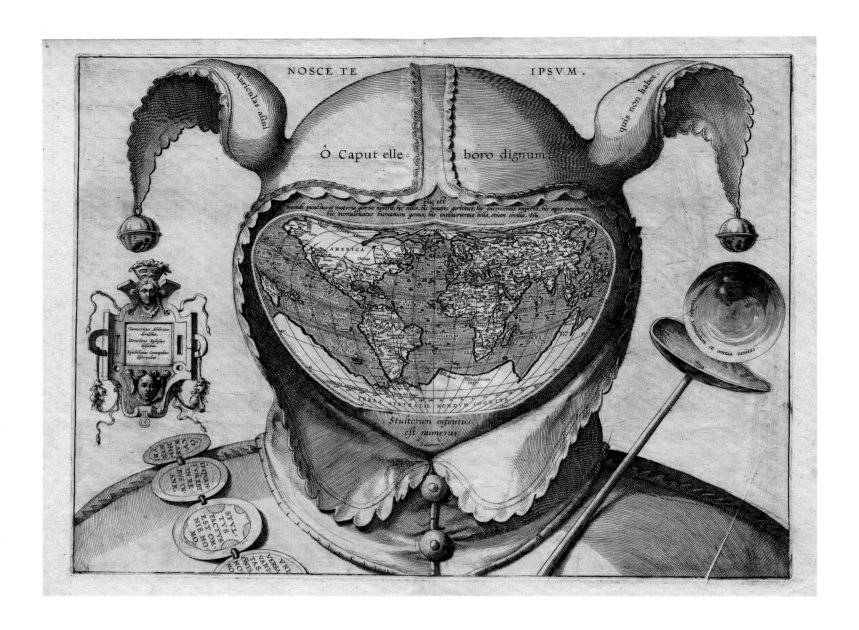

Fool's Head

Unknown cartographer
Antwerp (?), *c*.1590
Copperplate engraving
Sheet 397 × 557 mm; plate 357 × 482 mm
AMIB 1988.29

Based on an earlier fool's cap map made by Jean de Gourmont II (active 1565–1585), this striking map has been much discussed, but its authorship remains unclear. As Dallas Pratt wrote to R.V. Tooley in 1969, 'All in all, the Fool's map has succeeded in making mock of some of the experts, a situation quite in the spirit of the satirical mottoes of the map!' In Robert Burton's *Anatomy of Melancholy* of 1621 there is an allusion to a map, framed in a fool's head by one 'Epichthonius Cosmopolites', that expresses the

view of the world as either mad or melancholic. After extensive research to determine the identity of the map's maker, all that can be said with certainty is that this convoluted name may be a pseudonym. Whoever he was, the author of this map was either misanthropic or making a pretence of being so – as if playing a theatrical part. The Latin epigrams lamenting mankind's follies include: Cicero's dictum to 'know thyself'; the Biblical precept 'vanity of vanities and all [is] vanity'; 'O head in need of hellebore' (a plant remedy traditionally thought to cure madness); 'Who does not have asses' ears?'; and 'The number of fools is infinite'.

Jean de Gourmont's woodcut map had similar inscriptions in French, but it does not match the quality of the copperplate version pictured here.

On stylistic grounds, Frans Hogenberg has been proposed as the engraver of the work. This suggestion is credible because the map enclosed within the fool's cap is the world map from Ortelius's *Theatrum*, on which Hogenberg collaborated. Significantly, the 'bulge' mentioned earlier on the southwestern part of South America has been corrected, therefore dating this map to post 1587.

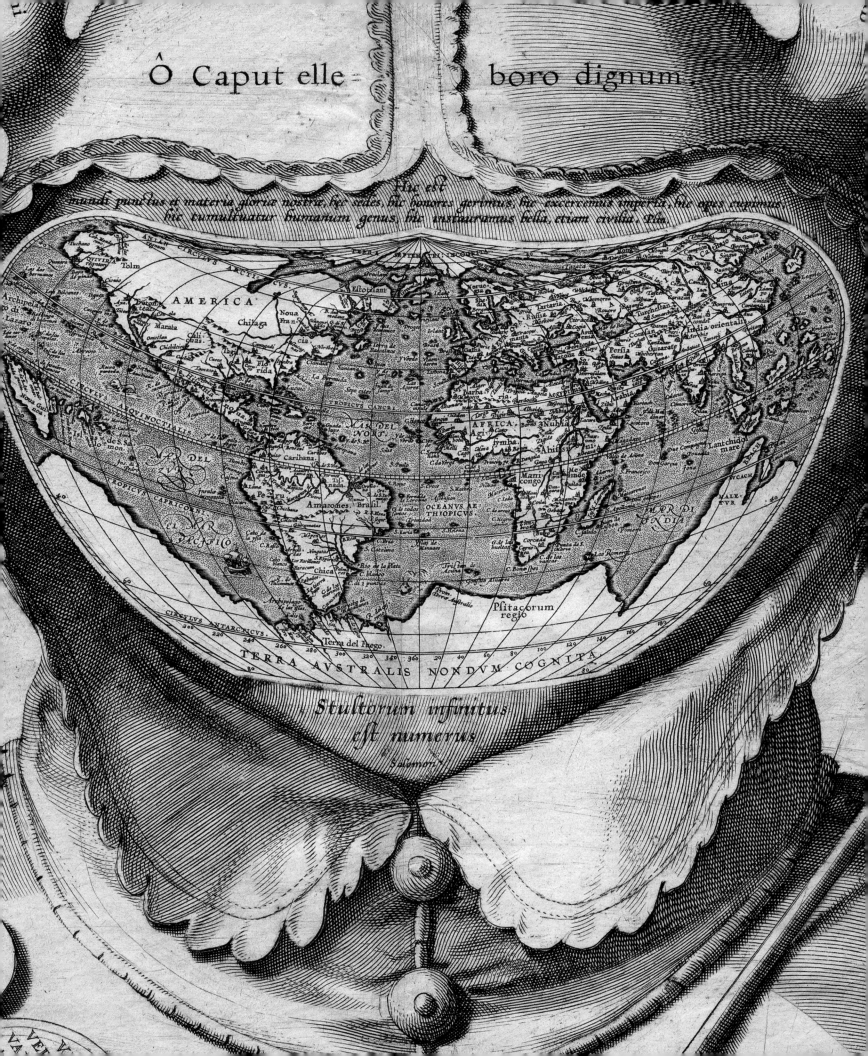

Ô Caput elle=boro dignum

Hic est mundi punctus et materia gloriae nostrae, hic sedes, hic honores gerimus, hic exercemus imperia, hic opes cupimus, hic tumultuatur humanum genus, hic instauramus bella, etiam civilia. Plin.

Stultorum infinitus est numerus

Salomon

The Famouse West Indian voyadge made by the Englishe fleet…

Baptista Boazio (fl. 1588–1606), cartographer
and illustrator
London, 1589
Hand-coloured copperplate engraving
Sheet (trimmed) 411 × 527 mm
AMIB 1988.125.1

Anti-Spanish feeling in England was running high in 1585. As a consequence, Sir Francis Drake (1540–1596), circumnavigator and some-time privateer, was given a new commission: to release some English ships detained in Spain; if possible to have a profitable encounter with Spanish treasure ships returning from the New World; and to make his presence felt in Spanish colonies on both sides of the Atlantic. The 'pricked line' on this spectacular map traces the fleet's route. After it called at Vigo in Spain and Santiago in the Cape Verde Islands, the fleet sailed across the Atlantic to Santo Domingo and on to the island of Hispaniola. Here Drake attacked and plundered the town. He then went on to Cartagena (now in Colombia), which was easily taken. By then, however, Drake's men were suffering from fever, and so he was forced to accept a smaller ransom from the colony than he would have wished, in order to move to a healthier climate. After an attack on the Spanish settlement of St Augustine, now in Florida, Drake sailed to the English colony at Roanoke, 'Virginia', where he was obliged to rescue most of the settlers from a 'great storm' before returning home.

BELOW: Elaborate compass rose showing the points of the compass measured from true north.

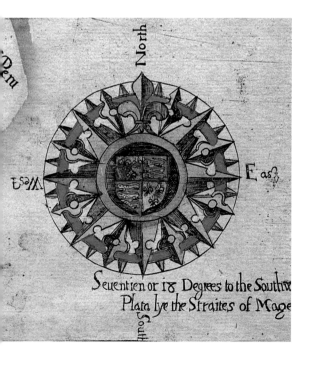

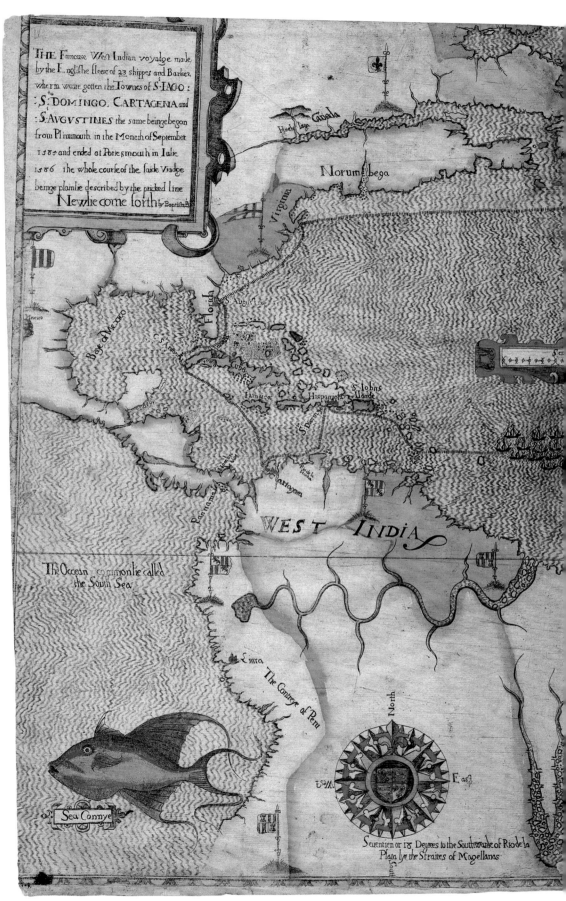

92

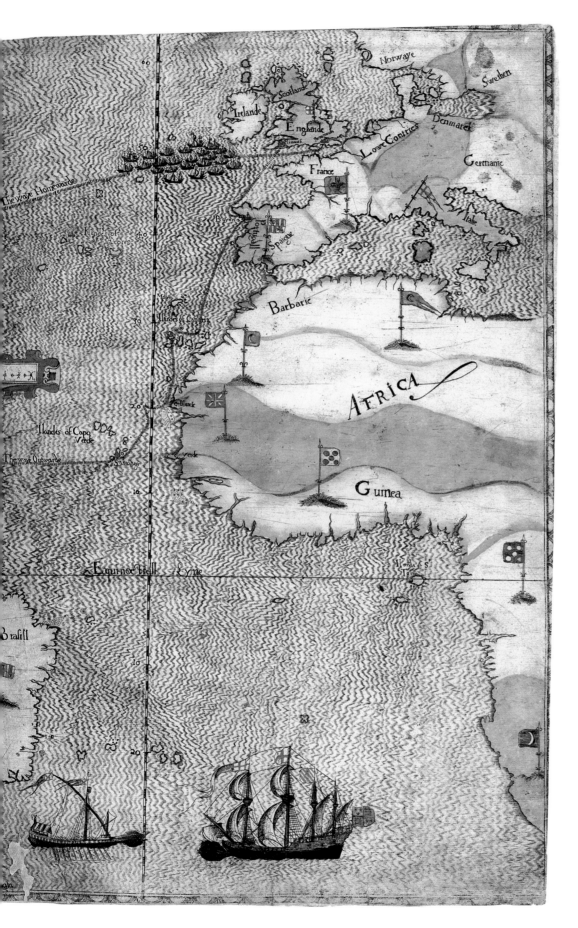

Among those who died in Cartagena was Captain Walter Bigges, the author of much of the official record of the expedition, later published as *A summarie and true discourse of Sir Francis Drake's West Indian voyage wherein were taken, the townes of Saint Jago, Sancto Domingo, Cartagena & Saint Augustine.* Christopher Carleill, the military commander of the campaign, had sent reports to his stepfather, the Queen's 'spymaster', Sir Francis Walsingham. It is thought that Walsingham may have had some connection with the publication of the *Summarie*, albeit with additions and the text heavily edited. With the accompanying maps, the book made good anti-Spanish propaganda.

The geographer and promoter of Elizabethan expansionism Richard Hakluyt had suggested that expeditions such as this should have an artist on board. The fortunate choice was an Italian living in London, Baptista Boazio. He is the author of the set of five maps illustrating the voyage, this being the fifth; it shows the whole voyage and, unlike the others, is printed in English. The maps are embellished with illustrations of the local fauna by the artist John White, one of the rescued Roanoke colonists.

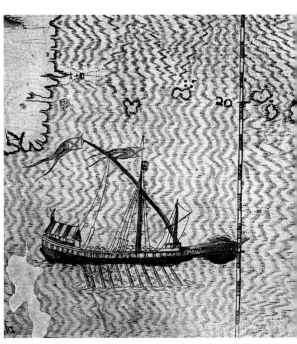

BELOW: This illustration is thought to be of a Portuguese trading vessel (based on a traditional design for a fishing boat) used to ply the African coast.

Plan of Santo Domingo, Hispaniola (Dominican Republic)

Baptista Boazio (fl. 1588–1606), cartographer and
illustrator
London, 1589
Hand-coloured copperplate engraving
Sheet (trimmed) 412 × 532 mm
AMIB 1988.125.3

All four plans of the cities raided by Sir
Francis Drake during his 1585–6 expedition
to the West Indies have keys to the letters marked
in various spots; these narrate the military
campaigns conducted by Carleill and explain the
bird's-eye views of the Spanish settlements with
their fortifications.

In the case of Santo Domingo, there was only
a paltry defence system for what was the principal
city of the West Indies – described by Walter
Bigges as 'elegantly built by the Spanish' – which
had the first cathedral built in the Americas. When
Drake's fleet was sighted, the majority of citizens
fled to their plantations in the interior, leaving
only a small number to prepare a defence; this
amounted to sinking ships in the harbour to block
the channel (DD on the plan). Instead of a direct
attack, Drake made for an inlet (B). Carleill's

BELOW: Drake assembled his troops close to an inlet ten
miles west of Santo Domingo. They are shown here making
ready to attack the city.

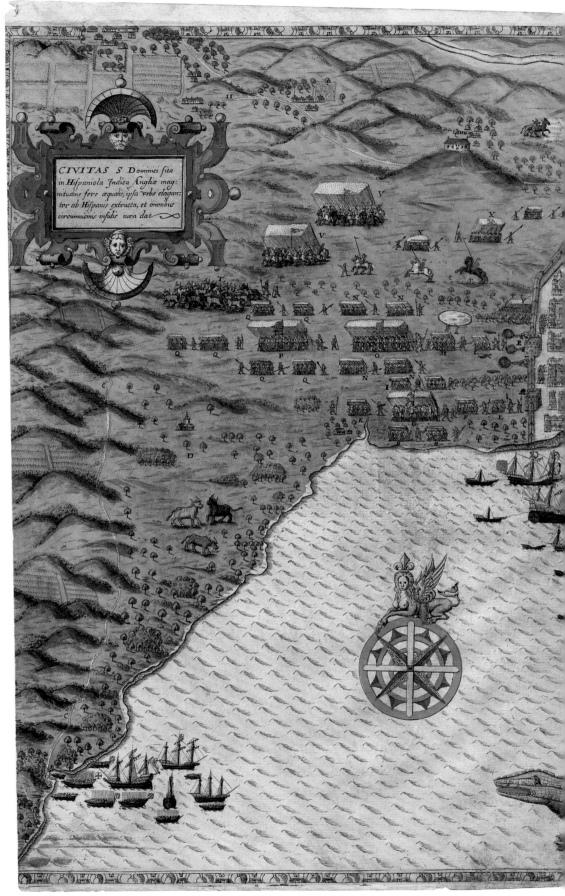

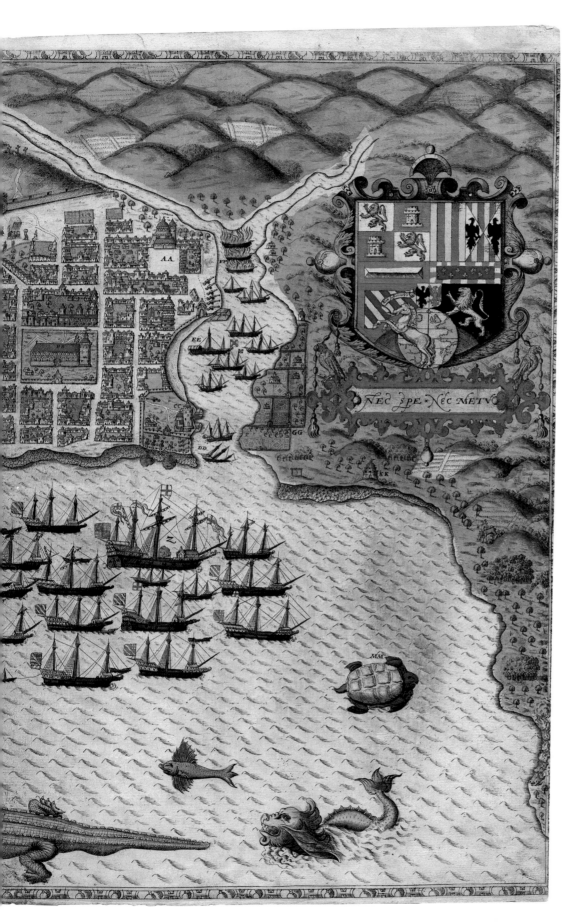

troops disembarked and proceeded to march ten miles along a 'woody way' (C) and then 'a beaten broad high way' to the city. With the only opposition being 'a greate drive of kine and oxen of huge bignesse', the city was soon taken. Drake made the cathedral his headquarters, and, when in need of an interpreter to negotiate with the Lord President of Santo Domingo, he sent as messenger Carleill's 'page' – one Baptista Boazio, the author of these maps.

On payment of a ransom, Drake prepared to leave, but could not bear to part with an escutcheon he had removed from the house of the governor. This said escutcheon – 'painted with the armes of the king of Spaine' – appears on the map as an invitation to nationalistic jeering at the words *Non sufficit orbis* ('the world is not enough'). The writer comments that some of the Spaniards were 'greatly ashamed thereof' on being told that if Queen Elizabeth made war on the king of Spain, 'hee should be forced to lay aside that proud and unreasonable reaching vaine of his: for hee should finde more than inough to doe to keepe that which he had already, as by the present example of the lost towne.'

BELOW: Ships were set ablaze and sunk in the harbour to prevent the entry of Drake's fleet into the principal city of the West Indies.

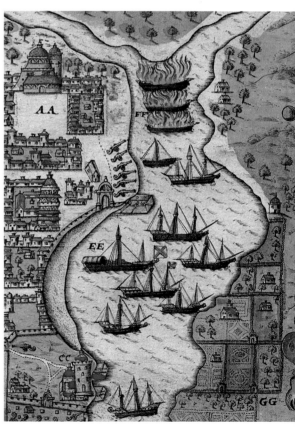

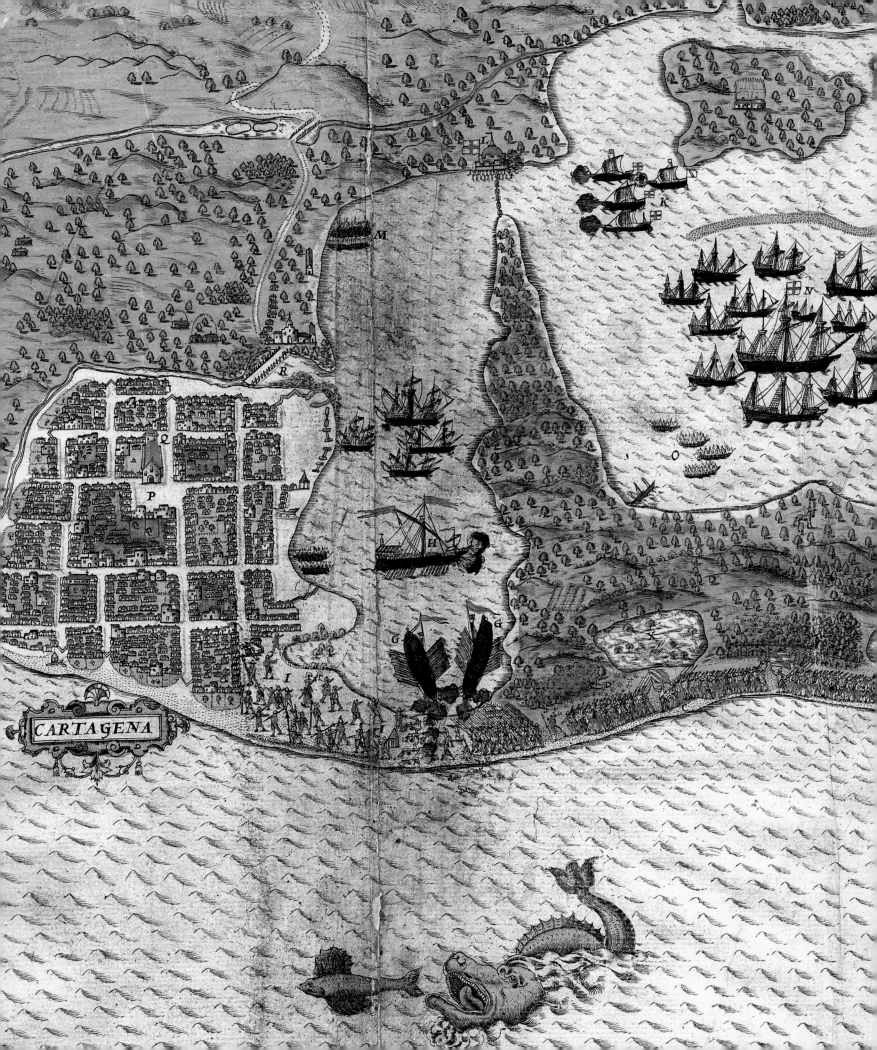

CARTAGENA

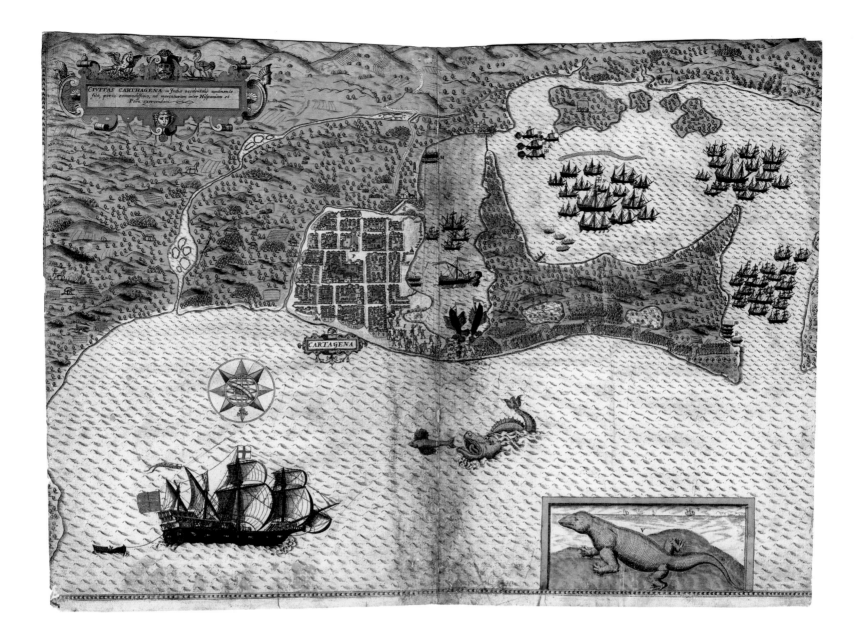

Plan of Cartagena (Colombia)

**Baptista Boazio (fl. 1588–1606), cartographer
and illustrator**
London, 1589
Hand-coloured copperplate engraving
Sheet (trimmed) 411 × 529 mm
AMIB 1988.125.4

According to the compass rose, this map is 'upside down' with south at the top. The city of Cartagena is described as 'a most convenient port for merchants trading between Spain and Peru' because of its position on the north coast of South America. It is shown here arranged around inner and outer lagoons. Having had warning of Drake's attack on Santo Domingo, the inhabitants were able to make some preparations. These measures included sending their families and

valuables to the country, hanging a chain to block the entrance to the inner harbour (see detail), and digging a trench across the neck of the Caleta, the narrow stretch of land extending westwards (to the right on this map). Poisoned stakes were planted along the way, and two galleys (shown on the plan with their oars, pennants and thundering cannon) positioned to further defend this territory.

While Drake's fleet lay at anchor in the outer harbour, Carleill's men disembarked (point B on plan) and set out to march eastwards along the Caleta shore. Although there were setbacks because of obstacles, the decision to attack before dawn under cover of darkness was a wise one; the Spanish were taken by surprise. The two royal galleys were ineffective: like the large galleass also

in the inner harbour, they could not move to the outer harbour to fire on the English because of low water. To add to these difficulties, the African galley slaves mutinied, some escaping to the English. One of these vessels caught fire after an explosion of gunpowder, and, in the end, both were burnt by order of the Spanish commander to prevent them falling into Drake's hands.

The English did not have long to enjoy their triumph. With delays caused by haggling over ransom payments, both land and sea forces were becoming victims of an epidemic of fever. Moreover, there was news of the imminent arrival of a fleet from Spain. Pressurised by his military captains, Drake was forced to accept a lower ransom payment and hasten to his next port of call: the Spanish colony at St Augustine.

Plan of St Augustine (Florida)

Baptista Boazio (fl. 1588–1606), cartographer
and illustrator
London, 1589
Hand-coloured copperplate engraving
Sheet (trimmed) 411 × 533 mm
AMIB 1988.125.5

With north at right, Boazio's bird's-eye view is the first printed map of a city in what was to become the United States. St Augustine had in fact been built on the site of an earlier settlement, which had been destroyed when Spanish forces evicted and massacred the French Huguenots living there – such was the importance given to supremacy on the south-east Atlantic coast, along which passed Spanish ships laden with New World treasure. Unlike the citizens of Santo Domingo, those of St Augustine were well prepared: news of Drake's raids had swept through the Caribbean, along with rumours of uprisings of African slaves and native Indians. Indeed, the depleted numbers on board Drake's plague-stricken ships had been augmented by five hundred escapees. No stranger to the slave trade himself, Drake was greatly assisted in his capture of the town by various anti-Spanish elements in the Caribbean and surrounding region.

By the time Drake arrived, the Spanish governor had evacuated the town and built a fort of cedar trees (point I on the plan). Drake's troops disembarked (at point B) and 'marched along the sand by the sea side towards their fort' (D). From the opposite side of the inlet, the English bombarded the fort until told by an escaped French prisoner that it had been abandoned. Having helped themselves to ordnance and treasure, Drake's forces went on to the town (at left on the plan). There they found local native tribes in the process of burning it. After resting three days in the fort, Drake and his men completed the destruction on their departure. According to the account, many of the freed African slaves chose to stay in Florida, perhaps liking the look of the country, 'as goodlie a soyle as maie bee, with so great abundance of sweete woodes as is wonderfull'.

Drake's last task was to sail north to the newly settled English colony of Roanoke in 'Virginia' to offer any necessary help. The artist John White was among the hard-pressed colonists offered a passage back to England. He must have met Boazio on the voyage and given permission to reproduce on the maps his watercolours of local fauna. These illustrations included this 'livelie portraiture of the fish called the Dolphin, which … taketh pleasure… by swimming by the ship'.

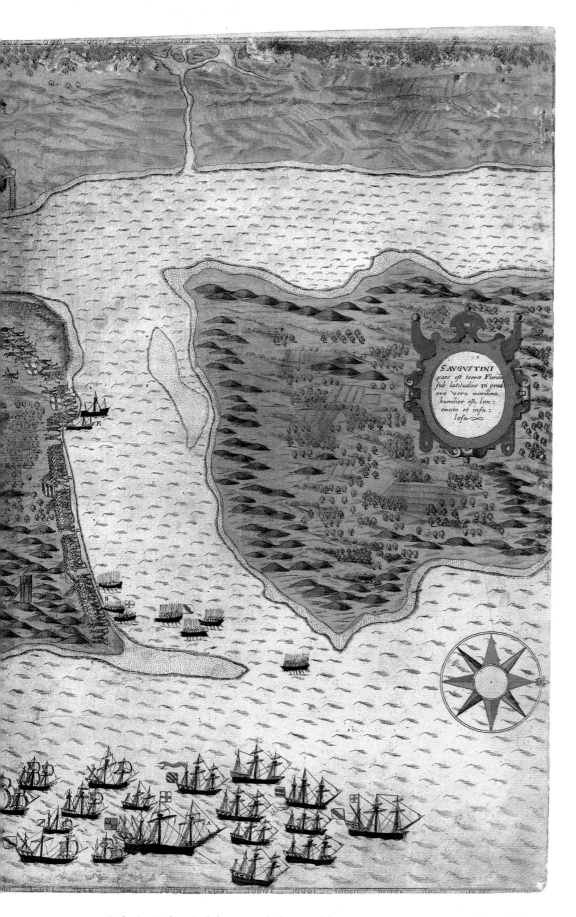

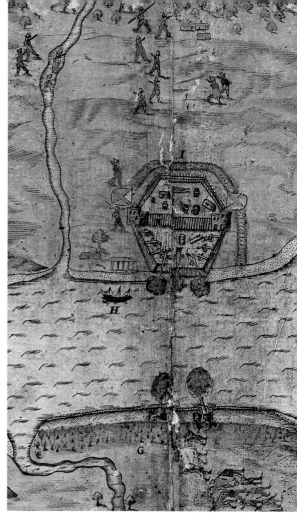

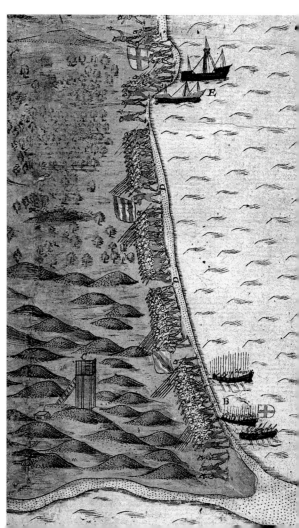

SAVGVSTINI pars est terræ Floridæ sub latitudine 30 grad ora vero maritima humilior est, lanæ cinata et insulosa

ABOVE RIGHT: By the time Drake arrived, the governor had evacuated the town and was waiting in a newly built fort (I) with eighty men. The English bombarded these troops with cannon positioned in woods across the bay (G).

BELOW RIGHT: After Drake's troops disembarked (B), they 'marched along the sand by the sea side towards their fort' (D).

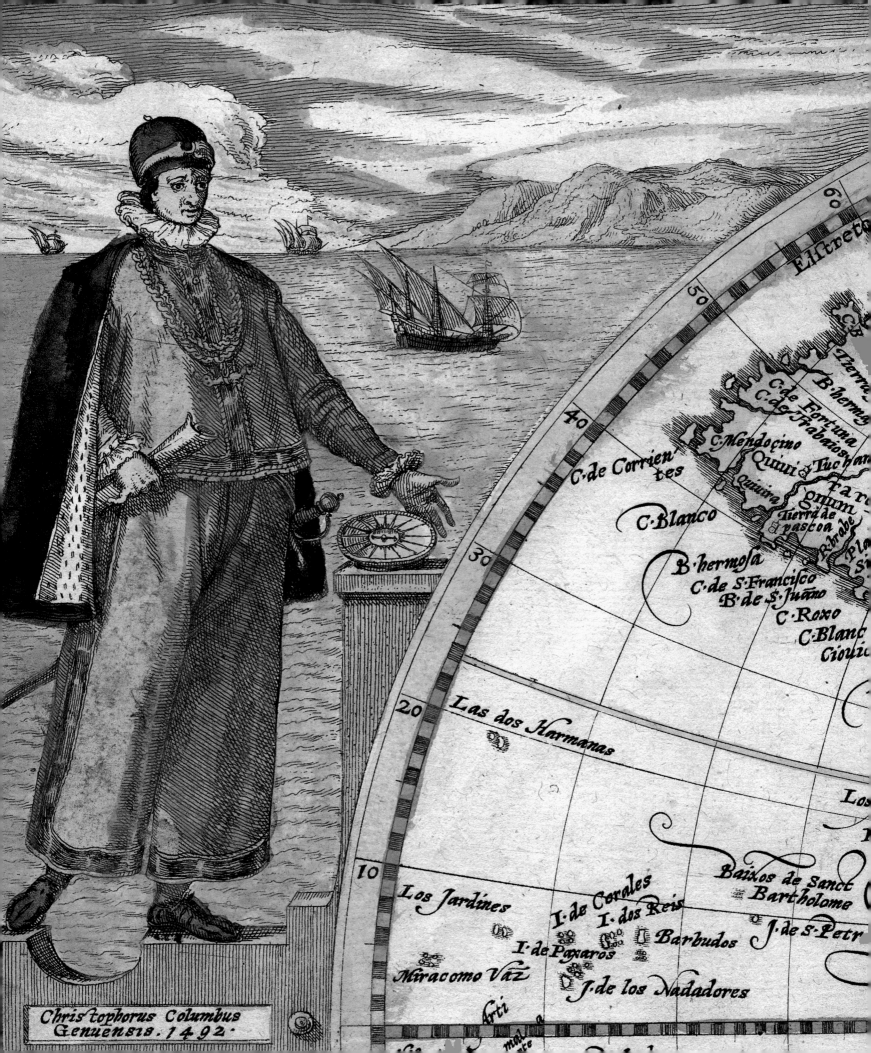

Christophorus Columbus
Genuensis. 1492.

Elstreto

90

50

40 C·de Corrientes

C·Blanco

30 B·hermosa
C·de S·Francisco
B·de S·Iuáno
C·Roxo
C·Blanc
Cioui

20 Las dos Harmanas

Tierra
B·herma
C·de Fortuna
C·de Trabaios
C·Mendoçino
Quiui y Tuchan
Quivira
Tara
onum
Tierra de
pascoa
R·brabe
Pla
Si

Los

10 Los Jardines I·de Corales Baixos de Sanct
I·dos Reis Bartholome
I·de Paxaros Barbudos J·de S·Petr
Miracomo Vaz J·de los Nadadores
Arti

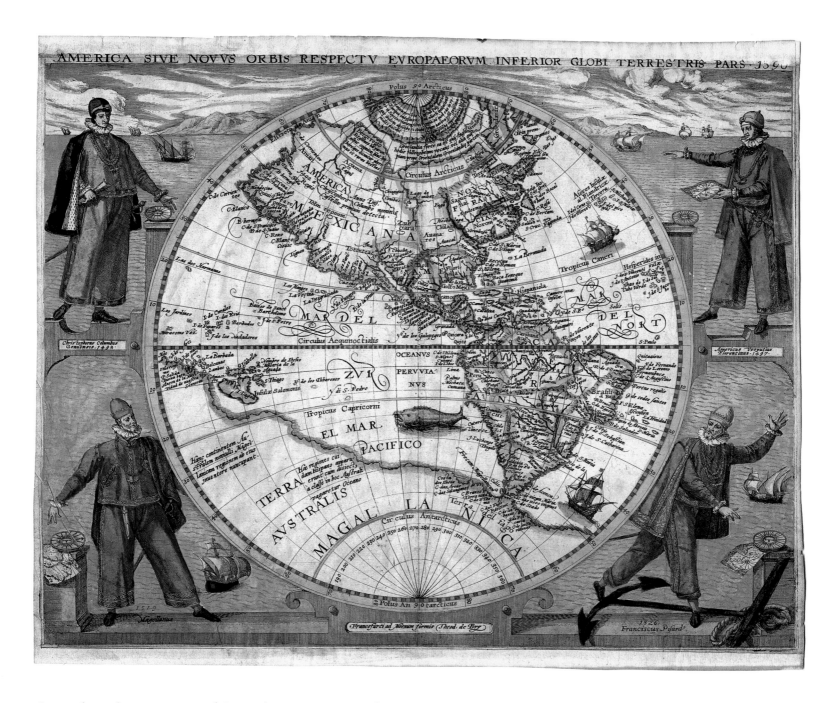

America sive novus orbis… (America or the New World…)

**Theodor De Bry (1528–1598), illustrator
and engraver**
Frankfurt, 1596
Hand-coloured copperplate engraving
Sheet 345 × 406 mm; plate 323 × 401 mm
AMIB 1988.124

Born in Liège, in the then Spanish Netherlands, Theodor De Bry came from a family of jewellers and engravers. A religious dissenter, he fled in 1570 to Strasburg, then a major centre of the Protestant publishing and book trade. From here he moved to Frankfurt and became established as an engraver and, subsequently, as a publisher. Aware of the public's interest in descriptions of the new territories discovered in the preceding hundred years, he travelled widely to search out accounts of explorations. In 1590 he launched his major series of illustrated books under the titles *Les Grands Voyages* or journeys to the West and *Petits Voyages* for those to the East and North.

This map of the Americas accompanied the third volume of Girolamo Benzoni's *History of the New World* (published as Parts IV–VI of *Les Grands Voyages*). The author, an Italian from a poor family, went to the Americas to seek his fortune, travelling as far as Peru. On his return, Benzoni decided to write a book to tell 'of the strange and rare things' he had seen. Together with de las Casas's *Brevissima Relación*, Benzoni's tales fuelled the so-called 'black legend' of Spanish cruelty in the New World. First published in 1565, Benzoni's account became more widely known when it was included in the *Les Grands Voyages*.

This map is largely based on the western hemisphere of the 1594 world map by Peter Plancius, but what draws the eye are the lively figures depicted in the corner spandrels. This gallery of explorers – Christopher Columbus (1451–1506), Amerigo Vespucci (1454–1512), Ferdinand Magellan (*c.*1480–1521), and the conquistador Francisco Pizarro (*c.*1471 or 1476–1541) – demonstrates De Bry's business acumen: finely executed illustrations could greatly add to the commercial success of a map.

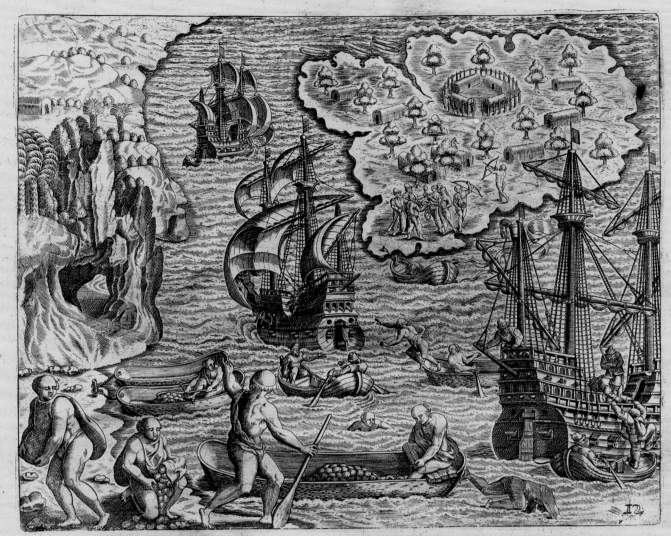

TERTIÂ *in Indiam expeditione, Columbus sinum Pariensem ingressus, Cubaguam appulit, quam ipse Perlarum Insulam nuncupauit, quia quum eum sinum nauibus percurreret, Indos è lintre ostreas piscantes conspexit: quas edules esse rati quum aperuissent Hispani, plenas vnionibus repererunt, vnde magna illis lætitia oborta. Peruenientes ad littus in terram egrediuntur, vbi mulieres Indicas pulcerrimos vniones collo & brachiis gestantes obseruant, quos vilibus rebus redimunt.*

<p style="text-align: right;">D Colum.</p>

Perlarum insula… (The Island of Pearls…)

Theodor De Bry (1528–1598), illustrator and engraver, after Girolamo Benzoni (b. 1519)
Frankfurt, 1594
Copperplate engraving
Page 297 × 225 mm; plate 166 × 202 mm approx.
AMIB 1988.204

Although early explorations in the New World focused mainly on the search for gold, pearls proved to be equally acceptable as objects of desire. This print by Theodor De Bry illustrates the island of Cubagua off the coast of Venezuela. Indians are shown diving for pearls, which are being loaded by the sackful onto Spanish ships. The text is from Benzoni's popular *History of the New World*. It describes how Columbus, on his third voyage in 1498, arrived from the Gulf of Paria at the island and observed Indians collecting 'sea snails' for food and 'saw Indian women with pearls beautiful beyond compare on their throats and arms'. It is disputed, however, whether Columbus discovered the island: although he certainly sailed into Paria, he had to hasten back to Hispaniola and turned north. Whoever it was, Benzoni remarks dryly that the Spaniards gave them worthless goods in exchange. It is certainly true that the pearl banks which initially provided Spain with immense riches were, in the end, over exploited and exhausted.

Right:

Document signed by the Queen of Spain ('Yo la Reyna')

Isabella I of Castille (1451–1504),
Granada, 5 Jan 1501
Manuscript
Page 301 × 214 mm
AMIB 1989.194

Although it is accepted that Isabella was more interested in bringing heathen souls to Christ than in the acquisition of treasure from the New World, she cannot have been indifferent to the quantities of pearls which were being brought from the Indies. This letter, in her secretary's handwriting but signed 'I, the Queen' by Isabella herself, is written from her court in Grenada. She instructs her chamberlain to 'give to Violante de Albion, my servant, who for me has charge of things from my boudoir, a pearl…brought back from the Indies… The said pearl [is the one that] weighs three *quilates* and three grains, which is all together 15 grains. [Give it to her] so that she can place it in a gold vessel that she has for my use which holds other pearls.' In the archives of the Spanish Royal Family until the 1920s, this letter was acquired by Dallas Pratt in 1989.

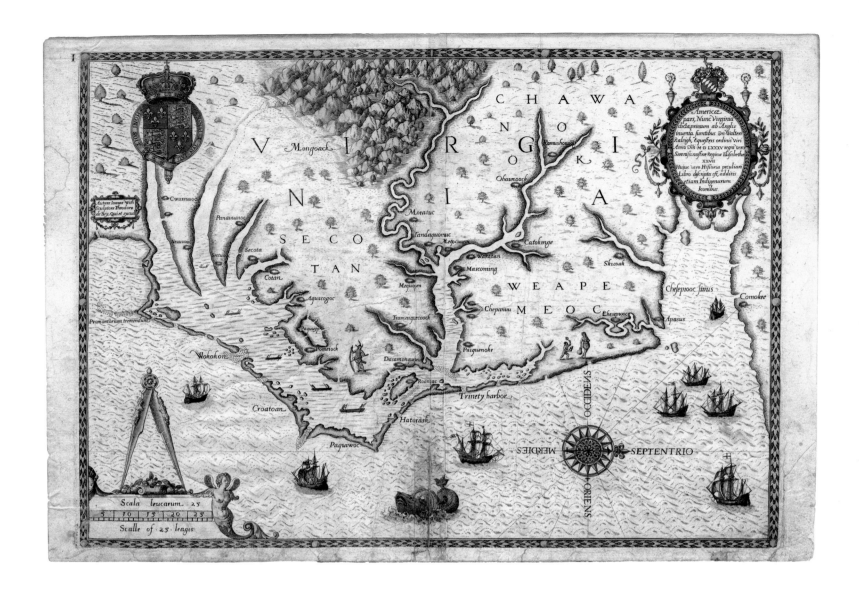

Americae pars, Nunc Virginia… (Map of Virginia) from *America Part I (Virginia)*

Theodor De Bry (1528–1598), illustrator
and engraver, after John White (*c*.1540–*c*.1593)
Frankfurt, 1598
Hand-coloured copperplate engraving
Sheet 322 × 455 mm; plate 305 × 416 mm
AMIB 1988.44

Originally published in 1590, John White's map of Virginia (now North Carolina) is a cartographic landmark: the first printed map of the first English colony in North America. Owing to its accuracy and detail, it is popularly considered to be the best sixteenth-century map of any part of the continent. The original water-colour map must have been made in about 1585. From 1590 onwards, however, it appeared in printed form in the various editions of De Bry's *America, Part I (Virginia)* in the *Les Grands Voyages* series. This publication, which also contained prints of John White's watercolour

drawings of the native people, flora and fauna, contributed significantly to English enthusiasm for overseas expansion in the New World, which was also encouraged and promoted by luminaries such as Richard Hakluyt and Sir Walter Raleigh.

With north at right, the map extends from Cape Lookout, along the Outer Banks of North Carolina up to Chesapeake Bay. Prominent within the banks is the island of Roanoke, where attempts were made at settlement in 1585. Red dots (the tint added by a later hand) show the places visited by the would-be colonists, among them John White and the scientist Thomas Hariot, whose book *A briefe and true report of the new found land of Virginia* (1588) provided the text accompanying White's drawings in De Bry's publication. The Tudor crest (left) and Raleigh's crest above the cartouche (right) denote theoretical possession by Elizabeth I of England, the Virgin Queen.

The attempted settlement came to a close in

1586 when Sir Francis Drake, returning from his West Indian voyage, called in at Roanoke to bring supplies, but on seeing the disheartened state of the colonists, offered them a passage home. A year later, Raleigh sent a second group of 150 colonists to Roanoke, with John White now acting as governor. Among the settlers was White's daughter, who gave birth to the first English child born on American soil, Virginia Dare. Hostility on the part of the Indians, who, unsurprisingly, did not feel that they should support the newcomers, prompted White to return to England in late 1587 to seek help and supplies. Because of the threat of the Spanish Armada the following year, White was unable to return until 1590, only to find that all the colonists had disappeared. In spite of efforts in later years, they were never traced and became known as the 'Lost Colony of Roanoke', one of the best-known unsolved mysteries in American history.

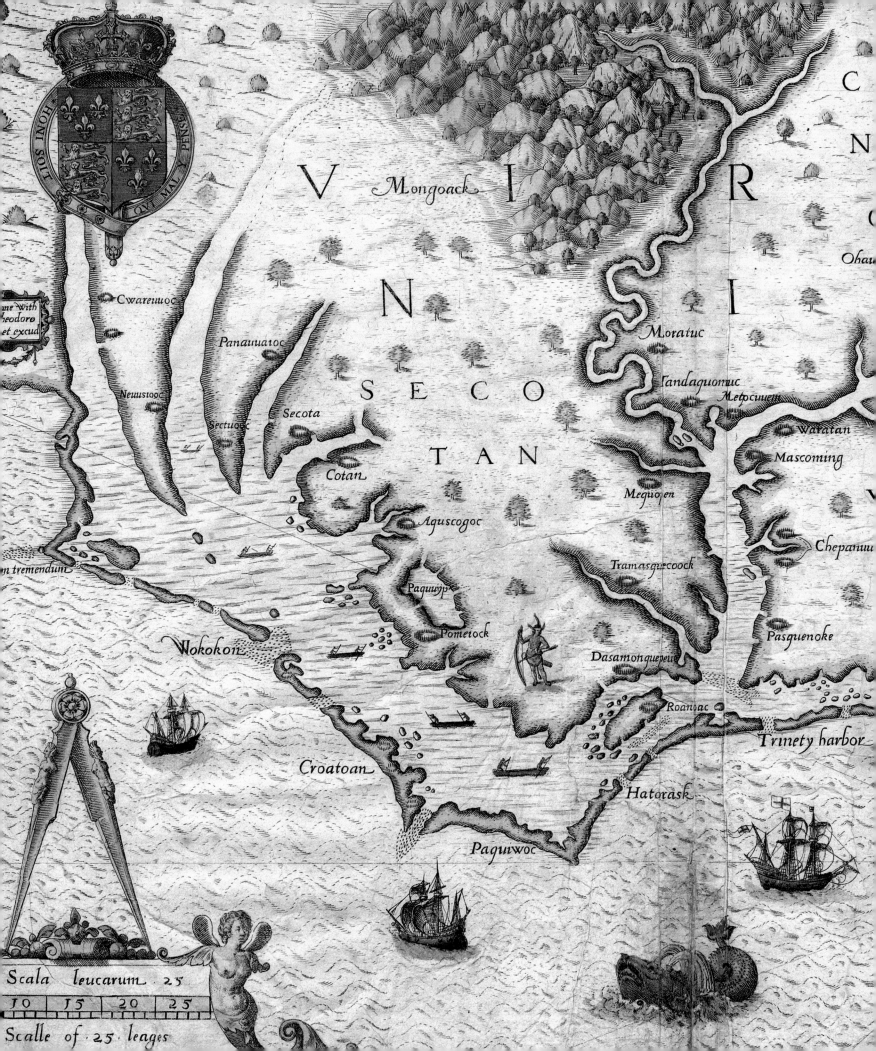

HONI SOIT QVI MAL Y PENSE

V I R
C
N
I
N
V
C
O
R

Mongoack

Cwareuuoc

Panauuaroc

Neuusiooc

Sectucoc Secota

SECO

TAN

Cotan

Ohau

Moratuc

Tandaquonuic Metocuuem

Waratan

Mascoming

Mequopen

Aguscogoc

n tremendum

Paquuyp

Tramasqucoock

Pomeiock

Chepanuu

Wokokon

Dasamonquepeu

Pasquenoke

Roanoac

Trinety harbor

Croatoan

Hatorask

Paquiwoc

Scala leucarum 25

10 15 20 25

Scalle of 25 leages

The many volumes of *Les Grands Voyages* are all linked by a common purpose: to undermine the claims of Catholic Spain in the New World. As such, De Bry's publishing enterprise is partly a work of propaganda. Caution is necessary particularly when assessing the engraved depictions of the Algonquian people, which, more than John White's original drawings, are works of artifice rather than ethnography. These idealised individuals, surrounded by an earthly paradise, inversely reflect the corruption of Europe. As if to accentuate this point in the first volume, *America Part I (Virginia)*, De Bry included depictions of tattooed Picts (also based on watercolour drawings by John White). De Bry did so, according to his Preface: 'for to showe how that the Inhabitants of the great Bretannie haue bin in times past as sauuage as those of Virginia.'

In 1588, when De Bry met White, who had returned to England to seek help and supplies, the nation was preparing for the threat of Spanish invasion. De Bry's suggestion that White's watercolour sketches should be published encouraged White to rework them in the hope that, by publicising their plight, the proposed book could aid him in his efforts to raise funds to salvage the Roanoke colony. De Bry utilised twenty-three of White's originals to accompany Thomas Hariot's 'brief and true' description of the land their sponsor Raleigh had named 'Virginia'.

De Bry made some concessions to contemporary taste when engraving copies of White's drawings: he added figures and other items to scenes for the sake of artistic balance; the men appear over-muscled to comply with the Mannerist style (although accounts do describe the native Virginians as having robust health and strong physiques); the women's figures are plumped to almost Rubenesque proportions; and poses have been altered for fear of offending a European reader's sense of decency.

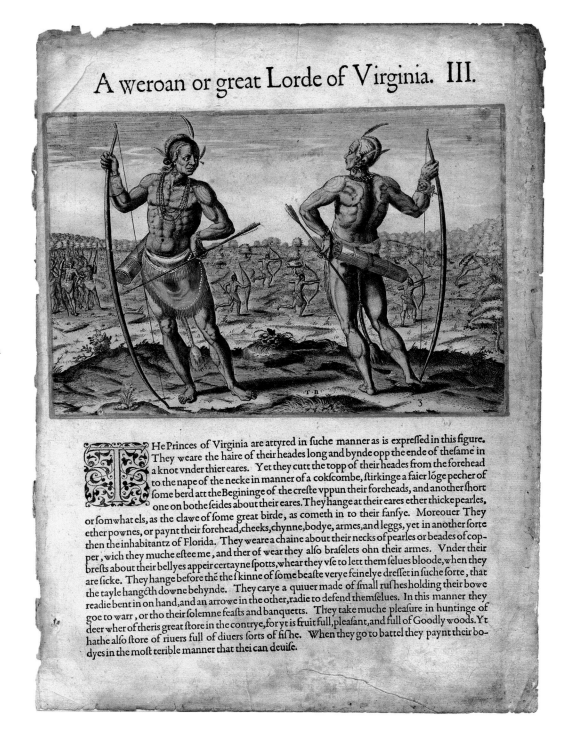

A Weroan or great Lorde of Virginia (plate III) from *America Part I (Virginia)*

Theodor De Bry (1528–1598), illustrator and engraver, after John White (*c.*1540–*c.*1593)
Frankfurt, 1590
Hand-coloured copperplate engraving
Page 338 × 241 mm; plate 150 × 218 mm approx.
AMIB 1965.129.2

The princes of Virginia are arrayed in suche manner as is expressed in this figure. They weare the hair of their heades long and bynde opp the ende of the same in a knot under their eares. Yet they cut the top of their heads from the forehead to the nape of the necke in manner of a cockscombe… They weare a chaine about their necks of pearles or beades of copper, wich they much esteeme. And ther of wear they also braselets on their armes. Under their breasts about their bellyes appear certayne spots, whear they use to let themselves bloode, when they are sicke… They take much pleasure in hunting of deer wher of ther is greate store in the countrye, for yt is fruitfull, pleasant, and full of Goodly woods. Yt hathe also store of rivers full of divers sorts of fishe. When they go to battle they paynt their bodyes in the most terrible manner that they can devise.

A Chief Lady of Pomeiock (plate VIII) from *America Part I (Virginia)*

Theodor De Bry (1528–1598), illustrator
and engraver, after John White (*c*.1540–*c*.1593)
Frankfurt, 1590
Hand-coloured copperplate engraving
Page 338 × 241 mm; plate 150 × 218 mm approx.
AMIB 1965.129.2

About 20 miles from that Iland [Roanoke]… is another towne called Pomeiock, hard by the sea. The apparel of the cheefe ladies of dat towne differeth but little from the attyre of those which live in Roanoke. For they weare their haire trussed opp in a knott,… and have their skinnes pownced [smoothed with pumice], yet they wear a chaine of great pearles, or beades of copper, or smoothe bones 5 or 6 fold about their necks, bearing one arme in the same, in the other hand they carye a gourde full of some kinde of pleasant liquor… Commonlye their yonge daughters of 7 or 8 yeares old do wayt upon them… They are greatlye Diligted with puppets, and babes [dolls] which wear brought oute of England.

Their sitting at meate (plate XVI) from *America Part I (Virginia)*

Theodor De Bry (1528–1598), illustrator
and engraver, after John White (*c*.1540–*c*.1593)
Frankfurt, 1590
Hand-coloured copperplate engraving
Sheet 335 × 243 mm; plate 152 × 213 mm approx.
AMIB 1965.129.1

Their manner of feeding is in this wise. They lay a matt made of bents [twigs] on the grownde and sett their meat in the mids therof, and then sit downe Rownde, the men upon one side, and the women on the other. Their meat is Mayz… of very good taste, deers fleshe, or of some other beaste, and fishe. They are very sober in their eatinge and trinkinge, and consequentlye very long lived because they doe not oppress nature.

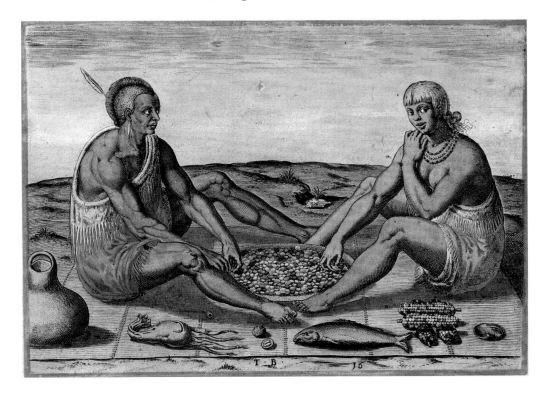

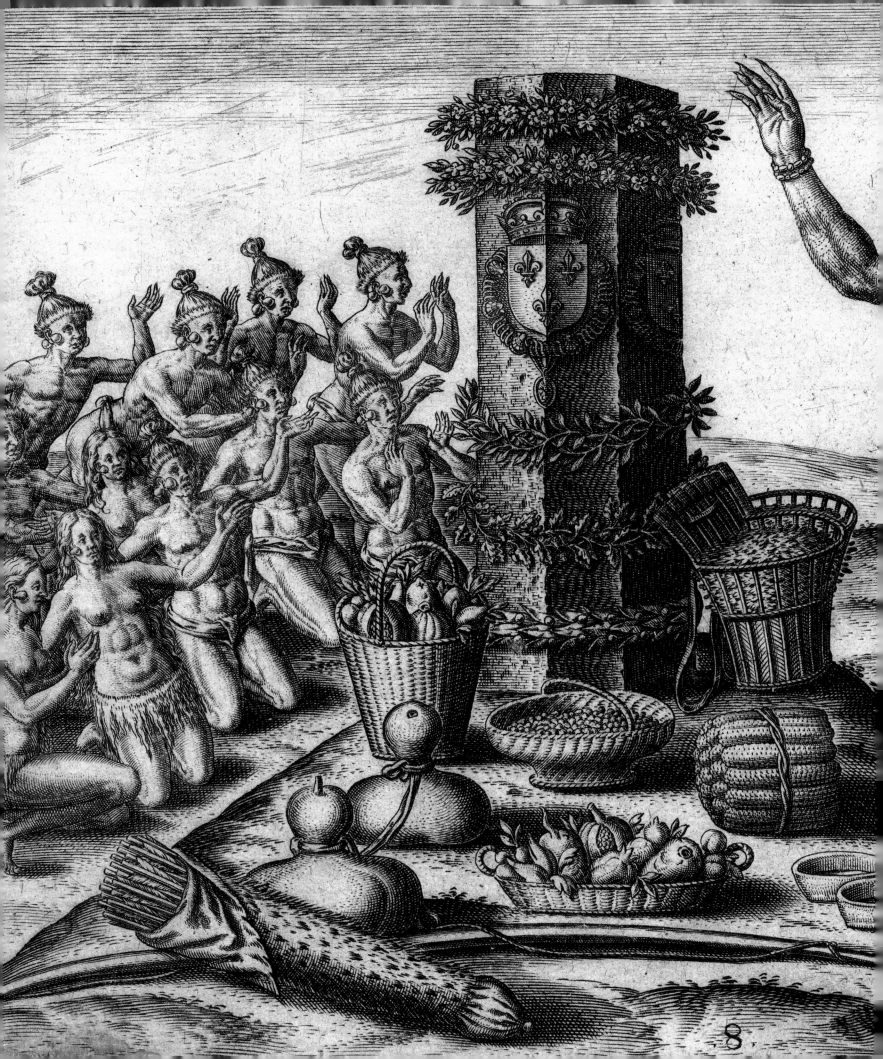

8

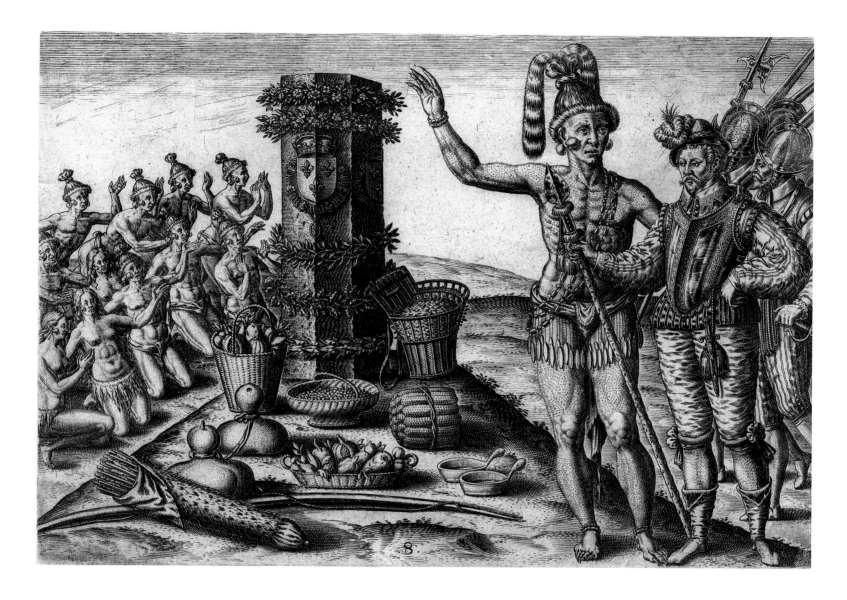

The Indians of Florida Worship the Column (plate VIII) from *America Part II (Florida)*

Theodor De Bry (1528–1598), illustrator and engraver, after Jacques le Moyne de Morgues (c.1533–1588)
Frankfurt, 1591
Copperplate engraving
Page 317 × 229 mm; plate 150 × 211 mm approx.
AMIB 1989.196

De Bry made several journeys to London between 1585 and 1588. Here he chanced upon the adventurers who were to secure his family's fortune and fame – most notably the geographer Richard Hakluyt, who was a close friend of the statesman and poet Sir Philip Sidney. Through Sidney's mother, a patron of the arts, De Bry may have met the French painter Jacques le Moyne, who had dedicated his only publication to her (a small quarto volume with woodcut illustrations based on his botanical drawings). The Sidney family were Huguenot sympathisers. If not for le Moyne – another refugee fleeing religious persecution – it is unlikely that De Bry would have embarked on his 'Voyages'.

In 1564, with other French Huguenots, le Moyne had sailed to 'la Florida', where he recorded the flora, fauna and native peoples in a series of watercolour drawings. A French expedition two years earlier had established a settlement (subsequently abandoned) in what is now South Carolina. Both voyages attempted to stake a Protestant claim in the New World. The second French fort was destroyed by Spanish Catholic forces, who massacred many of its inhabitants. A few men escaped through the swamps, including le Moyne; his drawings, however, did not survive the attack. Later, le Moyne repainted his pictures in London from memory. Using the already published narratives of the two French captains for text, De Bry hoped to produce an illustrated account of the French expeditions in Florida, by engraving le Moyne's second series of watercolours onto copperplate.

Although the Frenchman refused, after le Moyne's unexpected death in 1587 his widow sold his drawings to De Bry. What De Bry had intended to be the first illustrated travelogue in his *Les Grands Voyages* series was thus the second to be produced.

De Bry's engraving pictured here is based on the only surviving watercolour by Le Moyne and depicts the French commander René de Laudonnière being welcomed by Chief Athore during the second expedition to Florida. Athore is pointing to a stone column, carved with the arms of the king of France, erected by the commander of the previous expedition, Jean Ribault; it is surrounded by offerings of fruit, herbs and weapons and is apparently being worshipped by the Indians. Chief Athore is described as 'very handsome, wise, honourable and strong, and at least half a foot taller than the tallest of our men. He was grave and modest and his bearing was majestic.'

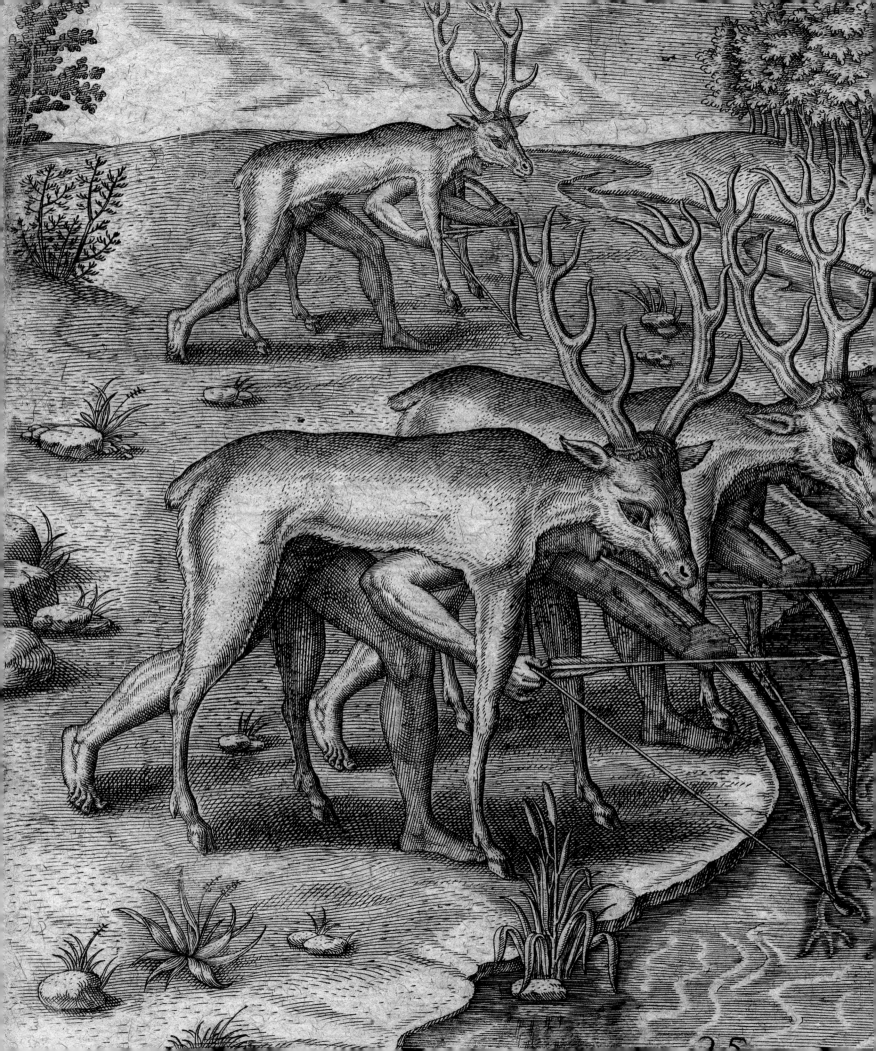

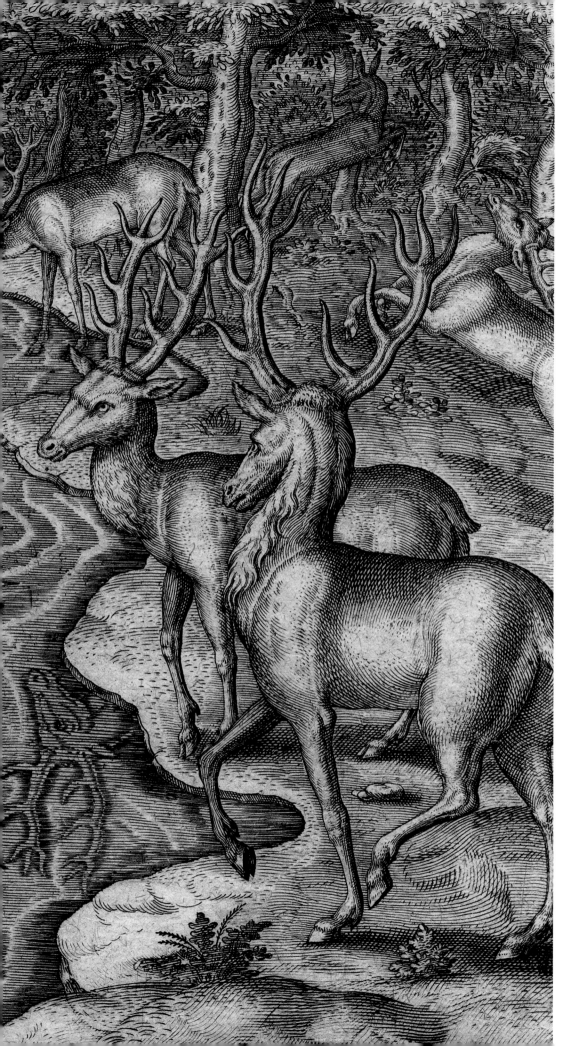

Hunting Deer (plate XXV) from *America Part II (Florida)*

Theodor De Bry (1528–1598), illustrator and engraver, after Jacques le Moyne de Morgues (*c.*1533–1588)
Frankfurt, 1591
Copperplate engraving
Page 319 × 220 mm; plate 155 × 211 mm approx.
AMIB 1989.198

The timing of De Bry's companion Virginia and Florida volumes (1590, 1591) was propitious. The defeat of the Spanish Armada in 1588 weakened the hold of Catholic Spain on the New World. North America was now ripe for (English) Protestant picking. Many of De Bry's illustrations paint a picture of an idyllic life led by the Indians of North and South Carolina, no doubt in order to encourage European colonisation.

Some scenes of warfare are included in *Part II (Florida)*, but the general impression is of Indians living a communal life in a Utopian society, in harmony with the natural world. Romantic scenes show: beautiful long-haired maidens tending crops; a family crossing to an island for a picnic, preparing for a feast and caring for their sick; and men collecting gold in streams. Below an illustration of the public granary is the comment: 'they go for supplies whenever they need anything – no one fears being cheated. Indeed, it would be good if among Christians there were as little greed to torment men's minds and hearts.'

There is in *Part II (Florida)* a picture of an alligator hunt, in which the poor creature is killed when a pole is pushed down its throat, but the deer hunt depicted here confirms the vision of a serene natural life. The unsuspecting and trusting deer fails to see the spears of the huntsmen who have donned skins as camouflage, 'looking through the eye holes as through a mask'. The author comments: 'they prepare the deerskins without any iron instruments, using only shells… I do not believe any European could do this better.'

111

Nova Francia (New France)

Petrus Plancius (1552–1622), cartographer; Jan van Doetichum the Younger (fl. 1592–d. 1630), illustrator and engraver, after Cornelis Claesz van Wieringen (1576–1633)
Amsterdam, 1594
Copperplate engraving
Sheet 418 × 548 mm; plate 388 × 550 mm
AMIB 1988.117

In spite of the thriving commercial map and chart trade in the Netherlands, Dutch navigators had mainly confined themselves to European waters. After the Spanish Netherlands had been divided into Holland and Belgium in 1581, however, Philip II of Spain gave exclusive shipping rights in European coastal waters as recompense to the Portuguese, whose land he had just annexed. This was a serious mistake, inciting the Dutch to seek routes to intercontinental trade and eventually to challenge and displace the Portuguese overseas empire in the East. The Dutch voyages could never have been made possible without a series of printed nautical charts of which this is the first.

Infested with sea monsters spouting jets of water vapour from two blowholes at the top of their heads, this richly detailed map is extremely rare. Fewer than ten copies are recorded.

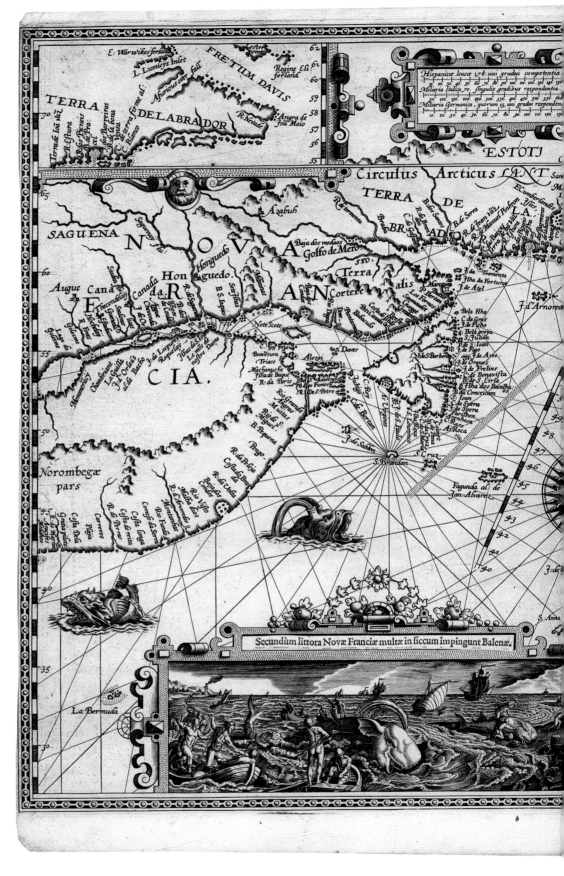

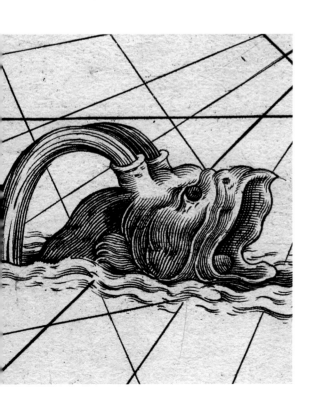

LEFT: A sea monster with two blowholes at the top of its head.

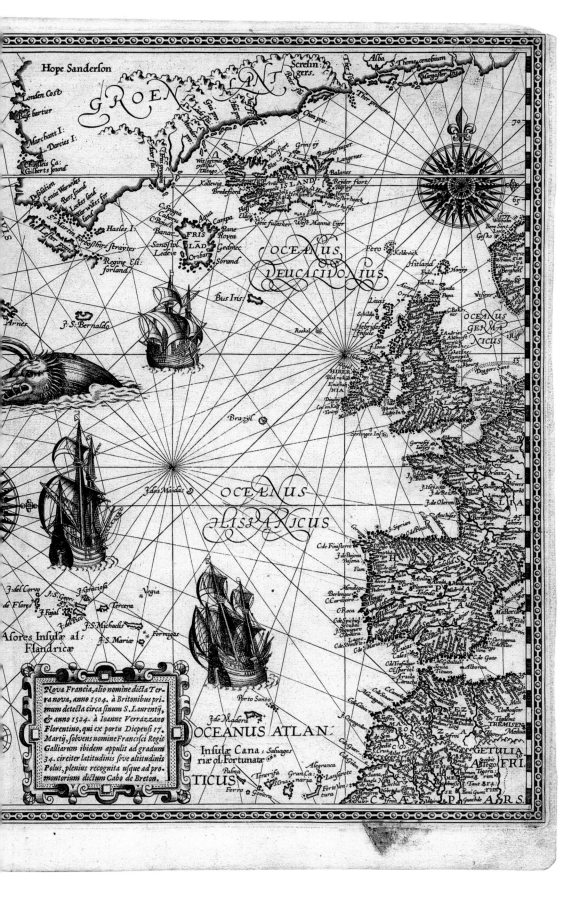

Moreover, the cartographic work matches the maker's technical skill in copperplate engraving and is considered among the finest ever produced. The tilted bar near the compass rose is the first attempt to depict magnetic north on a map, while the shaded strip near Newfoundland may represent the Grand Banks. The cartography of this map is partly based on that of Bartolomeu Lasso, the Portuguese portolan chart-maker. Lasso was the first to depict Newfoundland as a single triangular-shaped island, with one small island in the east named *Ilha dos Bacalhos* after the Portuguese word for 'cod'. The other source for this map is the globe created by the Elizabethan mathematician and instrument-maker Emery Molyneux of Lambeth. The information on Molyneux's globe reached Dutch map-makers through Jodocus Hondius, the globe's engraver, who returned to Amsterdam in 1593.

The dramatic whaling scene in the vignette below left (engraved by David de Meyn) bears the inscription: 'Along the shores of New France [Canada] many whales are grounded on dry land.' The delineation of Canada's northern parts is based on the Arctic voyages of the English explorers Martin Frobisher (1576–78) and John Davis (1585–87). The explorations in some instances overlapped, causing some confusion. An alternative outline of the territory is thus provided at top left.

RIGHT: A sharp-toothed leviathan – another peril to seafarers venturing across the ocean.

113

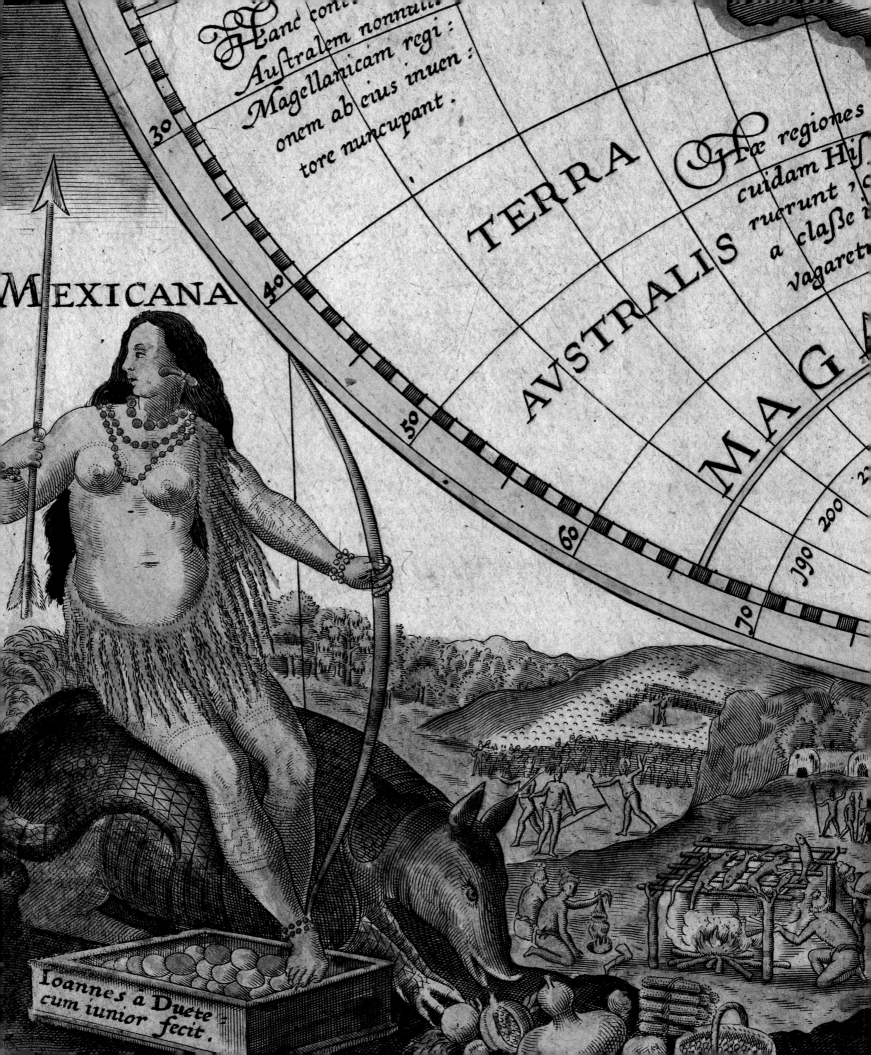

Hanc continentem
Australem nonnulli
Magellanicam regi:
onem ab eius inuen:
tore nuncupant.

MEXICANA

TERRA

AVSTRALIS

MAGA

Hæ regiones
cuidam His
ruerunt,
a classe
vagaret

30

40

50

60

70

200

190

Ioannes a Duete
cum iunior fecit.

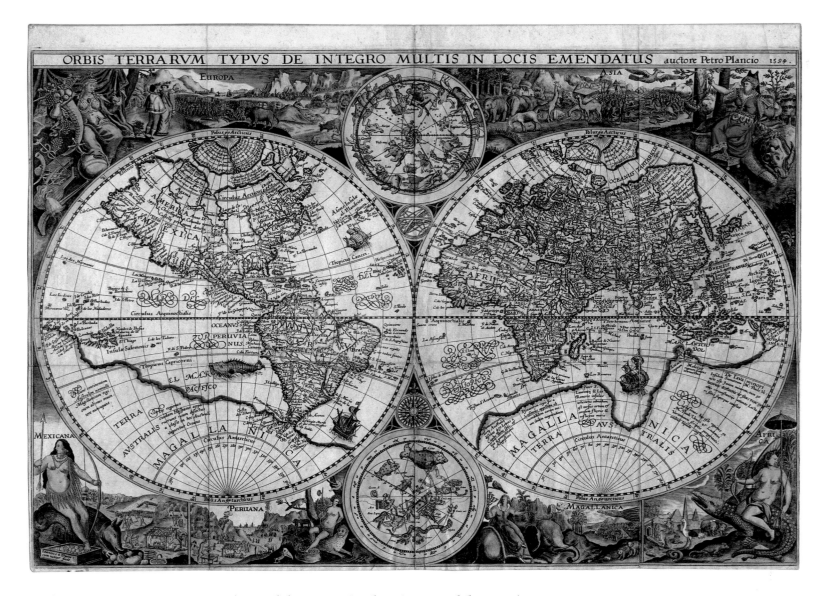

Orbis Terrarum Typus... (Double Hemispheric World Map)

Petrus Plancius (1552–1622), cartographer; Jan van Doetichum the Younger (fl. 1592–d. 1630), illustrator and engraver
Amsterdam, 1594
Hand-coloured copperplate engraving
Sheet (trimmed) 428 × 581 mm
AMIB 1988.40

By the late sixteenth century, map publishing in the grand manner was reaching its height in Amsterdam. With the expansion of Dutch overseas trade, attractive maps with decorative illustrations (such as this example) would hang in the offices of ship-owners and merchants. This double hemispheric world map by Plancius was later included in *Itinerario* (1596), a travel account by Jan Huyghen van Linschoten (1563–1611), but this large ornamental edition of 1594 was issued first as a separate sheet. The inscription above the map claims that it has been correctly amended in many places: in the East, for example, Korea is

shown as a peninsula, and there is a more accurate outline of Japan; in the Arctic, Novaya Zemlya is newly drawn as an island.

Plancius, who was born in Flanders but moved to Amsterdam, was one of the founders of the Dutch East India Company, and it was he who put together navigational instructions for the first Dutch voyage to the East Indies. Recognised as an expert on shipping routes, he provided the company with almost a hundred sea charts. With these, he promoted the use of Mercator's projection. Mariners had previously been reluctant to use maps with Mercator's innovation. Such maps were thought difficult to use without special training to calculate distance, even though the projection, with its increase in latitude towards the poles, gave more accurate sailing directions. When Dutch explorers and merchants returned from the East Indies and southern parts, Plancius questioned them about the stars in the southern hemisphere. From this collected data, Plancius

constructed and named various constellations, which were included by Johann Bayer in his 1603 *Uranometria*. These new stars also appear here, in the celestial chart below the main hemispheres.

The detailed decoration framing this map – the first printed example of its kind to feature elaborate allegorical figures in its borders – was possibly inspired by the illustrations incorporated into Theodor De Bry's *Les Grands Voyages*. The female figures represent Europe and Asia (above) and Africa, Magallanica, Peru and Mexico (below). Europe holds a cornucopia and is crowned. The other symbolic characters decorously ride side-saddle on such unlikely steeds as a rhinoceros, armadillo, leopard, elephant and crocodile. Note the tropical landscape imagined for *Terra Australis* – the unknown continent conjectured to 'balance' the lands of the northern hemisphere. This supposedly tropical southern landmass is represented by Magallanica, named after the explorer Ferdinand Magellan.

ABOVE LEFT: Celestial chart of the northern hemisphere.

BELOW LEFT: Celestial chart of the southern hemisphere.

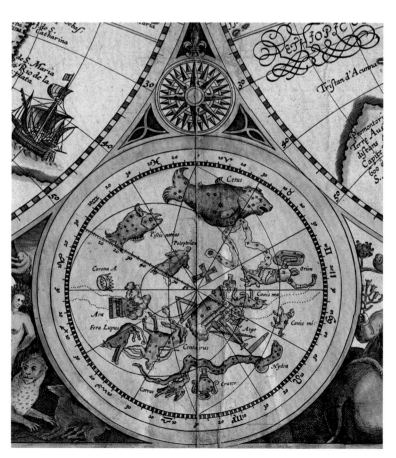

RIGHT: It was believed that an undiscovered southern continent, named after the Portuguese explorer Ferdinand Magellan, must exist to counterbalance the weight of Europe, Asia, Africa and the Americas. The elegantly dressed female personification of Magallanica sits atop an elephant, surrounded by exotic birds.

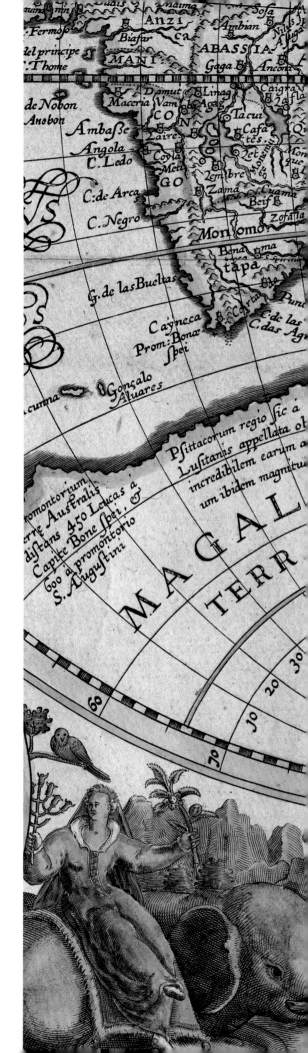

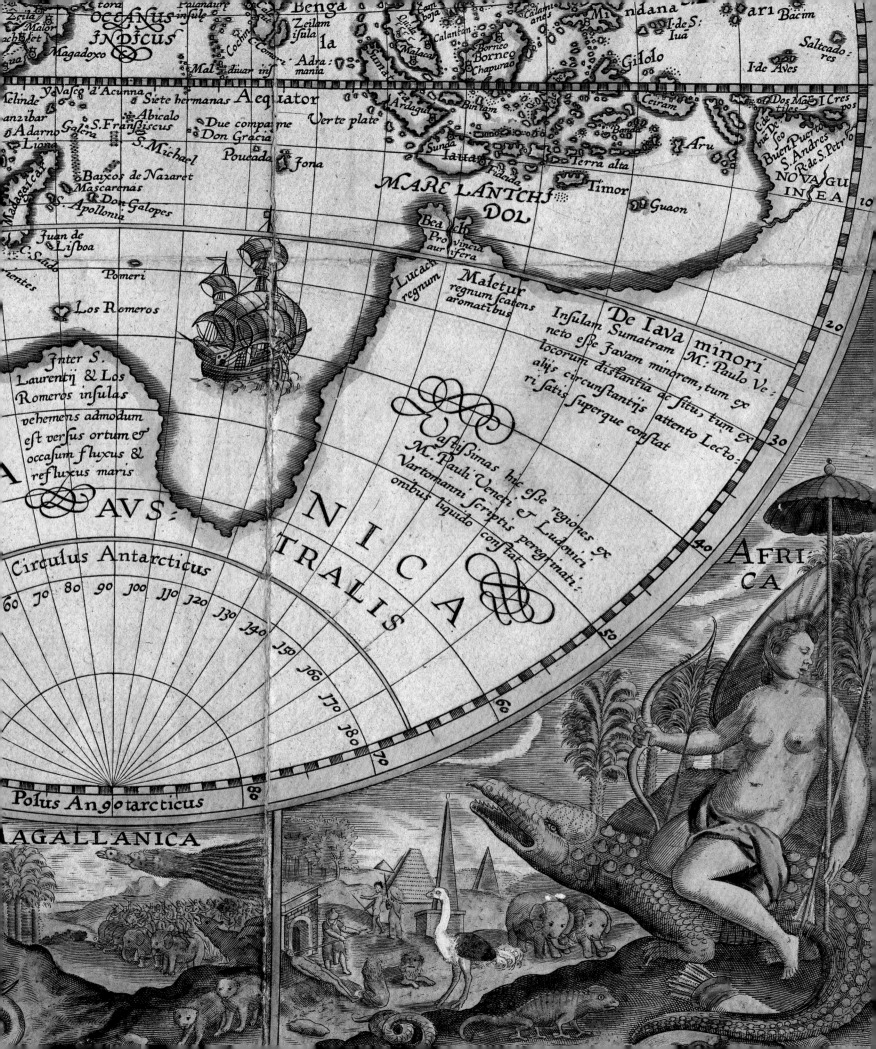

Septentrionalium Terrarum Descriptio (A Description of the Northern Lands)

Gerard Kremer, also known as Mercator
(1512–1594), cartographer
Amsterdam, after 1595
Hand-coloured copperplate engraving
Sheet 450 × 554 mm; plate 373 × 398 mm
AMIB 1988.39

Mercator's map of the Arctic was first published in 1595 in Duisburg, a year after his death, by his son Rumold. Dallas Pratt thought that this map was probably a later edition. He concluded this because the coast of the polar island opposite Europe has been burnished out; the shape of the arctic island Novaya Zemlya has also been revised, following the 1594–97 explorations of Willem Barents. The area covered extends beyond the Arctic Circle to latitude 60° and includes the recent discoveries made during the Arctic voyages of the English explorers Martin Frobisher (1576–78) and John Davis (1585–87). All these explorers had been engaged in a search for a Northeast or Northwest Passage to the riches of East Asia. European nations were encouraged in this quest by maps such as this, which showed an expanse of clear water between the polar ice and the northern shores of the continents. The roundels in each corner contain the title, the Faeroe Isles, the

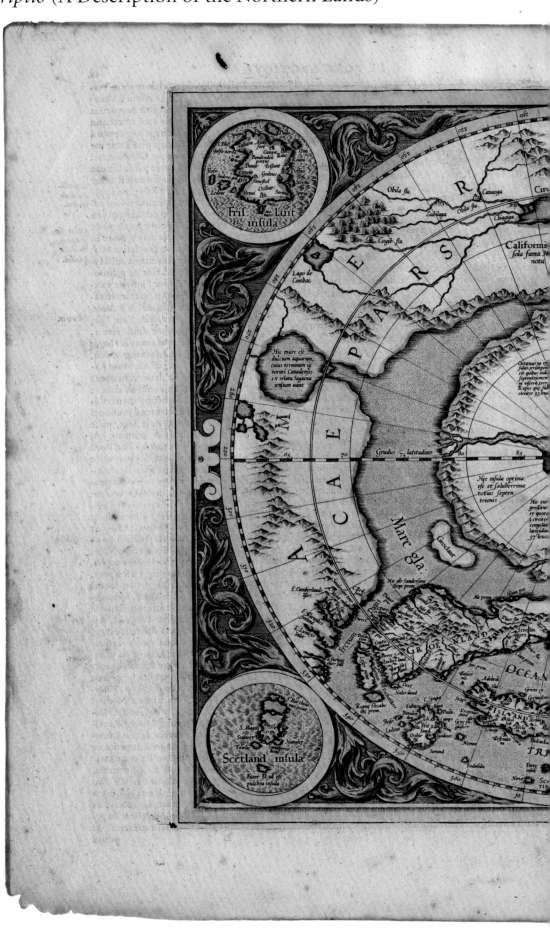

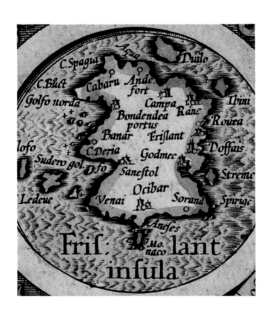

ABOVE: Roundel with the imaginary island of Frisland, which also appears on the main map between Greenland and Iceland.

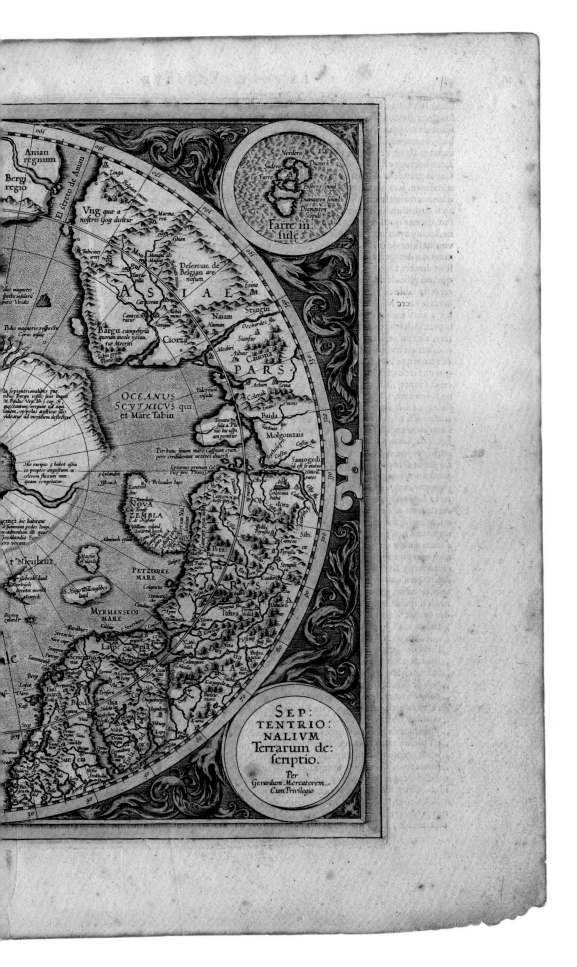

Shetland Isles and the imaginary island of Frisland, which is also shown on the main map between Iceland and Greenland.

Collecting material from his home in Duisburg, Mercator could only be as accurate as his informants. The Strait of Anian (now Bering) separates America from Asia, but what is now Alaska is named 'California, known to the Spanish'. The 'Sea of Sweet Water' in the north of America may be the result of reports of Hudson's Bay or the Great Lakes. The most surprising feature is the depiction of the North Pole: four islands are separated by four rivers that flow north towards a whirlpool with a black rock in its centre – the pole itself. When questioned by the occultist and scientist John Dee (1527–c.1608) about the source of his information, Mercator cited a second-hand account of a fourteenth-century English Franciscan from Oxford, who 'went to those islands; and… advanced still further by magic arts and mapped out all and measured them by an astrolabe'. The black rock pictured may thus be an attempt to explain the magnetic pole, apparent to voyagers in the mysterious deviation of the compass. Such is the enduring power of myth (when reinforced by a respected cartographer such as Mercator) that this depiction of the North Pole within four islands was much copied by later cartographers.

ABOVE: The magnetic north pole is represented by a rock surrounded by four islands, which are divided by four rivers that flow north.

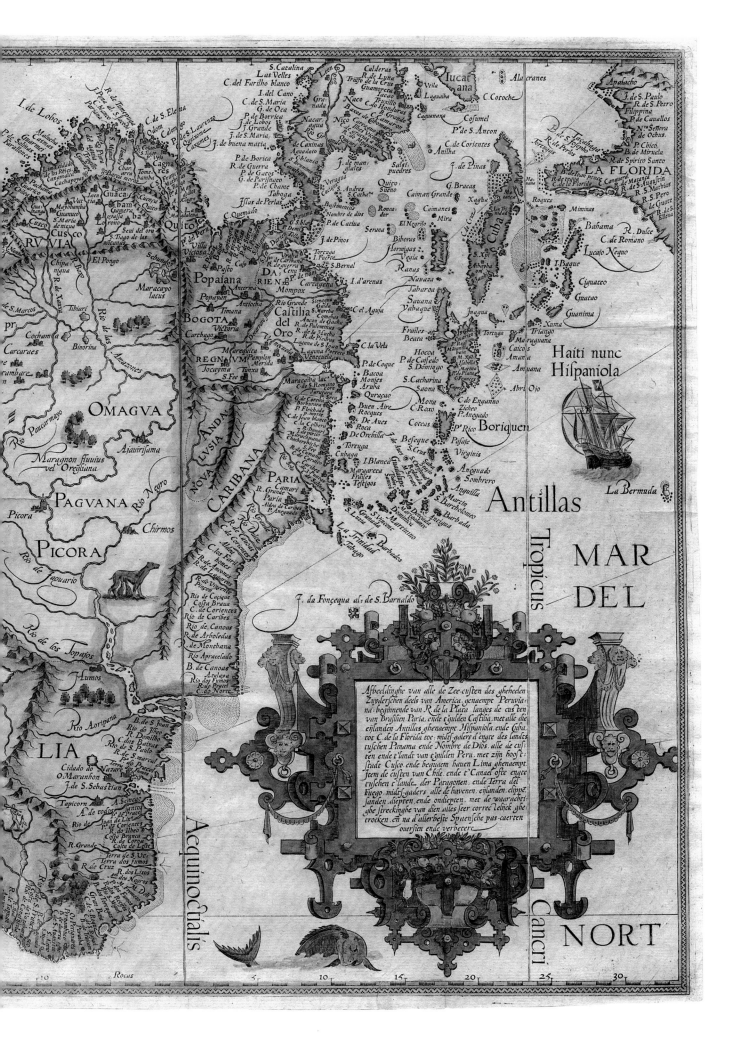

See previous page:

Delineatio omnium orarum totius Australis partis Americae...
(Map of all the coasts of the Southern part of America)

Jan Huyghen van Linschoten (1563–1611),
cartographer; Arnold Florent van Langren
(1580–1644), engraver
Amsterdam, 1596
Hand-coloured copperplate engraving
Sheet (trimmed) 397 × 564 mm
AMIB 1988.177

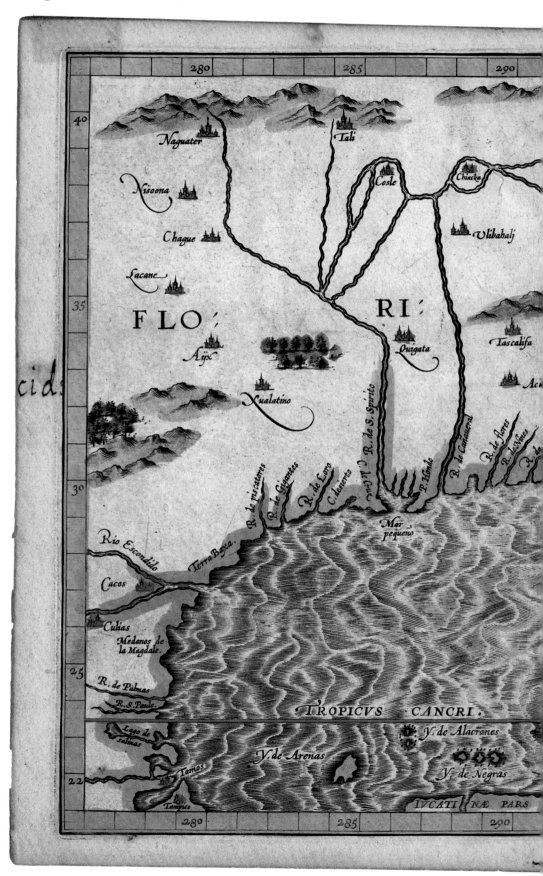

Linschoten was a Dutchman who, by his travel accounts and their accompanying maps, encouraged his fellow-countrymen to compete with and eventually displace Portuguese dominance in the East Indies. His *Itinerario*, published in English in 1598 with the title *Discours of Voyages into the Easte and West Indies*, was also instrumental in prompting the English and French to undertake eastward voyages, to India in particular.

Linschoten amassed his information in, of all places, Goa, where he, a Protestant, had a post as secretary to the Catholic archbishop. It was, he writes, better than 'living idleye in my native country'. For six years he was ideally placed to keep journals of the lives and customs of the native Indians as well as of the Portuguese colonists. More importantly, he also came into contact with Portuguese mariners on their way to the East Indies and back to Portugal by way, sometimes, of Brazil. From them he recorded accounts of the native peoples and the navigational routes used in this thriving overseas trade. Back in Europe, his travels were not over: in 1594 he travelled with the Dutch explorer Willem Barents on his first voyage to the Arctic in search of a Northeast Passage. After adventures with polar bears and hostile natives, Linschoten returned to the Netherlands to write his travel books.

Considering that Linschoten had never visited the Americas, this map is surprisingly detailed, with names of settlements crowded along the coastline of the whole continent. There is less accurate information about the interior: Brazil is described as a 'smal, but an invincible countrey'; and in Patagonia, the land of the original 'Big Foots', there are a couple of warriors. Gaps in knowledge are filled by pictures of the usual cannibals and strange beasts, including llamas.

The map was engraved by the celebrated globe-maker Arnold Florent van Langren, who was able to give full rein to his talent in the superbly decorated cartouches with their *putti* and elaborate strap work. The inscriptions in Latin and Dutch explain the scope of the map, which is indeed remarkable since it was published little more than a hundred years after the discovery of America.

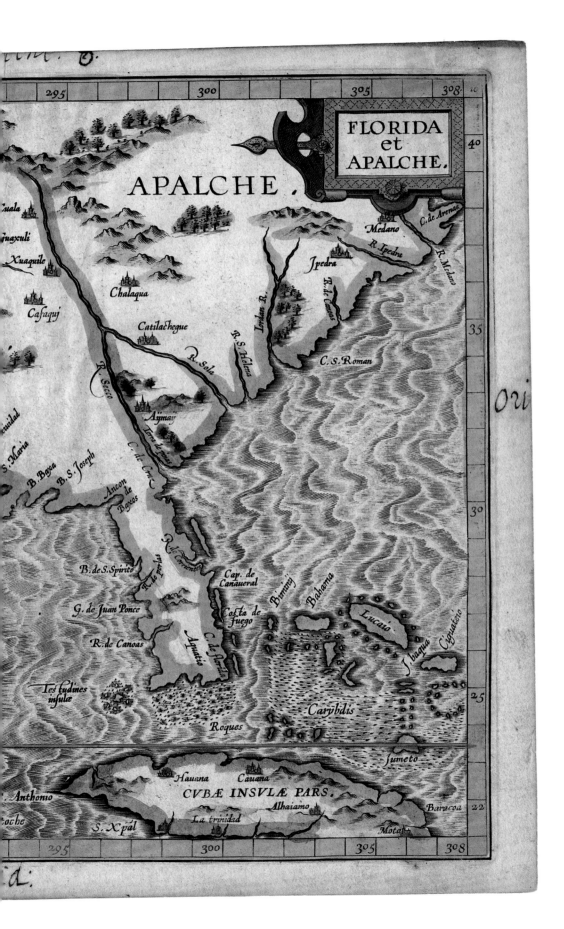

Florida et Apalche (Florida and Apalche)

Cornelis van Wytfliet (d. 1597), cartographer
Louvain, 1597
Hand-coloured copperplate engraving
Sheet 246 × 308 mm; plate 230 × 287 mm
AMIB 1988.41

Wytfliet's map is one of nineteen included in the first regional atlas of America, which featured eight maps devoted to North America. The atlas is called a supplement (*Augmentum*) to the *Geographia* of Ptolemy, who had, of course, no knowledge of America. Despite invoking the authority of the ancient geographer, this atlas does not follow Ptolemy's dictate that unknown areas should be left empty; the maps, particularly their unexplored interiors, are scattered with features arising from hearsay (the Great Lakes or Hudson Bay), wishful thinking (the Northwest Passage) and mythology (the Seven Cities of Cíbola and El Dorado).

The authorship of the maps is unknown; taken from various sources such as Mercator, Ortelius and Plancius, they were collected for the atlas by Cornelis van Wytfliet, secretary to the Council of Brabant in the Spanish Netherlands. Dedicated to Philip III of Spain, the atlas was highly successful, running to several editions. It was bought by readers, not normally interested in regional maps, whose curiosity about America had been sharpened by De Bry's *Grands Voyages* series.

The names 'Florida' and 'Apalche' cover an area extending from the Outer Banks of North Carolina as far as New Spain (Mexico), with the Yucatan Peninsula just making an appearance at the bottom. The geographical features are based on accounts from the survivors of Hernando de Soto's 1539–42 expedition. The route taken by de Soto and his followers extended from the west coast of Florida, northeast as far as the Carolinas, then looped westwards to cross the Mississippi, before finally reaching Mexico. De Soto died on the banks of the Mississippi (here shown as the *Rio del Spirito Santo*), having found neither treasure nor the fabled Seven Cities of Gold. De Soto bequeathed a dire legacy of European diseases to the once populous and thriving Mississippi Valley people, who were eradicated within a few years of this first European contact.

123

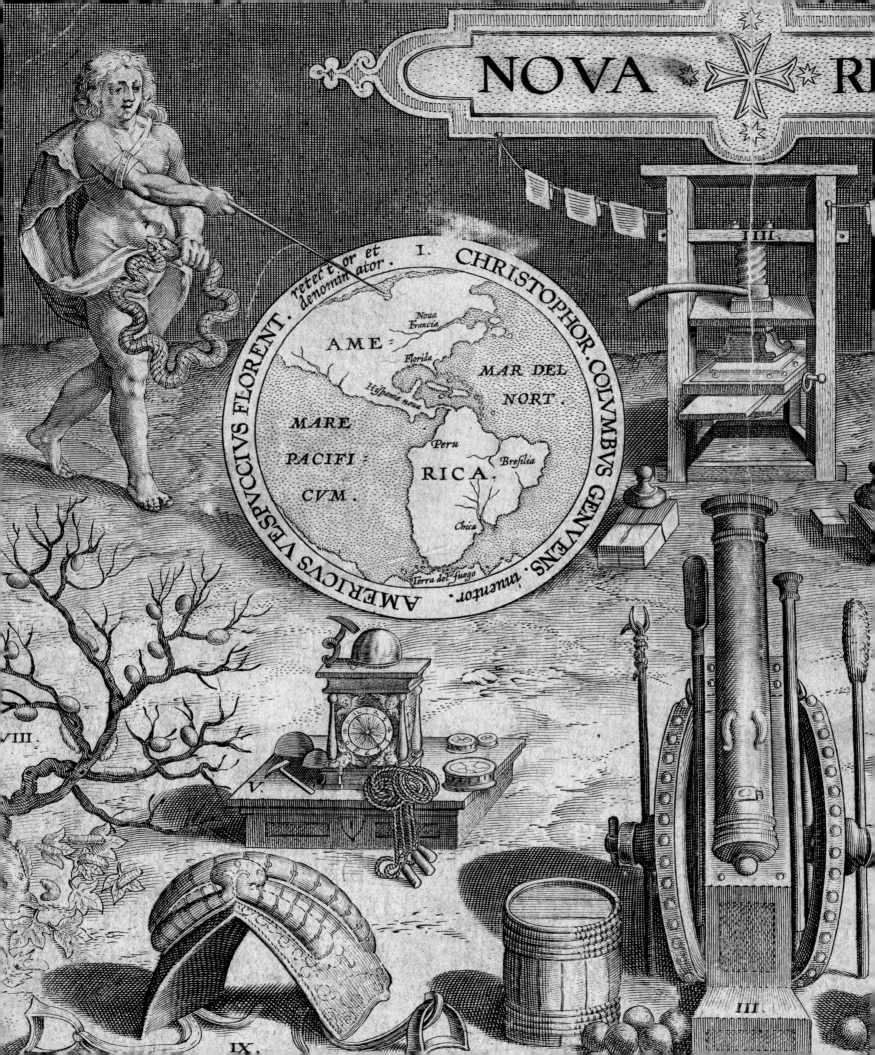

NOVA · R

CHRISTOPHOR·COLVMBVS·GENVENS·inuentor·

AMERICVS·VESPVCCIVS·FLORENT·retector et denominator·

I.

Noua Francia

AME

Florida

MAR DEL

Hyspania noua

NORT·

MARE

Peru

PACIFI-

Bresilia

RICA.

CVM.

Chica

Terra del fuego

IIII.

VIII.

V.

III.

IX.

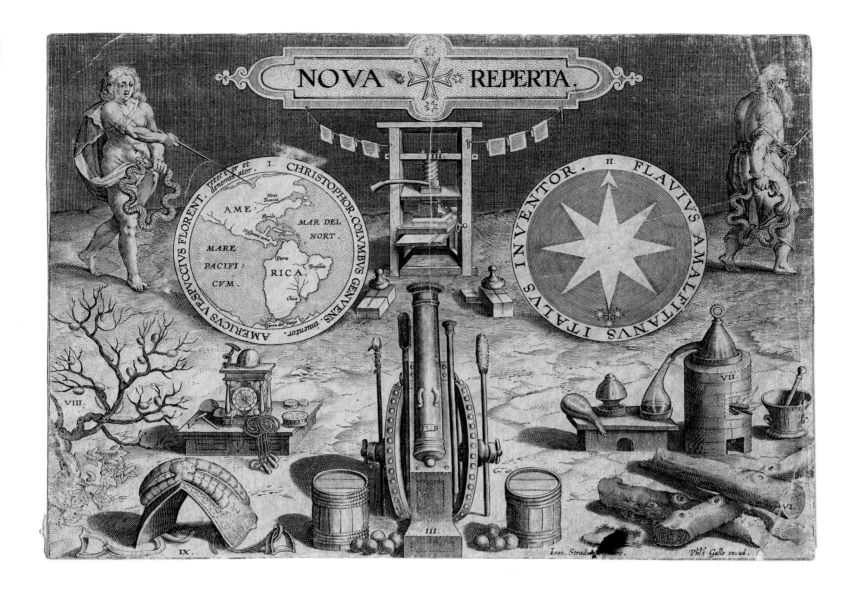

Title-page to *Nova Reperta* (New Inventions)

**Jan van der Straet, also known as Stradanus
(1523–1605), illustrator**
Antwerp, 1600
Copperplate engraving
Sheet (trimmed) 194 × 270 mm
AMIB 1988.156

At the end of the sixteenth century the
Bruges-born, Antwerp-trained artist known
as Stradanus commemorated the geographical
discoveries and mechanical inventions of the
Renaissance in a series of celebratory drawings.
He was living in Italy at the time, working for the
Medici family and Giorgio Vasari, but sent these
drawings to Antwerp to be engraved.

Working with the Antwerp-based master
engraver Adriaen Collaert (*c.*1560–1618) for the
publisher Filips Galle (1537–1612), Stradanus
had earlier produced a compendium of four
allegorical prints in 1585, which were grouped
together under the title *Americae Retectio*. These
earlier drawings depicted the arrival of the great
mariners Christopher Columbus (1451–1506),
Amerigo Vespucci (1454–1512) and Ferdinand
Magellan (*c.*1480–1521) in the New World.
This popular series (also collected by Dallas Pratt)
was re-issued in 1592 to mark the centennial of
Columbus's discovery of America and is of
artistic rather than factual interest.

Conversely, Stradanus's *Nova Reperta* does have
some scientific value. In the right-hand circle of
the title-page illustrated here, for example, Flavius
of Amalfi is credited with the invention of the
compass, while a prominently placed cannon in
the centre of the picture alludes to innovations in
the use of gunpowder. In the left-hand circle, the
discovery of America is showcased. Its discovery
is rightly attributed to Columbus, although
Vespucci is also acknowledged. The logs at the
right of the illustration are of the tropical wood
guaiacum. This was thought to be the source of a
cure for syphilis – the medical assumption at the
time being that if the venereal disease plaguing
Europe originated in the Americas (as was then
wrongly supposed), reason dictated that the cure
must also come from the New World.

Selected Bibliography

The American Museum in Britain

America in Britain. Annual journal published by the American Museum in Britain.

Barghini, Sandra, *Aspects of America: The American Museum in Britain* (London: Scala Publishers, 2007).

Beresford, Laura, *Folk Art from the American Museum in Britain* (London: Scala Publishers, 2011).

— and Hebert, Katherine, *Classic Quilts from the American Museum in Britain* (London: Scala Publishers, 2009).

Chapman, Dick, *Dallas Pratt: A Patchwork Biography* (Cambridge: Mark Argent, 2004).

— *Four Men and a Fortune* (Cambridge: Mark Argent, 2005).

De Pillis, Mario S. and Goodwillie, Christian, *Gather up the Fragments: The Andrews Shaker Collection* (New Haven: Yale University Press in association with Hancock Shaker Village, 2008).

Garrett, Wendell, ed., *The Magazine Antiques: The American Museum in Britain Special Issue* (March, 1993).

Pratt, Dallas, 'New World, Old Maps: The Adventures of a Collector,' *America in Britain*, 27/2 (1989), 15–22.

Roe, Sonia, ed., *Oil Paintings in Public Ownership in Somerset* (Frome: The Public Catalogue Foundation, 2009).

Wendorf, Richard, *Director's Choice: The American Museum in Britain* (London: Scala Publishers, 2012).

Maps of the New World

Bedini, Sylvio A., ed., *Christopher Columbus and the Age of Exploration: An Encyclopedia* (New York: Da Capo Press, 1998).

Binding, Paul, *Imagined Corners* (London: Headline Book Publishing, 2003).

Boorstin, Daniel J., *The Discoverers* (New York: Random House, 1983).

Brown, Lloyd A., *The Story of Maps* (New York: Dover Publications, Inc., 1979).

Burden, Philip D., *The Mapping of North America: A List of Printed Maps 1511–1670* (Rickmansworth, Hertfordshire: Raleigh Publications, 1996).

Cartier, Jacques, *March of America Facsimile Series*, x: *Navigations to New France*, trs. John Florio (Ann Arbor: University Microfilms, 1966).

Columbus, Christopher, *March of America Facsimile Series*, i: *Epistola de Insulis Nuper Inventis*, trs. Frank E. Robbins (Ann Arbor: University Microfilms, 1966).

— *Four Voyages*, trs. J.M. Cohen (London: Penguin, 1969).

Crane, Nicholas, *Mercator: The Man who Mapped the Planet* (London: Weidenfeld & Nicolson, 2002).

Diamond, Jared, *Guns, Germs and Steel: A Short History of Everybody for the Last 13,000 Years* (London: Vintage, 2005).

Eisenstein, Elizabeth, *The Printing Revolution in Early Modern Europe* (Cambridge: Cambridge University Press, 1983).

Fisher, Irving and Miller, O.M., *World Maps and Globes* (New York: Essential Books, 1944).

Gallo, Rodolfo, 'Antonio Florian and his Mappemonde,' *Imago Mundi*, 1/1 (1949), 35–8.

Girouard, Mark, *Cities and People: A Social and Architectural History* (New Haven: Yale University Press, 1985).

Goss, John, *The Mapping of North America: Three Centuries of Map-making 1500–1860* (Secaucus, New Jersey: The Wellfleet Press, 1990).

Harley, J.B. and Woodward, David, eds., *The History of Cartography, i: Cartography in Prehistoric, Ancient, and Medieval Europe and the Mediterranean* (Chicago and London: University of Chicago Press, 1987).

— *The History of Cartography*, iii: *Cartography in the European Renaissance* (Chicago and London: University of Chicago Press, 2007).

Hodgekiss, Alan, *Understanding Maps: A Systematic History of their Use and Development* (Folkestone: Dawson Publishing, 1981).

Hoskin, Michael, ed., *The Cambridge Illustrated History of Astronomy* (Cambridge: Cambridge University Press, 1997).

Howego, Ray, *The Book of Exploration* (London: Weidenfield & Nicolson, 2009).

Hulton, Paul, ed., *The Work of Jacques le Moyne de Morgues: A Huguenot Artist in France, Florida and England* (London: British Museum Publications, 1977).

— and Quinn, David Beers, *The American Drawings of John White 1577–1590* (London: British Museum Publications, 1964).

Jardine, Lisa, *Erasmus, Man of Letters: Construction of Charisma in Print* (Princeton: Princeton University Press, 1993).

Karrow, R.W. Jr., *Mapmakers of the Sixteenth Century and Their Maps: Bio-Bibliographies of the Cartographers of Abraham Ortelius, 1570* (Chicago: Speculum Orbis Press, 1993).

Keeler, Mary Frear, ed., *Sir Francis Drake's West Indian Voyage 1585–86* (London: The Hakluyt Society, 1981).

Kish, George, *The Suppressed Turkish Map of 1560* (Ann Arbor, Michigan: William Clements Library, 1957).

Koeman, Cornelis, *The History of Abraham Ortelius and his Theatrum Orbis Terrarum* (Lausanne: Sequoia, 1964).

Lister, Raymond, *Old Maps and Globes* (London: Bell & Hyman, 1979).

Lorant, Stefan, *The New World: The First Pictures of America* (New York: Duell, Sloan & Pearce, 1946).

Menzies, Gavin, *1412: The Year China Discovered America* (New York: Harper Collins, 2002).

More, Thomas, *Utopia* (Oxford: Oxford University Press, 1999).

Morison, Samuel Eliot, *The European Discovery of America: The Northern Voyages AD 500–1600* (New York: Oxford University Press, 1971).

— *The European Discovery of America: The Southern Voyages AD 1492–1616* (New York: Oxford University Press, 1974).

Nordenskiöld, A.E., *Facsimile-Atlas to the Early History of Cartography* (Stockholm: 1889; facs. edn., New York: Kraus Reprint Corp, 1961).

Polo, Marco, *The Travels*, trs. Ronald Latham (London: Penguin, 1958).

Portinaro, Pierluigi and Knirsch, Franco, *The Cartography of North America 1500–1800* (New Jersey: Edison, 1987).

Righini-Bonelli, M.L. and Settle, T., *The Antique Instruments of the Museum of History of Science in Florence* (Florence: Arnaud, 1973).

Roberts, Sean, 'Poet and "World Painter": Francesco Berlinghieri's *Geographia*,' *Imago Mundi*, 62/2 (2010), 145–60.

Schwartz, Seymour I. and Ehrenberg, Ralph E., *The Mapping of America* (New York: Harry N. Abrams, Inc., 1980).

Shirley, Rodney W., 'Epichthonius Cosmopolites: Who Was He?' *The Map Collector* (March 1982).

— *The Mapping of the World: Early Printed World Maps 1472–1700* (London: The Holland Press, 1983).

Skelton, R.A. ed., *Ortelius' Theatrum: Facsimile Edition with Commentary* (Amsterdam: Meridian Publishing Company, 1964).

Sloan, Kim, *A New World: England's First View of America* (London: The British Museum Press, 2007).

Taylor, E.G.R., *The Haven-Finding Art: A History of Navigation from Odysseus to Captain Cook* (London: Hollis & Carter, 1958).

Thomas, Hugh, *The Slave Trade: The History of the Atlantic Slave Trade 1440–1870* (New York, Simon & Schuster, 1997).

Tooley, R.V., 'Maps in Italian Atlases of the Sixteenth Century,' *Imago Mundi*, 3/1 (January 1939), 12–47.

Van den Broecke, M.P.R., *Ortelius Atlas Maps: An Illustrated Guide* (Utrecht: Hes & DeGraff, 1996).

Waldseemüller, Martin, *March of America Facsimile Series*, ii: *Cosmographiae Introductio*, trs. Joseph Fischer and Franz von Wieser (Ann Arbor: University Microfilms, 1966).

Warner, Deborah, *The Sky Explored: Celestial Cartography 1500–1800* (New York: Alan R. Liss, 1979).

Whitfield, Peter, *New Found Lands: Maps in the History of Exploration* (London: The British Library, 1998).

Woodward, David, ed., *Five Centuries of Map Printing* (Chicago and London: University of Chicago Press, 1974).

INDEX

Apian, Peter, *Cosmographia* 65
Arctic 118, *118–19*
Arias Montano, Benito 45–6
 Pars Orbis 44
Aristotle 49, 50, 78
Athore, Chief *7*, 109

Bacon, Francis, *The Advancement of Learning* 55
Balboa, Vasco Núñez de 11
Bayer, Johann, *Uranometria* 62, *62–3*, 115
Benzoni, Girolamo, *History of the New World* 101, 103
Berlinghieri, Francesco 15, 29
Bigges, Captain Walter 94
 Sir Francis Drake's West Indian voyage… 93
Blaeu, Willem Janszoon 9
Boazio, Baptista
 The Famouse West Indian voyadge… *1*, *15*, 92–3, *92–3*
 Plan of Cartagena (Colombia) 12, 15, 97, *97*
 Plan of St Augustine (Florida) 98, *98–9*
 Plan of Santo Domingo, Hispaniola (Dominican Republic) 94–5, *94–5*
Bongars, Johann 24
Borgia Map 14, 22, *22*, 25
Braun, Georg, and Hogenberg, Frans, *Civitates Orbis Terrarum* 86–7, *86–7*
Brazil 6, 13, 41, 60, 122
Bünting, Heinrich, *Asia in the form of Pegasus* 18, 88, *88–9*

Cabot, John 11, 33, 34, 41
Carleill, Christopher 93, 94–5, 97
Cartagena 92–3, 97, *97*
Cartier, Jacques 11, 12, 74, 77
Charles V, Emperor 11, 12, 17–18, 67, 80
Cicero, Marcus Tullius, 'Dream of Scipio' 14, 21
Cimerlino, Giovanni 71, 73
Collaert, Adriaen 125
Columbus, Christopher 6, 7, 10–12, *10*, 13, 29, 31, 34, 35, 60, 74, 80, *100*, *101*, 103, 125
 De insulis nuper in Mari Indico repertis 10
compass roses *1*, *47*, *92*
Copernicus, Nicholas 17, 35, 55
Cort, Cornelius, *Allegory of Astronomy* 55, *55*
Cortés, Hernán 6, 7, 67, 87
Cuba 34, 80
Cusco 87, *87*

Dare, Virginia 104
Dati, Gregorio, *La Sfera* 52, *52–3*
De Bry, Johann Theodor and Johann Israel 11, 80
De Bry, Theodor
 America sive novus orbis… *100–1*, 101
 Americae pars, Nunc Virginia… 104–6, *104*, *105*
 A Chief Lady of Pomeiock 107, *107*
 Les Grands Voyages 101, 104, 106, 109, 115, 123
 Hunting Deer *110–11*, 111
 The Indians of Florida Worship the Column *7*, *108–9*, 109
 Perlarum insula… *102*, 103
 Their sitting at meate 107, *107*
 A Weroan or great Lorde of Virginia *5*, 106, *106*
Dee, John 119
Doetichum, Jan van, the Younger 112, 115

Drake, Sir Francis 67, 92–3, 97, 98, 104
Dürer, Albrecht 16, 31, 46, *46*, 58
 Imagines coeli Septentrionales… *56–7*, 57

El Dorado 6–7, 123

Ferdinand, King of Aragon 6, 10, *10*, 12, 13, 34, 35, 80
Finé, Oronce, World Map 69, 71, *71*
Florian, Antonio 73, *73*
Florida 34, 92, 98, 109
Floris, Frans 55
Fool's Head 90, *90–1*
Forlani, Paolo, world map 45, *45*
François I, King of France 12, 18, 69, 74, 77
Frobisher, Martin 82, 113, 118

Gama, Vasco da 10
Gemma Frisius, *Cosmographia* 64–6, 65
Germanus, Donnus Nicolaus 28
Gourmont, Jean de 90

Hajji Ahmed World Map 13, 17, 69–70, *69–70*, 71
Hispaniola (Dominican Republic) 11, 34, 80, 92, *94–5*, 103
Hogenberg, Frans 82, 86, 90
Holbein, Hans, the Younger 17, 35
Hondius, Jodocus 113
Honter, Jan Coronensis, *Imagines Constellationum Australium* 58, *58–9*

Isabella of Castile, Queen 6, *10*, 11, 12, 34, 35, 103, *103*
Isidore of Seville 13–14

Jode, Gerard de, *Speculum Orbis Terrarum* 16
John XXII, Pope 24

Langren, Arnold Florent van 122
Las Casas, Bartolomé de 11, *11*
 Brevissima Relación 101
 Narratio Regionum Indicarum… 80, *80–1*
Lasso, Bartolomeu 113
Laudonnière, René de *7*, 109
Le Moyne de Morgues, Jacques 109, 111
Linschoten, Jan Huyghen van 115
 Delineatio omnium orarum… *120–1*, 122

Macrobius Ambrosius, *De Somnio Scipionis* 14, 21, *21*
Magellan, Ferdinand 10, 34, 41, *101*, 115, *116*, 125
Maiolo, Baldasare da, Portolan Chart 26, *26*, *26–7*
Martyr d'Anghiera, Peter 13
 Map of the Caribbean 34, *34*
Medina, Pedro de, *Nuevo Mundo* 67, *67*
Mercator (Gerard Kremer) 16, 17–18, 82, 115, 123
 Gored World Map in Two Hemispheres *72–3*, 73
 Septentrionalium Terrarum Descriptio 118–19, *118–19*
Mexico City (formerly Tenochtitlán) *86–7*, 87
Meyn, David de 17, 113
Molyneux, Emery 113
Münster, Sebastian 18
 Cosmographia 42
 Mostri marini e terrestri… *2–3*, 13, 42, *42–3*
 Tavola dell' isole nuove… *2–3*, 41, *41*
 Typus Cosmographicus Universalis 16, *38–9*, 39

Netherlands 112–13, 115, 123
Newfoundland 32, *33*, 113
Northwest Passage 18, 74, 118, 123
Nuremburg Chronicle, World Map *30–1*, 31

Olaus Magnus 42
Ortelius (Abraham Ortels) 17–18, 123
 Americae Sive Novi Orbis… *84–5*, 85
 Theatrum Orbis Terrarum 16, 78, *78–9*, 82, 86, 90
 Typus Orbis Terrarum 82, *82–3*

Philip II, King of Spain 12, 18, 80, 112, 123
Pizarro, Francisco 6, 7, 87, *101*
Plancius, Petrus 101, 123
 Nova Francia 9, 17, 112–13, *112–13*
 Orbis Terrarum Typus… *4*, 115, *115–17*
Pleydenwurff, Hanns 31
Ponce de Léon, Juan 34
Portugal 6, 10, 11, 67, 112, 122
Pratt, Dallas Bache 9, *18*, *19*, 22, 35, 41, 50, 69, 73, 80, 90, 103, 118, 125
 'Angel-Motors' 35
 collection 8–19
Prester John 25
Ptolemy, Claudius 17, 22, 57, 62, 69, 73, *128*
 Almagest 51
 Geographia 14–15, 25, 28–9, *28–9*, 32–3, *32–3*, 123

Raleigh, Sir Walter 104
 Discoverie of Guiana 7
Ramusio, Giovanni Battista, and Gastaldi, Giacomo
 La Nuova Francia 74, *75–6*
 La Terra de Hochelaga nella Nova Francia *76–7*, 77
Reisch, Gregor 45, 46
 Margaria Philosophica 49, *49*
Roanoke ('Virginia') 85, 92, 93, 98, 104, 106, 107
Ruysch, Johann 9, 32–3

Sacrobosco, Johannes de, *Sphaera* 50, *51–2*, 52
St Augustine (Florida) 92, 97, 98, *98–9*
Santo Domingo 82, 94–5, *94–5*, 97, 98
Sanuto, Marino 24
Schedel, Hartmann 18, 31
Shirley, Rodney 18–19
Solinus, Gaius Julius 14, 31
Spain 6, 11, 67, 92, 111
Stradanus (Jan van der Straet)
 Astrolabium 60, *60–1*
 Nova Reperta 16, *124–5*, 125

Taprobane (Sri Lanka) 29, 31, 32
Tordesillas, Treaty of 6, 12, 67

Venice 9, 13, 26, *27*, 69, 71
Verrazzano, Giovanni da 12, 18, 41, 74
Vesconte, Pietro, World Map 24–5, *24–5*
Vespucci, Amerigo 11–12, 34, 35, 60, *101*, 125

Waldseemüller, Martin
 Cosmographiae Introductio 11, 35
 Oceanus Occidentalis Terra Nova 10, 35, *35–7*
White, John 93, 98, 104, *104*, 106, *107*
Wytfliet, Cornelis van, *Florida et Apalche* 123, *123*

GLOSSARY

Armillary sphere: An early astronomical device made of fixed and movable rings representing circles of the celestial sphere, such as the ecliptic and the celestial equator. It was used as early as the third century BC as both a teaching instrument and an observational tool.

Astrolabe: An astronomical instrument employed by navigators and astrologers to measure the elevation of the sun and stars. It was used by Greek astronomers from about 200 BCE and by Arab astronomers from the Middle Ages, until superseded by the sextant.

Caravel: Any of several types of small, light sailing ships, especially one with two or three masts and lateen (triangular) sails used by the Spanish and Portuguese in the fifteenth and sixteenth centuries.

Compass rose: A circle or decorative device printed on a map or chart showing the points of the compass measured from true north and frequently magnetic north.

Ecliptic: The great circle on the celestial sphere that represents the sun's path through the background stars in one year. The northernmost point of this path is the Tropic of Cancer, its southernmost point is the Tropic of Capricorn, and it crosses the celestial equator at the points of vernal and autumnal equinox.

Gores: Tapering strips of paper, each section illustrated with part of a map, which would theoretically fold together to form a spherical globe.

Latitude: A measure of relative position north or south on the earth's surface, measured in degrees from the equator (which has a latitude of 0°, with the poles having a latitude of 90° north and south). Latitude and longitude (determining east–west positioning) are the coordinates that together identify all positions on the earth's surface.

Mappa mundi: A medieval, European world map. The Latin phrase means 'chart of the world'.

Parchment: The skin of certain animals, such as sheep, treated to form a durable material for bookbinding or manuscripts.

Portolan: Navigational charts drawn on animal skin, showing sailing directions and descriptions of harbours and coasts.

Prime mover: A philosophical concept proposed by Aristotle, who argued that in the beginning there must have been something that moved but was itself unmoved: the prime mover, or 'unmoved mover'.

Rhumb lines: An imaginary line on the surface of a sphere, such as the earth, that intersects all meridians at the same angle.

Treaty of Tordesillas: A settlement signed between Portugal and Spain in 1494 concerning the newly discovered lands outside Europe. The lands to the west would be Spanish territory; the lands to the east Portuguese.

Vellum: A fine parchment prepared from the skin of a calf, kid or lamb.

Wind head: The personification of wind on a map, often illustrated as a face blowing in the direction of the wind.

This edition © Scala Arts & Heritage Publishers Ltd, 2013
Text © The American Museum in Britain, 2013
Photography © The American Museum in Britain, 2013

First published in 2013 by
Scala Arts & Heritage Publishers Ltd
21 Queen Anne's Gate
London SW1H 9BU, UK
Tel: +44 (0) 20 7808 1550
www.scalapublishers.com

In association with
The American Museum in Britain
Claverton Manor
Bath BA2 7BD
Tel: +44 (0) 1225 460503
www.americanmuseum.org

ISBN 978-1-85759-822-3

Edited by Esme West
Designed by Yvonne Dedman
Printed in Italy

10 9 8 7 6 5 4 3 2 1

ABOVE: Portrait of Claudius Ptolemy, the most important geographer of classical times, from Albrecht Dürer's star chart of the northern skies (see p. 57).

FRONT COVER: Detail from *America sive novus orbis…* (see pp. 100–1).

BACK COVER: Detail from plan of Santo Domingo, Hispaniola (Dominican Republic) (see pp. 94–5).

INSIDE FRONT COVER: Detail from *Nova Francia* (New France) (see pp. 112–13).

INSIDE BACK COVER: Detail from *Typus Cosmographicus Universalis* (see pp. 36–9).